Blurring the Boundaries

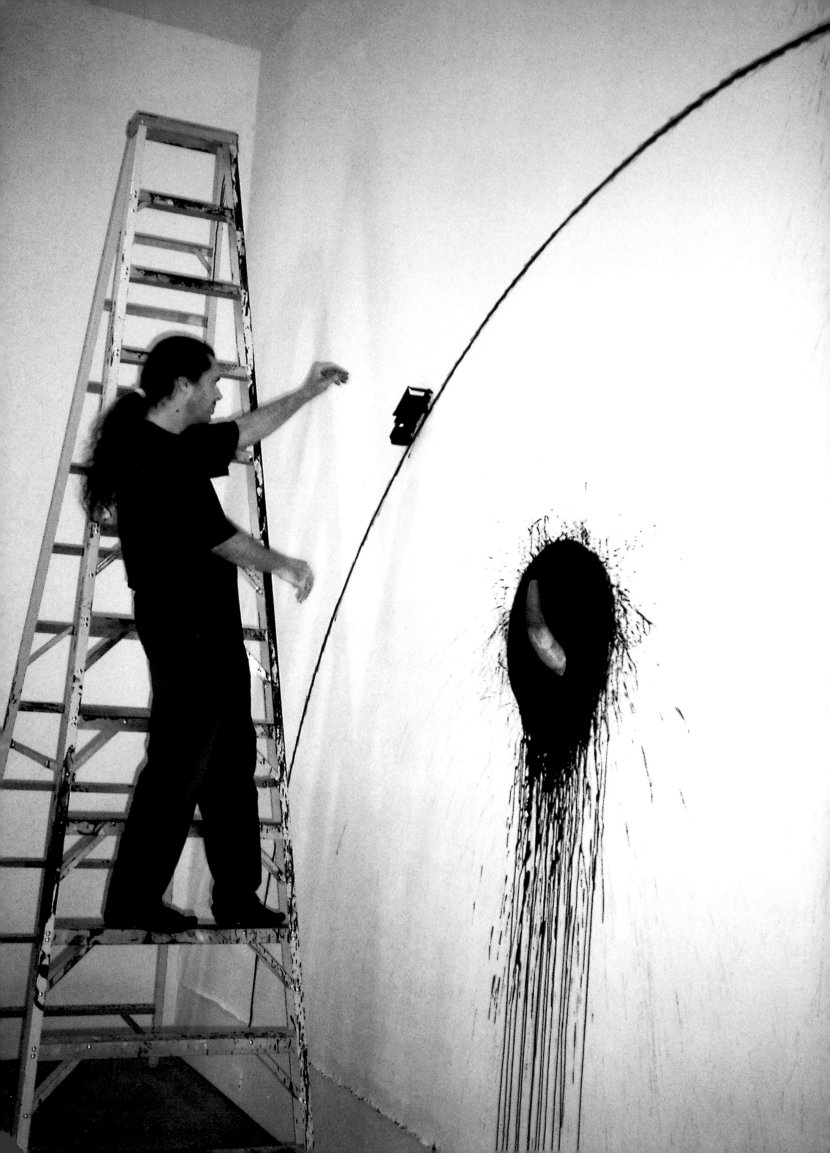

Blurring
the Boundaries
Installation Art 1969–1996

Essays by
Hugh M. Davies
Ronald J. Onorato

Catalogue entries by
Hugh M. Davies
Lynda Forsha
Louis Grachos
Madeleine Grynsztejn
Andrea Hales
Mary Johnson
Kathryn Kanjo
Seonaid McArthur
Ronald J. Onorato

Museum of Contemporary Art, San Diego

Catalogue coordinated by Lynda Forsha and Louis Grachos
Edited by Anne Farrell
Copyedited by Pamela Zytnicki
Designed by John Hubbard and Lynda Forsha
Produced by Marquand Books, Inc., Seattle
Printed and bound by C & C Offset Printing Co., Ltd., Hong Kong

ISBN 0–934418–50–0

Library of Congress Catalogue Card Number 94–075415

Second printing, 1999

This project was supported in part by grants from the National Endowment for the Arts, a federal agency, and a generous contribution from Lela (Jackie) Axline.

Endpapers: Ann Hamilton, *between taxonomy and communion* (details), 1990
Frontispiece: José Bedia at work on *Falsa Naturaleza (False Nature)*, 1984

Installations typically comprise more than one object and encompass large spaces, therefore one photograph usually cannot capture an installation in its entirety. The majority of photographs included in this catalogue should be considered details although this is often not indicated in captions.

All photographs by Philipp Scholz Rittermann unless otherwise indicated below. The following list applies to photographs for which the photographer is known: p. 181 (above), Jane and John Abbott, courtesy of Marian Goodman Gallery, New York; pp. 2, 16, 17, 88 (below), 89 (above), 93 (below), 96–108, 191 (below), Michael Arthur; p. 85 (below), courtesy of Mowry Baden; pp. 76, 77, Eduardo Calderón; p.122 (below), Becky Cohen; p. 191 (above), D. James Dee; p. 8, Larry Dale Gordon; p. 160 (below), courtesy of Silvia Gruner; p. 160 (above), Drei Kiel; pp. 25, 32, 36, 51, 116 (above), 118, 119 (below), 120, 121, 124–26, 129, 130 (above), 131, 134, 136 (middle), 137, 140, 141, 144–49, 190 (below), Mary Kristen; pp. 60 (below), 61, Richard A. Lou; p. 91, Kim MacConnel; frontispiece, Seonaid McArthur; p. 190 (above), courtesy of Burnett Miller Gallery, Los Angeles; p. 94 (above), Wanda Mock; p. 94 (below), 95, Roy Porello; p. 67, courtesy of Markus Raetz; pp. 47, 135, 136 (above and below), 138, 139, Louis Romano; p. 46, David Roselli/SECCA; p. 56, 57, Schopplein Studio, courtesy of Gallery Paule Anglim, San Francisco; p. 122 (above), Phel Steinmetz; pp. 18, 82, 83 (below), 85 (above), 87, Larry Urrutia; p. 88 (above), John Waggaman.

Contents

Richard Long,
Red Mud Circle,
1989

Acknowledgments

This book is a reflection of the Museum of Contemporary Art's long-standing commitment to site-specific and multimedia installation artwork, as evidenced by both the Museum's acquisitions record and the many significant exhibitions it has presented over more than twenty-five years. I am especially grateful to my colleague and friend, Prof. Ronald J. Onorato, for the insightful essay he contributed to this book, which documents the history of installation art and places MCA within the context of that history. As Senior Curator of the Museum from 1985 to 1988, Ron played an integral role in mounting many important exhibitions of installation and site-specific artwork by important contemporary artists. I also want to express my deep thanks to former MCA Curators Larry Urrutia, Robert McDonald, Richard Armstrong, and Lynda Forsha, who generously shared information about past exhibitions and acquisitions with which they were involved.

The production of this book could not have been realized without the dedicated efforts of many people. Particularly, I would like to acknowledge and thank the curatorial team, including MCA's former Curator Louis Grachos; current staff members Andrea Hales, Seonaid McArthur, Mary Johnson, Suzanne Scull, and Virginia Abblitt; and former Associate Curator Kathryn Kanjo. Their research was aided immeasurably by interns Laura Blank, Karen Congden, Sarah Hull, Ann Junod, and Michele Roberto Severino, and by 1996 summer college interns Denise Gray, Christian Kleinbub, Bryn Macvicar, Melissa McIntire, and Hilary Snow.

Lynda Forsha, who was MCA's Curator from 1982 until 1993, returned temporarily to MCA in 1996 to serve as Interim Curator. She skillfully managed the book's final production and her insights contributed greatly to its design. Anne Farrell, the Museum's Development Director, took on the job of final editing and organization of the catalogue material. Julie Dunn provided additional editorial assistance. We are grateful to Ed Marquand and the staff of Marquand Books, particularly John Hubbard, who is responsible for the elegant and lucid design, and Pamela Zytnicki, who so thoroughly copyedited the book.

Without the enlightened interest and generous support of the National Endowment for the Arts, this project would have been impossible. The Endowment's support of MCA and hundreds of other U.S. museums over the past thirty years has acknowledged in a very concrete way the obligation of museums to share their collections with as wide an audience as possible. We are especially grateful to the NEA for its ten-year support of MCA's *Parameters* series through the Museum Program, a funding category that was eliminated in the Endowment's 1996 reorganization. The majority of MCA's *Parameters* projects are described in the exhibition chronology of this book. They are a testament to the lasting value of the federal agency's support of unpredictable, unfettered contemporary expression in the years before the tide of political interference washed over the NEA.

We owe a special debt of gratitude to one of MCA's most beloved benefactors, Lela (Jackie) Axline, who has been a champion and patron of our Museum for many years. Finally, I express my deep thanks to the collectors who contributed the works featured in this catalogue and to the donors—individual, corporate, foundation, and government—who provided financial support to fund MCA's exhibitions and acquisitions over nearly three decades. Most of all, I would like to thank the many artists who patiently fielded our queries and contributed invaluable information about their work and past installation projects at MCA. We are proud to document their work and this Museum's unique history for present and future generations.

Hugh M. Davies

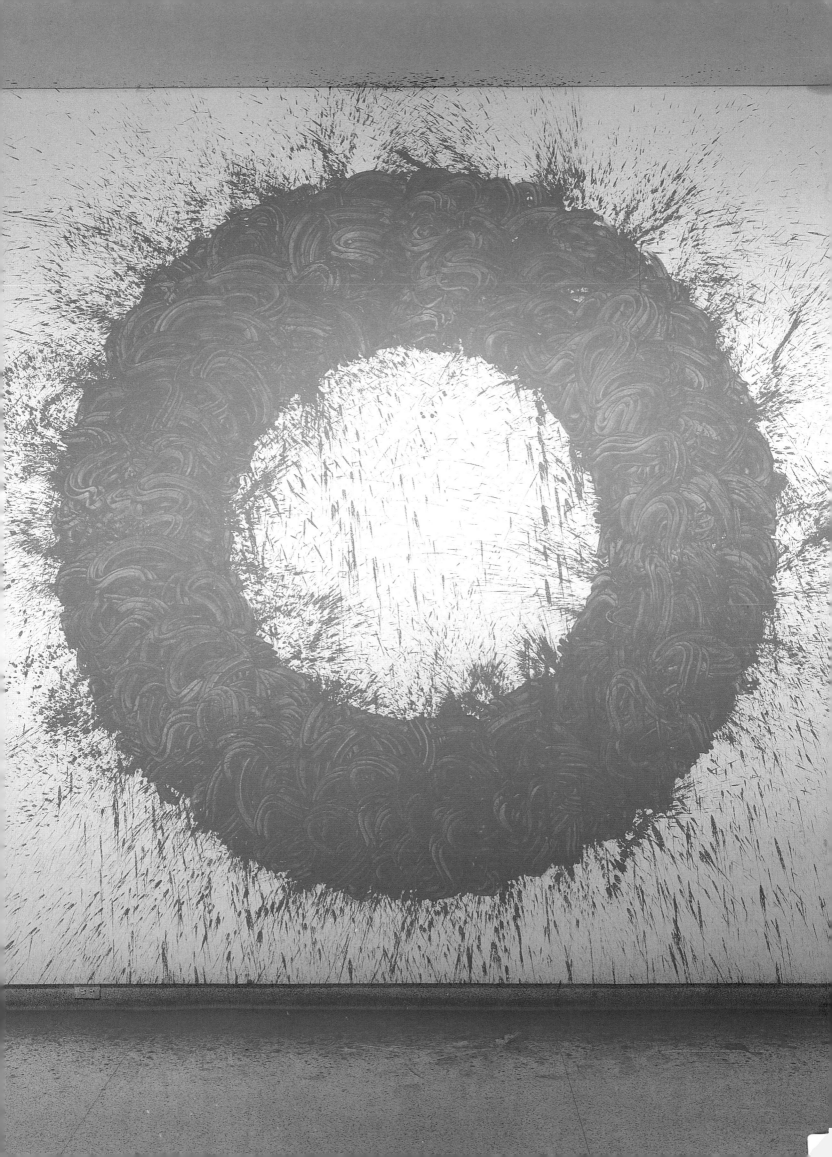

Introducing Installation
a Legacy from Lascaux to Last Week

Far from being the latest movement or a new development in contemporary art, the installation art we celebrate today, one could argue, is only the most recent manifestation of the oldest tradition in art. The earliest known artistic expressions—the gloriously simple drawings in the Lascaux and Altamira caves—sought to record hunting activity, perhaps to supplicate divine assistance, and certainly provided decoration above the proverbial couch. What is also significant about these elegant murals is that they were made directly on the wall. They could not be moved. The depicted animals follow the contours of the irregular surfaces of the wall as if the rock itself provides a painterly landscape background. These lovingly rendered hoofed creatures symbolically negotiate the uneven terrain they inhabited in reality. Did the artists intend such subtle meaning? Almost certainly not, but they did choose to make their drawings part of the architecture rather than portable.

My point is that the framed painting—the portable commodity—is a relatively recent phenomenon in Western art. Going back in time and tracing successive civilizations, it is clear that until roughly the seventeenth century art was almost invariably and inextricably interwoven with architecture. The tombs of Egypt, the temples of Greece and Rome, the cathedrals of the Middle Ages, all supported two- and three-dimensional systems of decoration. In preliterate societies, the art on these walls became the primary method of recording events and beliefs for posterity. Through stained-glass windows, mosaics, and bas-relief sculpture the Church taught the Bible much as advertising today trains consumers. The portable art of these times came in the form of armor, jewelry, furniture, and illuminated manuscripts—primarily personal and domestic trappings outside the canon of what was considered high art.

Why did artists start making portable pictures? In this necessarily abbreviated history, two good reasons can be identified. First, the status of artists changed from that of dependent artisan to independent artist. As a part of this shift in status, artists gained freedom of expression—they could paint what they wanted rather than having to work within the constraints of the spatial and iconographic program dictated by the patron, be it pope, emperor, Medici, Church, state, or individual. A second, related reason was the ability to transport artworks and thereby actively sell them to a wider range of clients, rather than wait passively for commissions. Henceforth, artwork as a portable commodity began to

Mural (detail), Lascaux II, Dordogne, France, 13,000–10,000 B.C.

supplant artwork as architectural embellishment. New methods of manufacture and distribution of goods gave rise to the advent of museums and galleries where art was assembled and displayed. Artists increasingly worked out of studios rather than in situ, producing portable works of art. This gradual move toward more readily portable forms of art stimulated lively commerce in art galleries and auctions, as evidenced by the founding of Christie's in London in 1766. Many patrons continued to commission artists to create works for specific sites in their private residences, in churches, and in universities, but by and large, the transportable canvas or sculpture has dominated the creation and commerce of art to this day.

In the first half of the twentieth century, an interest in making art more ambitious in scope and scale than the standard gallery-size picture continued, but was sporadic, as seen in examples as disparate as Picasso's sets for theater and dance, Kurt Schwitters's *Merzbau* room environments, the large-scale works of the Mexican muralists, and Marcel Duchamp's string-wrapped room for Peggy Guggenheim's Art of This Century Gallery and his ultimate and intimate *Etant Donnés*—the permanent peeping Marcel behind his barn door installation at the Philadelphia Museum of Art. After mid-century, inspired perhaps by the ambitious reach of Picasso's *Guernica* and American artists' firsthand experience with mural making gained through the Works Progress Administration, the Abstract Expressionists aspired to again envelop the viewer's field of vision with paintings of heroic proportions. The vast canvases of Clyfford Still, Jackson Pollock, and Barnett Newman challenged the notion of domesticated pictures and reintroduced architectural scale into mainstream art.

In the formal tradition, the next step in liberating art from the frame was Frank Stella's shaped canvases, which broke the hegemony of the rectangle and, in a circuitous, Minimalist fashion can be said to have led to Sol LeWitt's wall drawings—our century's strongest contribution to the tradition of the architecturally integrated fresco or mural. For other, less traditional artists of the Pop and Minimalist persuasions, two dimensions seemed too constricted, if not irrelevant to the contemporary world. The Happenings of Allan Kaprow that melded theater and art, Claes Oldenburg's *The Store,* and the varied tableaux of George Segal, Edward Kienholz, and Tom Wesselmann all brought environmental vitality back into art.

During this fecund and heady time in the sixties and seventies, for some artists, art became conceptual, and the primacy of intellectual aims over the visual ends threatened to result in the idea expunging the object altogether. By this time, it was clear that art had come a long way from the delightful, nonthreatening Impressionist pictures that hang demurely in gold frames at the Met. The intellectual possibilities for art have expanded exponentially during the course of this century. Yet ironically, with the exception of the important introduction of electronic technologies, the equally essential physical component of art—the medium—has not grown, but rather has recovered the expansive reach of art that existed before portability constrained creativity. It remains a capitalist verity, however, that competent painters of modestly sized realist pictures will make a living, while brilliant environmental sculptors will make art history and need a day job. The secondary market for site-specific artworks is no better today than it was in the

seventeenth century for Bernini. Which is a roundabout way of explaining why it has been so important for the Museum of Contemporary Art, San Diego, to commission, exhibit, publish, and, when possible, to collect and preserve installation artworks.

Since the late 1960s a few visionary and well-to-do art dealers, such as Virginia Dwan and Leo Castelli, have supported and exhibited artists who make immovable, inaccessible earthworks, virtually invisible conceptual art, and space-demanding, ephemeral installation pieces. Similarly, a handful of daring collectors like the Panzas and Pulitzers have purchased or commissioned works that have little or no possibility for resale or reincarnation at subsequent sites. For the last quarter of the twentieth century, however, contemporary art museums and alternative spaces have been the primary patrons of artists who make work that is not easily accommodated or commodified. It is entirely appropriate that noncommercial, publicly supported institutions should sustain creative people who pursue advanced aesthetic research.

Artists who work in unconventional media such as installation function as the aesthetic explorers of their generation, and they operate in territory well beyond the conventional supply lines and safety nets of galleries and collectors. Whatever aesthetic bounty experimental artists bag rarely translates into trophy art to hang above the mantel that is likely to turn a handy profit. "We got in on the Schnabel thing early, snagged a plate piece for nothing before the Boone happened, hung on until the Whitney begged for it, and then turned a tidy profit on the appreciation when the tax window reopened. Julian's delighted and we are too. Nifty, really, this art business." As opposed to . . . "Gee hon, what would we ever want with an earthwork? We don't even use the swimming pool."

Experimental work in any field is hard to finance. When it comes to art, few venture capitalists jump at the opportunity to advance civilization by supporting forward-thinking artists since the downside promises critical ridicule, collegial scorn, and spousal incredulity if the attempt comes up short. Given this scenario, it's amazing how many individuals do support experimental art. Even so, for the past twenty-five years the single most critical, daring, and consistent source of funds for such advanced work as installation art has been the federal government, through the National Endowment for the Arts. If science can be taken as a parallel, even the most enlightened corporation finds it hard to justify to stockholders the support of pure research that holds only the most distant prospect of a better mousetrap to market in upcoming fiscal quarters. Everyone acknowledges, however, the importance of unfettered scientific research to ensure our advantage in the global economic race. This is why the primary source of research money available to pure science is the government, through the National Science Foundation, which has to fight harder every year to protect its funding from further Congressional cuts.

Those who argue that the art market should determine which artists will prosper are destined to banal prospects in the art of the future: duck prints, doe-eyed children—superficial art devoid of all but Hallmark content—or sloppy, decorative abstraction and compulsive photographic realism. It cannot be forgotten that part and parcel of the role we enjoy as the so-called leader of the free world is the preeminent position we have held in the visual arts since mid-century. The measure of artistic hegemony is not easily quantified, since we don't have an aesthetic equivalent of Wall Street's big board. There is

no doubt, however, that if we back away from the spirit of inquiry, adventure, and courage that got us here in the first place, we will inevitably lose our position of prominence in the arts.

The National Endowment for the Arts has been under siege from conservatives on the religious and political right for several years now, and the continuing decrease in funds allocated to the Endowment is taking its toll. As has been pointed out ad nauseam, only a fraction of NEA funds has gone to support "controversial" art. Holding the agency accountable for the moral suitability of art produced *after* a grant has been given is patently absurd and impossible to regulate. The gray area of family values plays well on the campaign trail, but issues of obscenity are best settled in a court of law so as not to impinge on the Constitutional right to freedom of expression. I suppose we in the arts should have anticipated that counterculturalists would supplant communists in Gingrich's demonology, but God help a generation whose definition of art comes from the eye of Newt.

Most of the installation works in our permanent collection are too cumbersome to exhibit on a regular basis, but this catalogue allows us to permanently document these works. More important, the pages that follow include dozens of examples of significant pieces commissioned and constructed as part of the Museum's exhibition program since 1969 that have not survived and which now exist only in photographs.

It is noteworthy that many of these installations and exhibitions were originally funded by the NEA. For all these reasons and more, we are honored and grateful that this publication was supported by a major grant from the Museum Program of the National Endowment for the Arts. We invite readers to enjoy the work chronicled here and to celebrate the achievements of the artists, the Museum of Contemporary Art, San Diego, and the National Endowment for the Arts. Long may they all prosper.

Hugh M. Davies

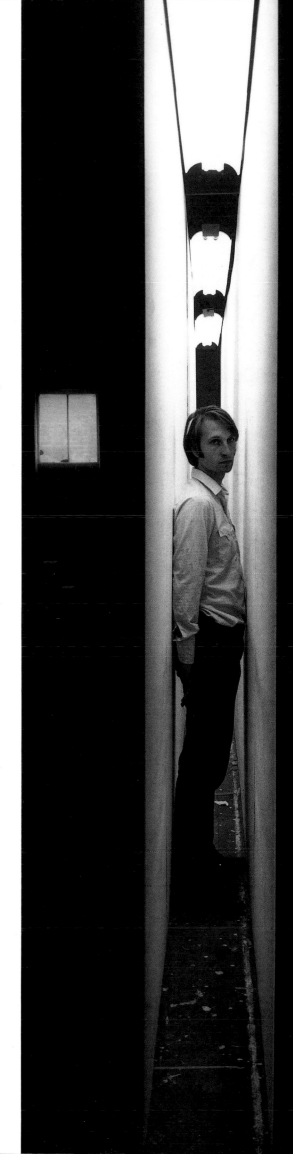

Bruce Nauman in the *Green Light Corridor* in 1971

Blurring the Boundaries
Installation Art

Since the beginning of the 1950s, artists have been making works characteristic of what is now called installation art. Fundamental aspects of installation artwork are its habitation of a physical site, its connection to real conditions—be they visual, historical, or social—and often, its bridging of traditional art boundaries: public and private, individual and communal, high style and vernacular. The aesthetic power of installation art does not reside in the singular, commodified object but in an ability to become, rather than merely represent, the continuum of real experience by responding to specific situations. Installation art is a decidedly inclusive idiom, and the work of a variety of artists using disparate media—from painting and sculpture to performance and video—can be traced through the permanent collection and exhibition record of the Museum of Contemporary Art, San Diego, which has a unique heritage of support of such art stretching back to the 1960s.

There are several arenas within which most installation artists work: light and audio, performance and process, constructed architectural environments, narrative or political work, and video. While such categories at first appear distinct, they frequently overlap in practice. All have in common, however, an ambition to reengage art making with experiences outside the symbols, mythologies, and constraints of the conventional language of the visual arts.

Precursors to current installation practice were plentiful in the 1950s and '60s. Jackson Pollock, followed by other action painters, shifted the emphasis of painting from product to environmental process when he choreographically recorded his locomotion through space on canvas. Early Happenings by Allan Kaprow, Jim Dine, and Claes Oldenburg in the late 1950s further obscured the line between real time and space and the fiction of art. Once the real world was engaged by Pop-era artists of the 1960s, artworks that inhabited and inflected real spaces began to appear everywhere. Even when the artwork was a prime object—a painting or sculpture—considerations of site and associated contextual references were crucial to understanding the work.

These primary characteristics of installation art are borne out by art history. Andy Warhol's stacked boxes of the early sixties rely for their meaning on a Duchampian shift from an expected consumer context—a supermarket or a warehouse—to a recognized art space. Oldenburg's papier-mâché commodities of 1961 reference the storefront context from which they originated. When James Rosenquist installed his airplane-size mural, *F-111,* around the walls of the Leo Castelli Gallery in 1965, viewers couldn't see the work from an ideal, static location outside the illusionistic space of the canvas, but instead needed to navigate the reality of their own space in order to completely comprehend the painted form.

In the same decade, but on a more perceptual plane, it would be hard to imagine Robert Irwin's discs from the late 1960s without the armature of a wall or the container of the room space—despite the artist's insistence that he was "breaking the frame." In the

piece *Untitled* (1969), among the earliest installation works in the MCA collection, Irwin sets up the relationship between the artwork and its architectural surroundings through its iconic hanging, the inclusion of lights that are spatially separated from the acrylic disc, and the shadow effects the lights create at the center of the work. Irwin had already experimented with ways to control the context for viewing his art in his line paintings of 1962–63, in which the frontality of the paintings forces the viewer to perceive them from a single dominant vantage point. With the disc works Irwin not only dictates the vantage point, but orchestrates the context in which the piece is viewed by providing his own light sources—further blurring the perceptual boundaries between object and space.

In several other artworks in the MCA collection artists have employed similar strategies to mediate perceptual phenomena. In *Stuck Red* and *Stuck Blue,* both of 1970, James Turrell also employed electric light: colored fluorescent tubes were placed behind rectangular openings cut into specially constructed walls to create an illusory environment in which the walls and the cutouts read simultaneously as planes and as voids. In *De Ondas* (1985), Maria Nordman manipulated natural light through the use of large baffles, exposing situational variations in the piece. Stephen Antonakos in *Red Box Over Blue Box Inside Corner Neon* (1973) and Dan Flavin in *Untitled (to Marianne)* (1970) both used colored fluorescent or neon light to wash corners, walls, floors, and ceilings with colors, articulating spaces within a preexisting environment. Here, perhaps reflecting an East Coast bias, the lighting equipment was neither marginalized nor hidden, but integrated into the geometric framework of the piece.

When installation artists ask viewers to relate to the artwork in some way other than through visual observation—often by asking them to participate in the completion of the piece—they challenge more than the viewers' expectations about materials and conventions. For example, Mowry Baden's work *I Walk the Line* (1967) is strongly allied with body, performance, and action art of the period. Baden encouraged viewers to balance visual comprehension with more dominant tactile and spatial sensations as they walked through the toroidal shape of the piece.

Baden, Chris Burden, and Bruce Nauman were the subjects of a 1971 exhibition at MCA entitled *Body Movements,* which introduced viewers to the kinetic explorations of these young sculptors. Baden knowingly wrote at the time: "Perception and action occur in a time continuum. Most actions alter the visual and tactile field sufficiently to make new judgments possible. . . . Action (or behavior) is the only medium that I have to confront and judge my mind's decisions."[2] Baden's seat belt pieces, which harnessed a participant's movements; Burden's simple machines, which set up specific psycho-physiological problems for one or more audience members to solve; and Nauman's light-filled corridor each provided the art audience of 1971 with real-time and real-space behavioral experiences that evoked human capabilities, reactions, and emotions.

In a later work, *The Reason for the Neutron Bomb* (1979), now in MCA's permanent collection, Chris Burden took his psycho-physiological experiments and turned them into political metaphors. If there is a physical dimension to this work, it is in the knowledge that a concerted effort was needed to create the broad, precise grid of coins as part of the installation process. The monotonous repetition and sheer size of the piece—50,000 nickels and matchsticks installed on the gallery floor to represent the amassment of arms in eastern Europe during the late 1970s—conveyed Burden's critique of the cold war at the outset of a trend by artists of Burden's generation to incorporate socio-political themes into artwork.

Much installation art is transient and does not survive in the form of permanent objects. To engage contemporary installation art, museums are challenged to operate as patrons instead of collectors—supporting the production of installation works through exhibitions and acquisitions, and colonizing new venues for installations outside the museum setting. Over the past quarter century, MCA has used these strategies to support a wide range of temporary installations and activities.

As early as 1970, in *Projections: Anti-Materialism,* a group exhibition meant to herald this new genre of dematerialized art, the Museum brought together the work of Robert Barry, Barry Le Va, Sol LeWitt, and others, and invited no less a visionary than R. Buckminster Fuller to write a short catalogue introduction that, while opaque in style, is particularly prescient of the use of electronic media in art and architecture today:

> Today's epochal aesthetic is concerned almost exclusively with the invisible, intellectual integrity manifest by the explorers and formulators operating within the sensorially unreachable, yet vast, ranges of the electro, chemical and mathematical realms of the physical and metaphysical realities. Their invisible discoveries and developments will eventuate as sensible instruments, tools, machines and automation, in general.
>
> Architecture, for example, will be an unobtrusive part of a vastly larger preoccupation of world society with life in universe. When successful, tomorrow's architecture will be approximately invisible, not just figuratively speaking, but literally as well. What will count with world man is how well the architecture serves all humanity while sublimating itself spontaneously. Architecture may be accomplished tomorrow with electrical fields and other utterly invisible environment controls.[3]

Robert Barry put it much more succinctly in the same catalogue in his axiomatic paradigm, "Art Work" (1970):

IT IS ALWAYS CHANGING.

IT HAS ORDER.

IT DOESN'T HAVE A SPECIFIC PLACE.

ITS BOUNDARIES ARE NOT FIXED.

IT AFFECTS OTHER THINGS.

IT IS AFFECTED BY OTHER THINGS.

IT MAY BE ACCESSIBLE BUT GO UNNOTICED.

PART OF IT MAY ALSO BE PART OF SOMETHING ELSE.

SOME OF IT IS FAMILIAR.

SOME OF IT IS STRANGE.

KNOWING OF IT CHANGES IT.[4]

In the exhibition, the artists used different approaches to express antimaterialism, all of which were dependent to varying degrees on the architecture of the Museum. Sol LeWitt sketched systematic drawings on the Museum's walls, a process he also explored in a later work, *Isometric Pyramid* (1983), now in the MCA collection. Barry Le Va created a performance piece in which the artist ran into the walls of the gallery; visitors experienced the piece as an audio recording. David Thompson constructed a water barrier, in which water cascaded down the gallery windows overlooking the Pacific

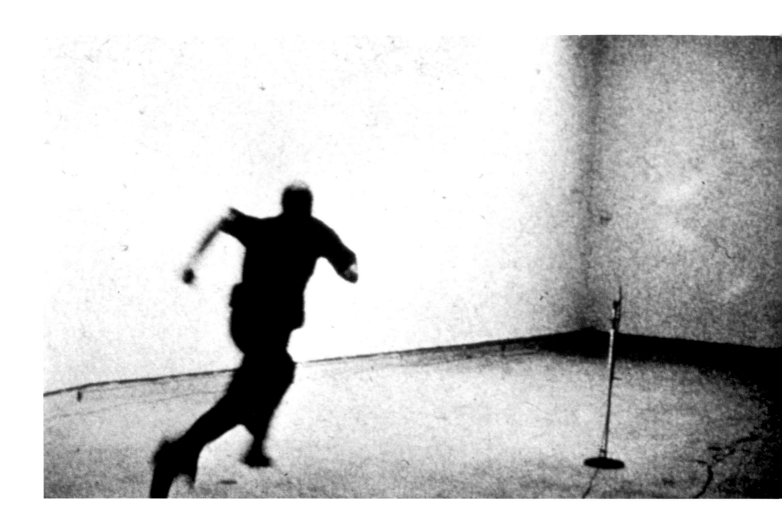

Barry Le Va
Velocity Piece, 1970

Ocean like a man-made deluge. Robert Barry produced a wall text containing a description of an artwork that had no other physical manifestation than the words in the description. Like Irwin's disc, Antonakos's cubes, and Flavin's fluorescent corner, each of these artworks echoed Fuller's definition of an approximate invisibility in architecture. They occupy spaces, vistas, or situations—such as existing walls, windows, or wall labels—that would not normally be articulated as art.

Whether the art world labels them as conceptual or perceptual, these artists create situations or events that are influenced by other forces—natural light, preexisting architecture, another installer's decisions, mathematics, recording devices, or even Fuller's "electrical fields." Many of these unpredictable conditions would have been regarded by earlier artists as compromising the relationship between viewer and artwork. By the 1970s, however, such strategies provided a means for artists to break from the white cube of most exhibition spaces, while simultaneously opening up the range of what could be considered an art experience. Although not quite "sublimated to serve humanity," the investigations of this generation of artists in the late 1960s forged a new direction for other artists to take over the next two decades, in which art practice reached into the social realm.

Numerous exhibitions at MCA between 1970 and the mid-1990s explored every aspect of installation work. Some artists, such as sculptor Robert Grosvenor, moved outdoors. In *Kinetic Ocean Piece* (1971), Grosvenor constructed a geometric form out of four-inch pipe that floated into the Pacific Ocean within sight of the Museum, responding to the motion of the waves. In that same year, as part of *Earth: Animal, Vegetable and Mineral,* a group exhibition on natural forces, Newton Harrison utilized the space outside the galleries to precipitate natural processes operating somewhere between the accepted

fields of art and science. In the Museum courtyard, Harrison established a garden that represented, on a small scale, an ecosystem in which white ducks controlled the snail population. Harrison's investigations addressed mundane earthbound systems, whereas Charles Ross, in a 1976 exhibition, *The Substance of Light,* focused attention on large-scale astronomical movements by providing a visual record of the sun's energy. In *Solar Burns,* Ross exhibited 366 wooden planks, placed around a room in a calendrical pattern. On each plank he had recorded burn patterns dependent on the solar intensity of a particular day. The grand scale of weather conditions, planetary movements, and the temporal expanse of a year were made visible in Ross's "solar narrative."

Investigations of light and color were undertaken by Ron Cooper, who created a piece composed of neon, fluorescent light, and reflective glass for a solo exhibition in 1973 that exposed his audience to the optical mixing of projected light. Other artists, such as Michael Brewster and Paul Kos, created environments where visual and aural elements were combined. In *rEVOLUTION Notes for the Invasion MAR MAR MARCH,* installed at MCA for a group show in 1973, Kos created a set of different stimuli to prompt his audience. Marching music emanated from a case at the far end of the room and a series of wooden planks were placed on the floor; the viewer was forced to "march" over the planks to inspect the compartmentalized case. In *Guadalupe Bell* (1989), now in the MCA collection, Kos married a sound-producing object (a bell), visual effect (a picture of the Virgin of Guadalupe), and audience participation to produce a spectacle

Robert Grosvenor
Kinetic Ocean Piece,
1971

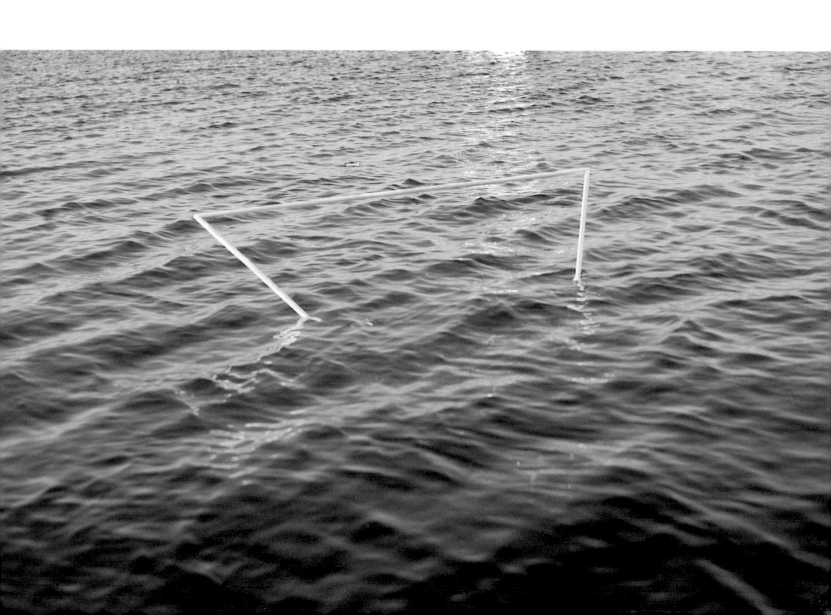

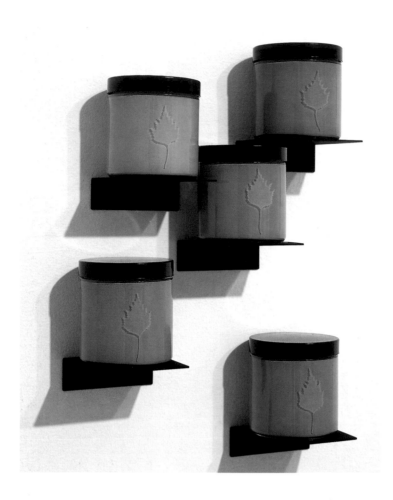

Kate Ericson and Mel Ziegler
Leaf Peeping (detail), 1988

blending different kinds of belief systems—technological, religious—in contemporary society. Brewster's work is less image oriented than Kos's and concentrates on auditory stimulation. In his installation, *Synchromesh* (1977), Brewster activated a rhomboidal volume of space within a gallery by producing two colliding tones that set up distinctive auditory patterns. While visually reductive, *Synchromesh* still retained the presence of technology and architecture, which influenced the experience of the piece. Brewster's work paralleled the evanescent investigations of light and space conducted by West Coast artists Robert Irwin, James Turrell, and others during the same decade.

By the end of the 1970s, artists were taking every opportunity to break out of the white cube of the traditional gallery space or at least energize it with more physical and spatial insertions. Given its long involvement with installation works, it is fitting that MCA hosted a 1977 solo exhibition of the work of the artist and critic who popularized the "white cube" concept and whose writing articulated the intentions of many installation artists of the period. For the exhibition, Patrick Ireland, the name under which the critic Brian O'Doherty exhibits, produced a series of rope drawings. In these pieces, in which colored ropes were used to "draw" geometric forms in the gallery spaces, the features of the galleries became a volumetric armature for artistic gestures, articulating provisional relationships between architecture, spatial voids, and the viewer. Ireland's art seemingly accepts the conventional role of the gallery as a neutral space even as he subversively reinvents the viewer's ability to comprehend it as a particular place. Just prior to the MCA installation of his rope drawings, Ireland wrote "Inside the White Cube,"[5] an article in which he surveyed issues crucial to installation art and related them to the history of gallery conventions, spectator expectations, and context as content. Many of the points made in his article resurface in this installation work.

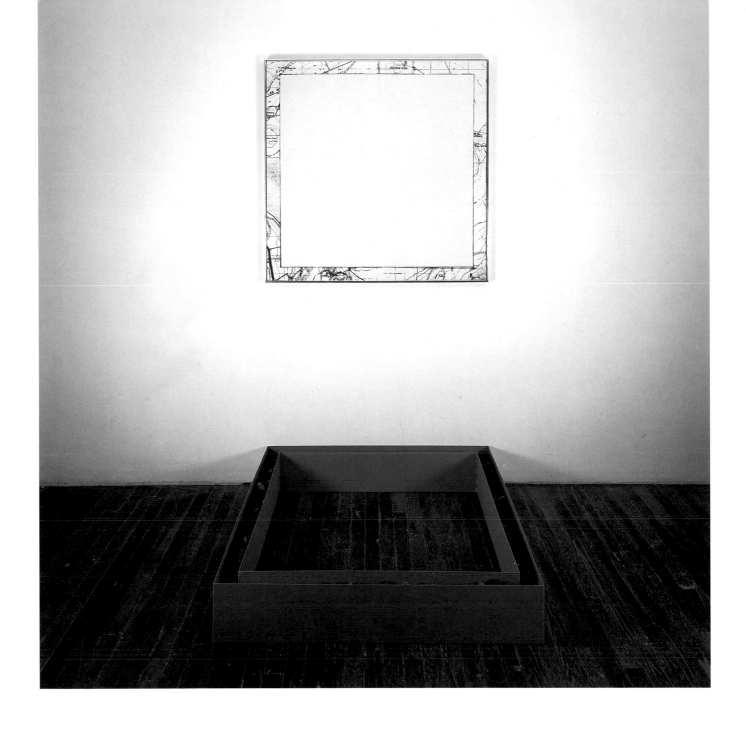

The most problematic installation works for a museum to exhibit are earthworks and other very large-scale constructions. There are several sculptural objects in MCA's collection relating to this category, such as *Mono Lake Non-Site (Cinders Near Black Point)* (1968) by Robert Smithson and *Baja California Circle* (1989) by Richard Long, both of which operate by dislocating characteristic aspects of natural sites and placing them in the gallery context. Such conceptualized site shifts are also part of Kate Ericson and Mel Ziegler's piece *Leaf Peeping* (1988). Jars containing paints the colors of fall leaves and etched with images of leaves that match those found on trees in the sculpture garden at the Museum of Modern Art, New York, were placed on small wall shelves. In this piece, Ericson and Ziegler deconstructed language and value systems by focusing on one or more layers of information about an object, such as a leaf, and recontextualizing it. Through this process the artists appropriated control over an object's visual form and cultural import.

Numerous artists who have worked on site at MCA over the past twenty years are represented in the collection by gallery-size objects, drawings, and by temporary

Robert Smithson
Mono Lake Non-Site (Cinders Near Black Point), 1968

installations in the Museum galleries, on its grounds, and in auxiliary spaces. Among the artists whose work is part of MCA's permanent collection are Christo and Jeanne-Claude. These collaborative artists operate more as critics than builders, exploring at length the matrix of legal and social codes, and the processes that precede actual construction of their work in a public forum. When completed, their on-site installations provide another physical layer that simultaneously simplifies and mystifies, and encourages viewers to look again at familiar natural or human-made environments: ocean inlets, cliffs, buildings, or even smaller objects such as wheelbarrows or commercial vitrines —like those found in MCA's *Store Front* (1965–66).

Echoing Christo and Jeanne-Claude, but in a more rudimentary way, the work of Carl Andre inhabits the most humble of spaces. In *Magnesium-Zinc Plain* (1969), Andre created a ruglike grid from industrial-grade materials. The work inhabits both a "site" and, to use Robert Smithson's expression, a "non-site": the plates of metal create an arena that can be walked on or around, but we also sense their other life as quotidian scraps from the real world before having been incorporated into Andre's art.

Unlike Carl Andre, whose works often blend into their surroundings, Vito Acconci constructs situations and environments that are anything but neutral, rather, they are charged with psychological and social meanings. Acconci underscored a common thread in all these installation-related experiments when he stated, in typical axiomatic language, "Time is fast, space is slow."[6] Acconci's *Instant House* (1980) conflates the qualities of space and time into a hybrid of performance, process, architecture, symbol, and memory. Reminiscent of a child's game, a house of cards, or a jury-rigged contraption, the piece is activated by a participant who sits on a swing and whose body weight causes four walls depicting flags to rise. The participant and other viewers are caught in a construct of private and political meanings informed by both innocent childhood reveries and, more ambiguously, by world politics of the early 1980s. The slow, almost awkward mechanism of the old-fashioned pulley system that raises the walls triggered personal memories and suggested political realities separated by many years when it was created in 1981. Now, fifteen years after its making, the piece serves as a historical marker.

The works by Christo and Jeanne-Claude, Andre, and Acconci were made to fit in gallery-size spaces and cannot provide the scale and environmental continuity of outdoor artworks. In an effort to support such work, MCA commissioned George Trakas to create an environment on part of the Museum's spectacular site overlooking the ocean. Early in his career, Trakas had worked inside the Museum as part of a group exhibition, *Ten Young Artists: Theodoran Awards,* that featured temporary gallery installations. With the help of matching funds from the Art in Public Places Program of the National Endowment for the Arts, MCA commissioned Trakas to create *Pacific Union* (1986–88). The work afforded the opportunity for the artist to more permanently address issues of artisanal craftsmanship, natural site, and place making that Trakas and Alice Aycock, Richard Fleischner, and Mary Miss have addressed in their work.

MCA's 1986 exhibition *Sitings* surveyed the work of Trakas, Aycock, Fleischner, and Miss through drawn proposals and built projects they had produced to date. The exhibition revealed the processes and motivations of these artists and articulated their similarities and differences. In *The Glass Bead Game: Circling 'Round the Ka'ba* (1986), Aycock moved away from outdoor, site-related works and toward object making on a scale that approximates architecture. Aycock created a gallery-size gaming board in which references to mythology and history were mixed with personal interpretations to produce

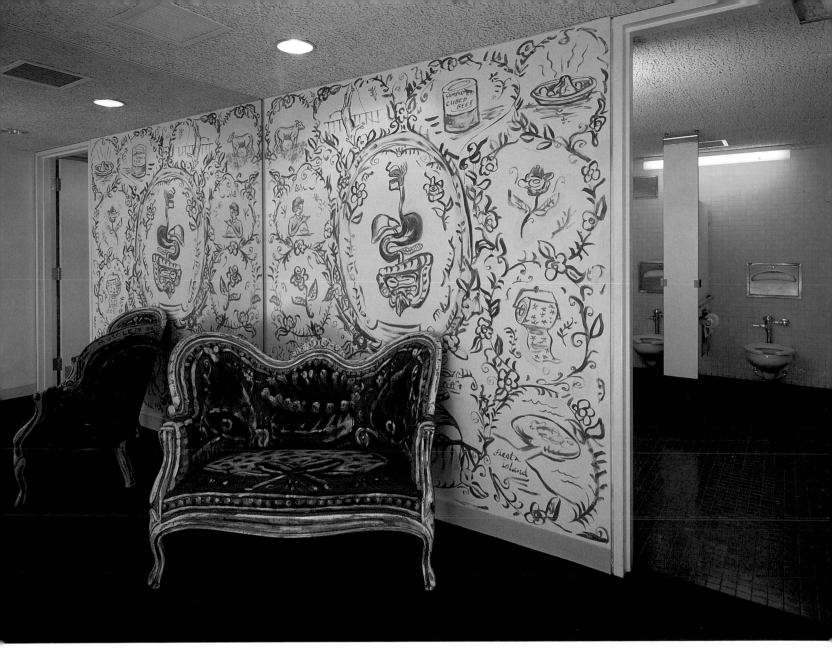

Jean Lowe
Ladies' Room, 1990

another kind of site dislocation whose meanings are at once publicly factual and privately fantastic. The geometry and finish of Richard Fleischner's *Froebel's Blocks* (1983) revealed his belief that primary forms, specialized craftsmanship, and proportionally resolved compositions are the basis of all successful works of art and architecture. Mary Miss's *Glass* (1967) documented her initial movement away from traditional object making as she set out to explore spatial and perceptual references—translucency, gravity, and the physics of various materials.

Some artists who deal with issues other than the creation of meaningful spaces still rely on incorporating extant architectural elements into their works. In *Scribe* (1987), Jeffrey Schiff combined a simple machine with the record of its human use: the machine's physical gestures left a trace arc on a gallery wall partially draped in heavy felt. Another kind of bio-physical analog is conjured by the subtle, cyclical swelling of Wendy Jacob's *Wall, MCA Downtown* (1993), in which the architecture was infused with an anthropomorphic presence.

At the opposite end of the installation spectrum from artists who produce large-scale constructions are those artists who dramatically transform an entire space through a single small gesture or object. In *The Healing of St. Thomas* (1989), in which a woundlike gash of red paint slashed a wall, Anish Kapoor imbued solid architecture with human frailty as he

Border Art Workshop/
Taller de Arte Fronterizo,
*911: The House Gone
Wrong*, 1987

metaphorically turned plasterboard into flesh. Similarly, in *Drains* (1990), Robert Gober shifted how we see both the volume and the orientation of an entire room by imbedding a small circular drain in the wall. Gober is not interested in optical perception in the way that Robert Irwin is, but in the cultural assumptions and referential meanings viewers perceive in the familiar objects he recasts in the gallery setting.

Also included in MCA's collection are artists whose works touch on architectural issues through the creation of domestically scaled spaces that incorporate cultural references. In works such as Roy McMakin's *A Furniture and Painting Set for a Small Study* (1984), Patricia Patterson's *The Kitchen* (1985), or Jean Lowe's *Ladies' Room* (1990), the artists used furniture and architectural features, often combined with mural-size paintings, to evoke the ambiance of a particular place—the inhabitant's ethnicity, a particular time in history—through carefully and sometimes wittily combined details of color, texture, and style.

Domestically scaled settings also provide a context for Ann Hamilton, who works with unlikely combinations of objects, materials, people, or animals—familiar or exotic, singularly large or repetitiously small, inanimate or organically alive—to create poetic, surreal tableaux that are dependent as much on sound, smell, and touch as on sight.

Entering one of Hamilton's environments, such as *linings* (1990), it is as if the observer has stepped backstage at a theatrical production. Hamilton's narrative is never recounted in detail, but only suggested by juxtapositions and spaces between things, and her works are often permeated with isolation, discomfiture, and even a sense of *tristesse*.

In 1987 MCA opened its first space in downtown San Diego and invited the Border Art Workshop/Taller de Arte Fronterizo, an artists' group based in the region, to create an installation for the new space. In their collaborative piece, *911: The House Gone Wrong*, these artists also explored the use of domestic environments to suggest metaphorical meanings. Instead of presenting predictable, comfortable surroundings, however, they created a disconcerting place imbued with harsh political realities. Some rooms were sheathed in cardboard, in others lawns crept up the walls, and a cruciform table sat in one space. The table was hollow and a television monitor was inset into each end of the cross. On top of each monitor was a place setting: a clear plate—through which the omnipresent glow of the television could be seen—and knives, forks, and spoons made from skeletal remains. The work emphatically condensed into the space of a few compact galleries the collision of U.S. and Mexican media and vernacular culture along the two-thousand-mile-long border.

Vito Acconci,
*Garden Installation
(Grass Man),* 1987

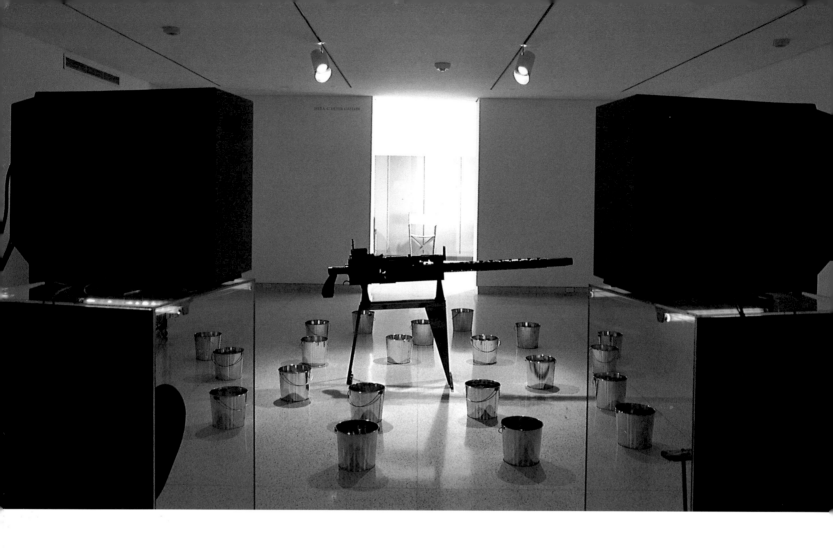

Francesc Torres
The Dictatorship of Swiftness,
1986

In *A.A. Meeting/Art History* (1990–91), James Luna used the rudimentary trappings of everyday life to convey value-laden messages about contemporary culture. Folding chairs, old coffee cups, beer bottles, ashtrays, a television set, and books—the artifacts of late-twentieth-century culture—were strewn about the room. Maybe a self-help meeting has just broken up, a class has ended, or has a crime scene just been fled? The wall behind the disarray of furnishings was decorated with photographs of Luna, who is Native American, earnestly portraying familiar poses from European art history. The piece is filled with a multitude of references that juxtapose the Old World and the New, vernacular and high culture.

Whereas Richard Fleischner in *Froebel's Blocks* (1983) and Scott Burton in *Steel Furniture* (1979–80) used architectonic forms that related architecture and crafted furniture, and James Drake in *Knife Table* (1984) or David Mach in *Untitled (Gargoyle)* (1991) incorporated found or specially fabricated furnishings into their works to reveal cultural idiosyncrasies, Allan Wexler doesn't rely on existing forms—he creates a new vocabulary of polymorphic forms that refer to places and things. In *Scaffold Furniture* (1988), Wexler merged common materials—dishes, flatware, a napkin, a drinking glass, and a chair—and worldly needs to design objects or spaces cobbled together out of common sense, wit, and necessity in a kind of intellectualized vernacular.

Just as technology has informed everyday life, it has also impacted installation work from the 1970s to the present. Vito Acconci, Joan Jonas, Bruce Nauman, and Nam June Paik manipulate time and space using video in their installation pieces. Works that incorporate video are always strongly connected to performance work and often present a powerful narrative component.

The exploration of video in installation art by artists in the 1970s formed the basis for a later generation of artists, who also incorporated electronic imagery into their

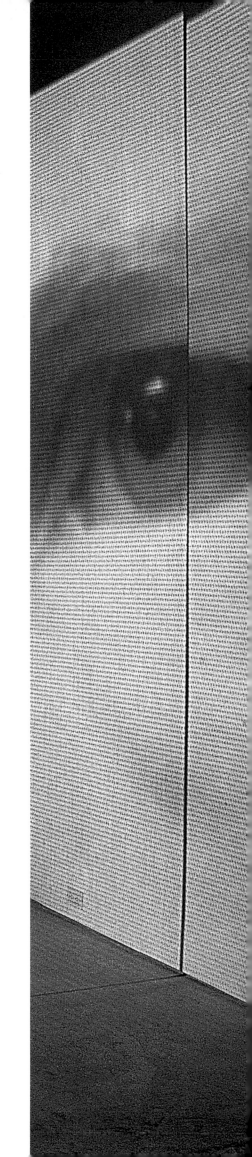

Bill Viola,
*Slowly Turning
Narrative*, 1992

installations, but with more overt socio-political intentions. Two such artists are Krzysztof Wodiczko and Alfredo Jaar. In *The Border Project: San Diego/Tijuana* (1988), Wodiczko presented two related works on two consecutive nights: *Projection on the San Diego Museum of Man, Balboa Park, San Diego, California,* and *Projection on the Centro Cultural Tijuana, Baja California, Mexico.* In these works, Wodiczko projected slide images on two building facades, one in San Diego and one in Tijuana. His ephemeral overlays onto the built environment provided a spectacular visual commentary on architectural form and its subtext of socio-political meanings. While originally projected over extant facades, Wodiczko's work—particularly when represented by the light box transparencies—suggests diagnostic X-ray film, employed by the artist to expose the symbolism inherent in familiar, somewhat anthropomorphic architectural features. Alfredo Jaar also used light boxes in his work *Gold in the Morning* (1986). In this work the light boxes containing transparencies of photographs of the Serra Pelada gold mine in Brazil are hung on the walls and are accompanied by boxes of nails within gilded frames—commenting on the economic and social dynamics of the mining industry. Wodiczko's transparencies are not installations themselves, but only re-present his on-site work in a gallery context, whereas Jaar sets journalistic fragments of the real world into a spatial composition wherein the images form essential components of his rhetorical exposé of the political and social conditions of mining.

While light-box installations stay within conventional exhibition parameters and predictable viewing patterns, video installations create more complex, layered scenarios and often transform or even illusionistically dissolve physical spaces cinematically by manipulating illumination, movement, sound, and scale. In *The Dictatorship of Swiftness* (1986), Francesc Torres combined video with three-dimensional objects to create a complex set of meanings. Six video monitors placed on tall bases were set in an arc at one side of the room and formed a backdrop for an arrangement on the floor: shining metal buckets filled with water surrounding a large military weapon. The arrangement of the monitors suggested multiple interpretations: a theatre, a security control station, the apse of a cathedral. The video images—a tumbling race car, war footage, and a close-up of a dying soldier—were multiplied and repeated. Rather than setting the work in a specific context, Torres's piece created a sense of timelessness and ambiguity. Vito Acconci crystallized this sensibility in 1984, when he wrote: "Video installation is the conjunction of opposites. . . . On one hand, 'installation' places an artwork in a specific site for a specific time (a specific duration and also, possibly, a specific historical time). On the other hand, 'video' (with its consequences followed through: video broadcast on television) is placeless. . . . Video installation, then, places placelessness; video installation is an attempt to stop time. The urge toward video installation might be nostalgic."[7]

In the installation work of Bill Viola, which incorporates video and audio, we come full circle in realizing Buckminster Fuller's prediction of an "electrical architecture." Viola's most powerful installations are at once perceptual and narrative: in his room-size works the space is flooded with evanescent images that simultaneously create and dissolve the physical boundaries of their architectural container. This effect is demonstrated in *Slowly Turning Narrative* (1992), shown at MCA in 1993, in which Viola projected large-scale video images over mirrors and into the viewer's space. In a more sculptural piece, *Heaven and Earth* (1992), a work acquired for MCA's permanent collection, Viola powerfully condensed two related images—his newborn son's face and his elderly, dying mother's face—on two monitors that faced each other vertically, one pointing downward and the

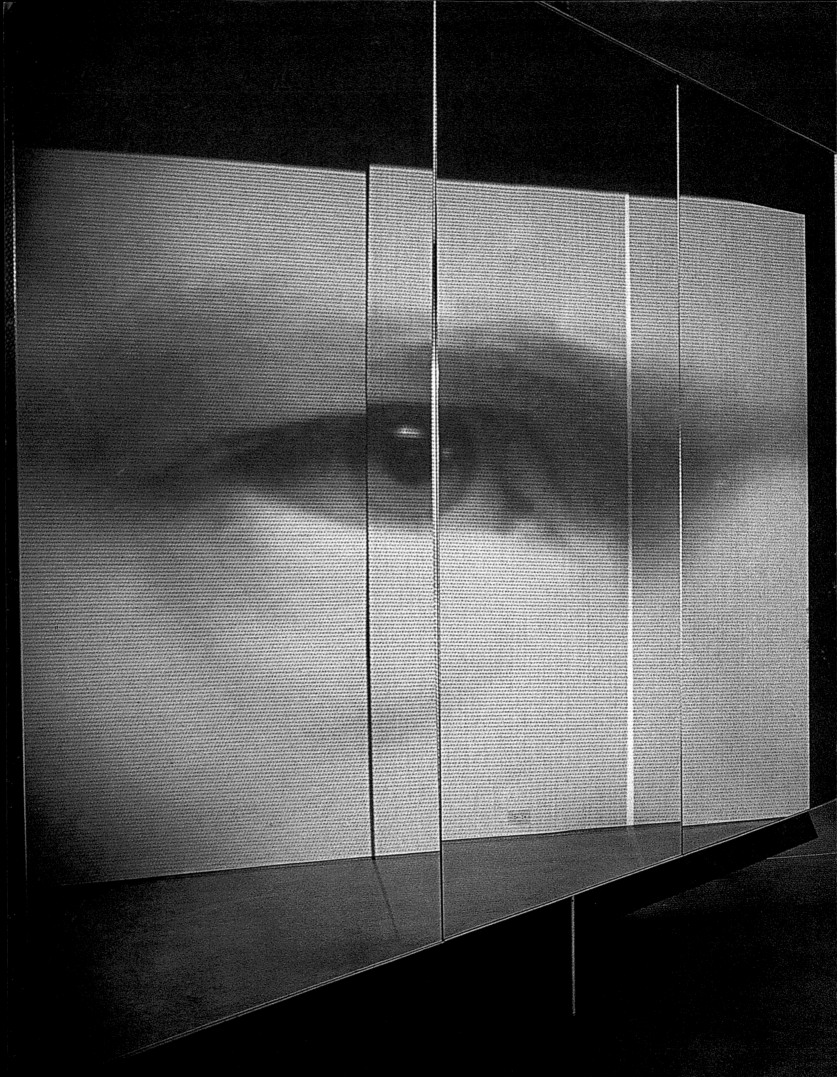

other upward, charging the gap between them with both electrical and psychic force. In Viola's earlier installations, such as *Room for St. John of the Cross* (1983) or *The Sleep of Reason* (1988), the kind of mental images that we "see" in our mind were made palpable through projection. These works not only dissolve their physical, built environment, but achieve the ambition that installation work has always had at its core—of art becoming real, metamorphosing into the continuum of our conscious life. Viola clearly understood this when he described his own art in this statement: "We all get dreams like this every once in a while throughout life. What is interesting is that their vividness is not really about visual clarity or detail—it is a fidelity of experience, of being. The total sensation of what it is like to really *be* there fills our body. . . . These are the real 'images.'"[8]

Abandoning the typical confines of art spaces, subverting art-world conventions, challenging interpretive assumptions, and enveloping audiences in sensations, memories, and narratives—these are the main intentions of installation artists as varied as Irwin, Acconci, Trakas, Wexler, Luna, Hamilton, and Viola. Their works have had a lasting impact on the art produced in the last quarter of the twentieth century and have given another generation of artists a new set of options and assumptions with which to work. Artists like Cady Noland, Matthew Barney, Damien Hirst, and Rachel Whiteread owe much to the previous generation of installation artists for their approaches, technology, and messages. More than anything else, it is the yearning for a sense of "being there" or, better yet, of just "being" that informs our preoccupation with installation art and is the reason why it continues to be such a dominant mode of art production.

Ronald J. Onorato

NOTES

The current name of the institution, Museum of Contemporary Art, San Diego (MCA), has been used throughout this essay, although the Museum's name has changed several times since its founding; the Museum has been known as: the La Jolla Art Center, the La Jolla Museum of Art, and the La Jolla Museum of Contemporary Art. These changes reflected the Museum's professional transformations and the growth of its urban presence. When "permanent collection" appears in the text, it always refers to the permanent collection of the Museum of Contemporary Art, San Diego.

1. Walter Benjamin, "The Arcades Project," quoted in Susan Buck-Morss, *The Dialectics of Seeing: Walter Benjamin and the Arcades Project* (Cambridge: MIT Press, 1989), p. 25.

2. Mowry Baden, "Toucheye," undated typescript in MCA Artists' Files, pp. 3–4.

3. R. Buckminster Fuller, "Foreword," in Larry Urrutia, *Projections: Anti-Materialism* (La Jolla: La Jolla Museum of Contemporary Art, 1970), n.p.

4. Robert Barry, "Art Work," in Larry Urrutia, *Projections: Anti-Materialism* (La Jolla: La Jolla Museum of Contemporary Art, 1970), n.p.

5. Brian O'Doherty, "Inside the White Cube," *Artforum* (March, April, and November, 1976). Three-part essay: part I, "Notes on the Gallery Space"; part II, "The Eye and the Spectator"; part III, "Context as Content."

6. Vito Acconci, "Public Space in a Private Time," unpublished manuscript (January 1990), p. 8.

7. Vito Acconci, "Television, Furniture and Sculpture: The Room with the American View," working manuscript for catalogue, *The Luminous Image* (Amsterdam: Stedelijk Museum, 1984), p. 7.

8. Bill Viola, "History, 10 Years and the Dreamtime," in Kathy Rae Hoffman, *Video: A Retrospective, Long Beach Museum of Art, 1974–1984* (Long Beach, Calif.: Long Beach Museum of Art, 1984), p. 22.

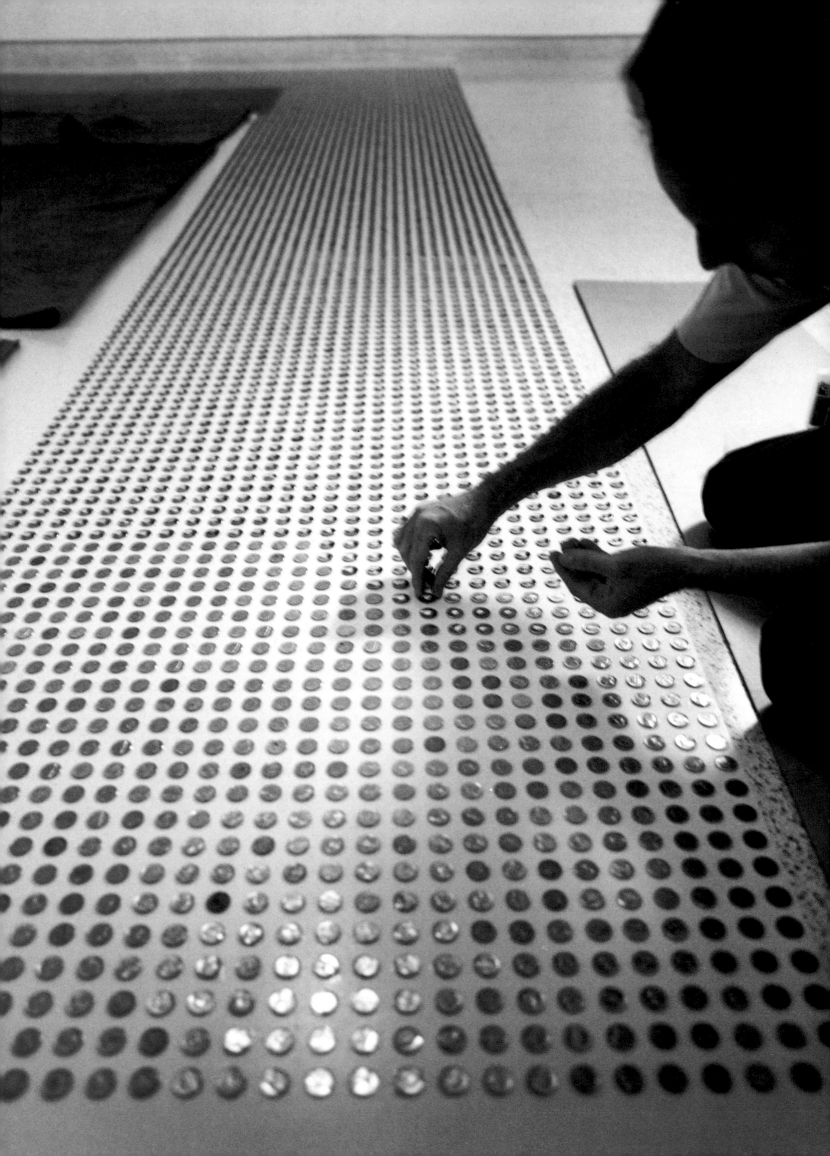

Installation Art in the Collection

The broad spectrum of works described as installation art share a common aspect: they are not spatially autonomous art objects. The architectural site or environmental context is as integral to installation art as any object placed within it. Installation artists employ both indoor and outdoor spaces for works that are permanent or temporary—existing only for the duration of the exhibition. Some installation art is specific to a particular site; other installations change, chameleon-like, according to the particular sites in which they are installed. Artists often co-opt the exhibition space and transform it, and in so doing, challenge the traditional notion of the clean, white cube of the museum gallery.

Through its acquisitions and exhibitions since the late 1960s, the Museum of Contemporary Art, San Diego, has mapped the continually expanding parameters of this art form. The works described on the following pages are part of MCA's permanent collection and serve as exemplary representations of the work of artists who have expanded the definition of art and who, time and again, challenged the expectations of the art-going public.

Installation works vary according to the site in which they are presented. To assist the reader in understanding a work's scale, dimensions for at least one fixed element of the work are given. In many cases, however, the dimensions of a work will vary significantly depending on the size of the gallery or other space in which it is installed. Where dimensions of illustrated works are given, height precedes width precedes depth. For accession numbers, the first two digits indicate the year in which a work entered the collection, followed by a number that indicates the order of its accession. A final range of digits in the accession number indicates the number of elements in multipart works.

Catalogue authors are indicated by their initials as follows: Hugh M. Davies (H.M.D.), Lynda Forsha (L.F.), Louis Grachos (L.G.), Madeleine Grynsztejn (M.G.), Andrea Hales (A.H.), Mary Johnson (M.J.), Kathryn Kanjo (K.K.), Seonaid McArthur (S.M.), and Ronald J. Onorato (R.J.O.).

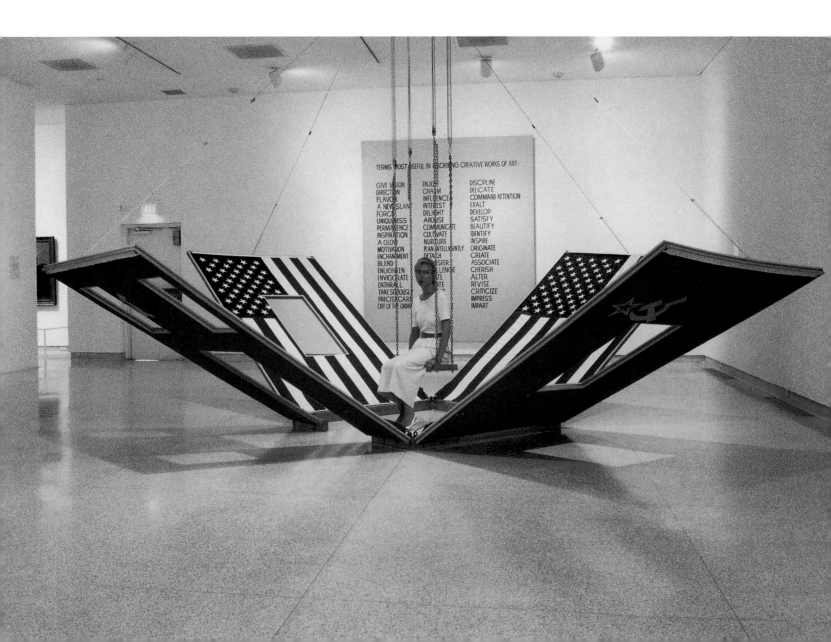

Vito Acconci

AMERICAN, B. 1940

Upon entering the gallery space that holds *Instant House,* a viewer sees flat rectangles of flags on the floor and linear chains holding a metal swing. Nowhere is there the familiar architectural volume that might be recognized as "house." The viewer activates the piece by sitting on the swing. Acconci's contraption of swing, cables, pulleys, and flag panels first closes around the participant, who is enveloped by the simple structure with cutout windows and doors, and then blossoms back into its original form as the swing is released. Four American flags, which could initially be seen lying face up on the floor, are only partially glimpsed from inside the structure, and the exterior surfaces of each of the erect walls reveal the flag of the former Soviet Union.

The references here are manifold: the intimate sense of home and hearth is mixed with childhood playground reveries and the potent symbolism of superpower flags. The physically awkward balancing required to resolve the piece is rife with personal and public overtones—from old-fashioned barn raisings and children's toys to distress symbols (all the flag images are reversed) and political détente. Some of the international implications of the piece clearly tie the work to the cold war era. Acconci choreographs his audience and co-opts them as willing collaborators in the manipulation of potent symbols, resulting in a work that is physically charged, intellectually provocative, and as ephemeral as a house of cards. R.J.O.

Instant House, 1980
Flags, wood, springs, ropes, and pulleys; open: 96" × 252" × 252"; closed: 96" × 60" × 60". Museum purchase, 84.6.

Stephen Antonakos

AMERICAN, B. 1926 (GREECE)

In this piece, Antonakos, who often uses geometric forms in his work, has placed neon—an essentially linear medium—in a setting that informs both the architecture and the surrounding space. The electrically charged gas contained in the glass tubes forms a line that demarks space, and the ambient light the gas emits fills the volume. In *Red Box Over Blue Box Inside Corner Neon,* two simple cubes are stacked vertically and are differentiated only by their intense color. Cobalt blue and red-orange are the two colors Antonakos has used most frequently since his earliest neon pieces dating from 1960. In this work blue and orange combine to form a third color, its ambient glow reflecting on the floor, the walls, and the space around it. Gravity seems to be defied by the particular placement of the cubes, which hover close to the ground and hug the corner of the gallery. Antonakos has carefully considered the neon's placement in relation to architecture. This, along with the inherent properties of neon, works to suggest atmospheric space so effectively that it almost becomes a physical presence. Both the viewer and the sculpture can exist in this space together. Depending on the auxiliary light, the work changes visually as well—an essential part of the viewer's experience of the piece. A.H.

Sitting at an angle on the Museum's roofline, *Incomplete Neon Square for La Jolla* extends into space above the architecture. The incomplete aspect of the piece activates the viewer's participation with the work, which alters according to both the location of the viewer and the time of day. *Incomplete Neon Square* animates the architecture and functions as a beacon of MCA's presence. A.H.

ABOVE: *Red Box Over Blue Box Inside Corner Neon,* 1973
Neon tubes; 49¾" × 24" × 24". Museum purchase with matching funds from the National Endowment for the Arts, 74.5.

OPPOSITE: *Incomplete Neon Square for La Jolla,* 1984
Neon tubes and painted metal; two sides, each: 180". Museum purchase with contributions from the Museum Art Council Fund, 85.32.

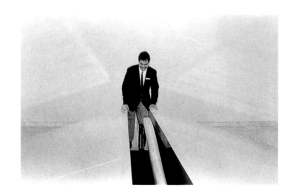

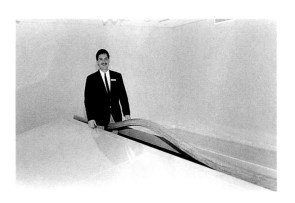

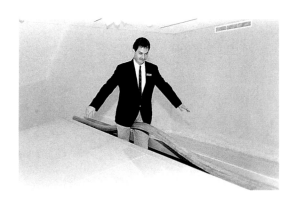

Mowry Baden

AMERICAN, B. 1936

As early as 1965, an interest in body movement and dissatisfaction with what he termed the "stand-off-and-look-at-it" attitude of the work of his day inspired Mowry Baden to explore ways in which his sculpture could be experienced physically. By 1969, he had completed a number of works that demanded physical exertion on the part of the viewer for their completion. As in his other early works, Baden constructed *I Walk the Line* in proportion to his own body measurements. Rails, voids, and curves are not simply abstract components, but relate exactly to aspects of his own body—hip width, crotch height, length of stride. In *I Walk the Line,* the participant—straddling a curved wooden rail —is offered a brief trip down the central aisle of the sculpture. The viewer's initial visual assumption is that it will be impossible to negotiate the rise at the center of the rail. The visitor soon discovers, however, that a corresponding ramp hidden within the structure provides the necessary clearance. By participating in the completion of the work, the viewer is forced to rely on tactile and kinesthetic senses and is led to question the accuracy of what is seen, accentuating one of Baden's central concerns: that vision is unduly emphasized in art. Baden's early experiments in the mid- to late sixties stand apart from those of his Southern California contemporaries such as the influential Ferus Gallery artists and Light and Space practitioners James Turrell and Robert Irwin. Baden's art and teaching, akin to contemporary dance and movement, brought a different set of concerns to young artists in Southern California, and his influence can be seen in the works of his former students Chris Burden, Michael Brewster, and Peter Shelton in MCA's permanent collection. M.J.

I Walk the Line, 1967
Wood, steel, and carpet; approximate dimensions 41" × 240" × 204". Gift of the artist, 70.19.

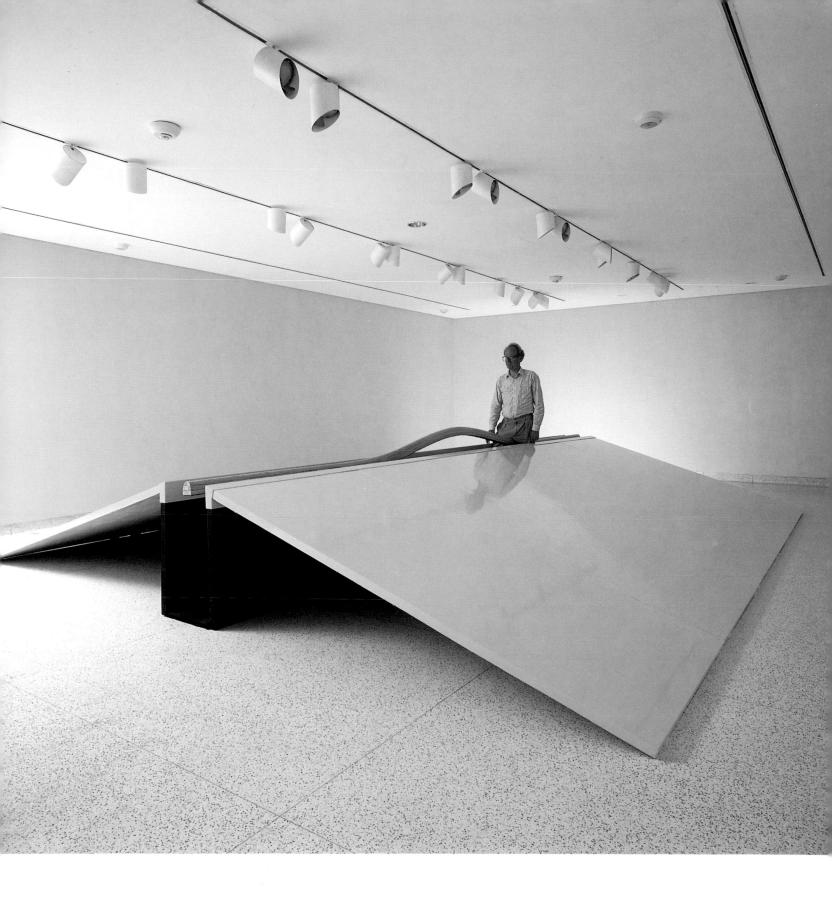

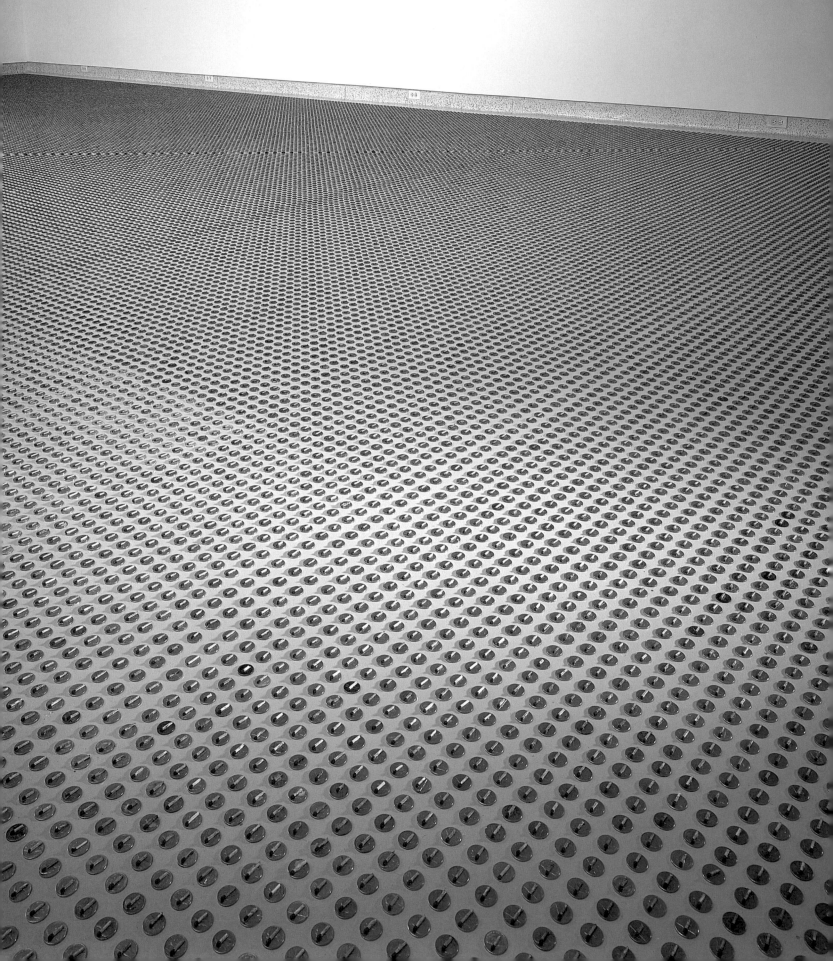

THE REASON FOR THE NEUTRON BOMB

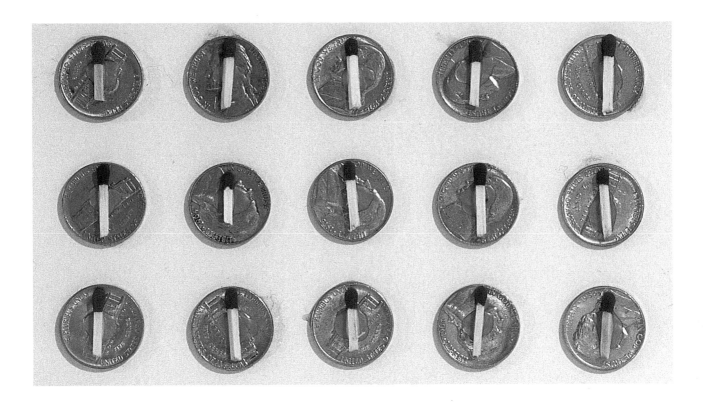

THE REASON FOR THE NEUTRON BOMB

Behind the iron curtain, along the border between Western and Eastern Europe, the Soviet Union maintains an army of 50,000 highly sophisticated tanks. The United States possesses only 10,000 tanks, and the combined tank strength of all Western European nations, including the NATO forces, is estimated to be no more than 20,000. The Western European forces are outnumbered by more than two-to-one. This numerical imbalance is the reason given by our military for the existence of the Neutron Bomb. Each nickel-and-matchstick combination here represents one Russian tank.

—CHRIS BURDEN, 1979

Chris Burden

AMERICAN, B. 1946

Composed of 50,000 nickels arranged in a regular grid on the gallery floor, *The Reason for the Neutron Bomb* is more elegant and restrained than many of Burden's other installation works. The head of a wooden matchstick is glued to the top of each nickel in the silver carpet of coins. The piece is accompanied by text describing the massive buildup of armaments in Eastern Europe—the artist's explanation of the metaphoric meaning of the ranks of coins. Initially installed in Washington, D.C., the nickels, each adorned with an image of Jefferson, seem the perfect miniature symbols of governmental spending. Each coin also simulta-

neously represents the number of Russian tanks amassed in Eastern Europe. Although the number and expanse of coins is impressive, their details and size tend to trivialize the magnitude of firepower and seriousness of social implications of an international arms race that was continuing to grow with exponential speed into the mid-1980s. In this work and in many of his other installations, Burden astutely uses the scale and the familiarity of objects such as coins, toys, or miniature models to evoke meanings layered with both humor and more serious intent. R.J.O.

The Reason for the Neutron Bomb, 1979
Fifty thousand nickels and matchsticks, signage; 308 sq. ft.; overall dimensions vary with each installation. Museum purchase, 86.20.

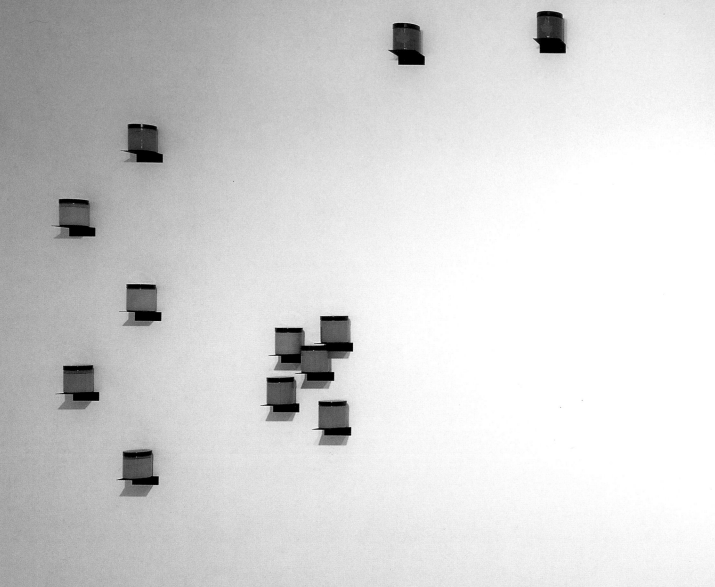

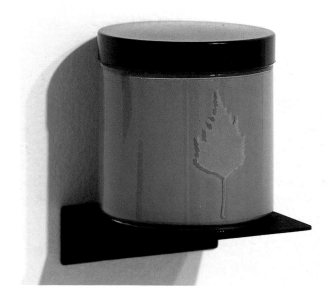

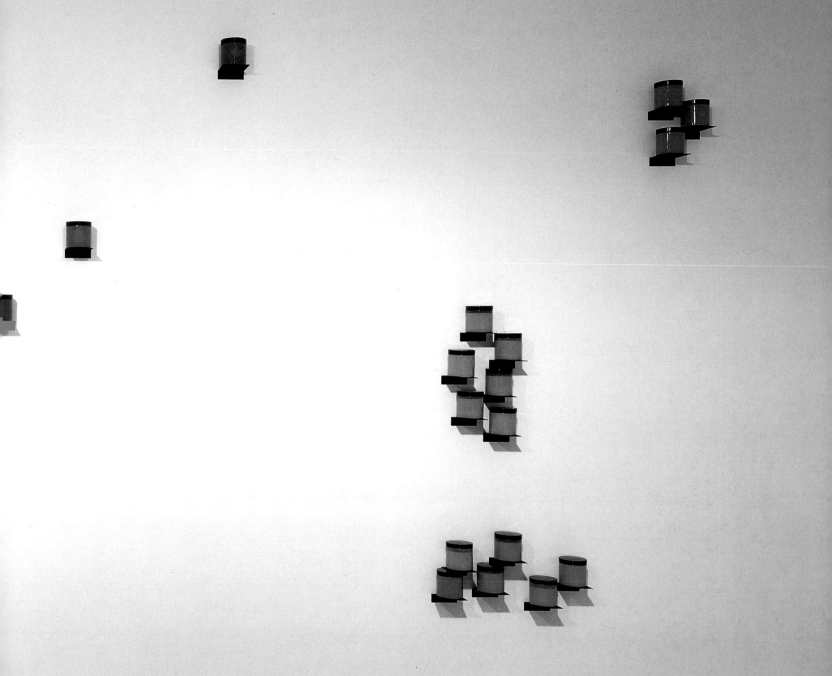

Kate Ericson and Mel Ziegler

AMERICAN, 1955–1995
AMERICAN, B. 1956

Works by the collaborative team of Kate Ericson and Mel Ziegler often comprise various arrangements or structures encoded with meanings that reflect systems of control in our society. The thirty-one glass jars in *Leaf Peeping* are filled with latex paint and sealed with black lids. The apparently random arrangement of the jars on tiny shelves on the gallery wall actually corresponds directly to a plan of the trees located in the sculpture garden of the Museum of Modern Art, New York. The different colors of paint in each jar match the color of the leaves of a particular tree in the garden on the day the artists visited MOMA in the fall of 1988. To further isolate the identity of each tree, the artists have assiduously etched the individual shape of each leaf onto its corresponding jar. The artists' transposition of nature into sealed containers denotes the role of cultural institutions in preserving and displaying examples of culture. In works such as this, Ericson and Ziegler analyze societal organization and control, and encode the information they glean into static visual elements. A.H.

Leaf Peeping, 1988
Thirty-one sandblasted glass jars filled with latex paint, metal shelves; jars, each: 3¾" × 3⅝"; overall dimensions vary
with each installation. Museum purchase, Contemporary Collectors Fund, 90.9.1–31.

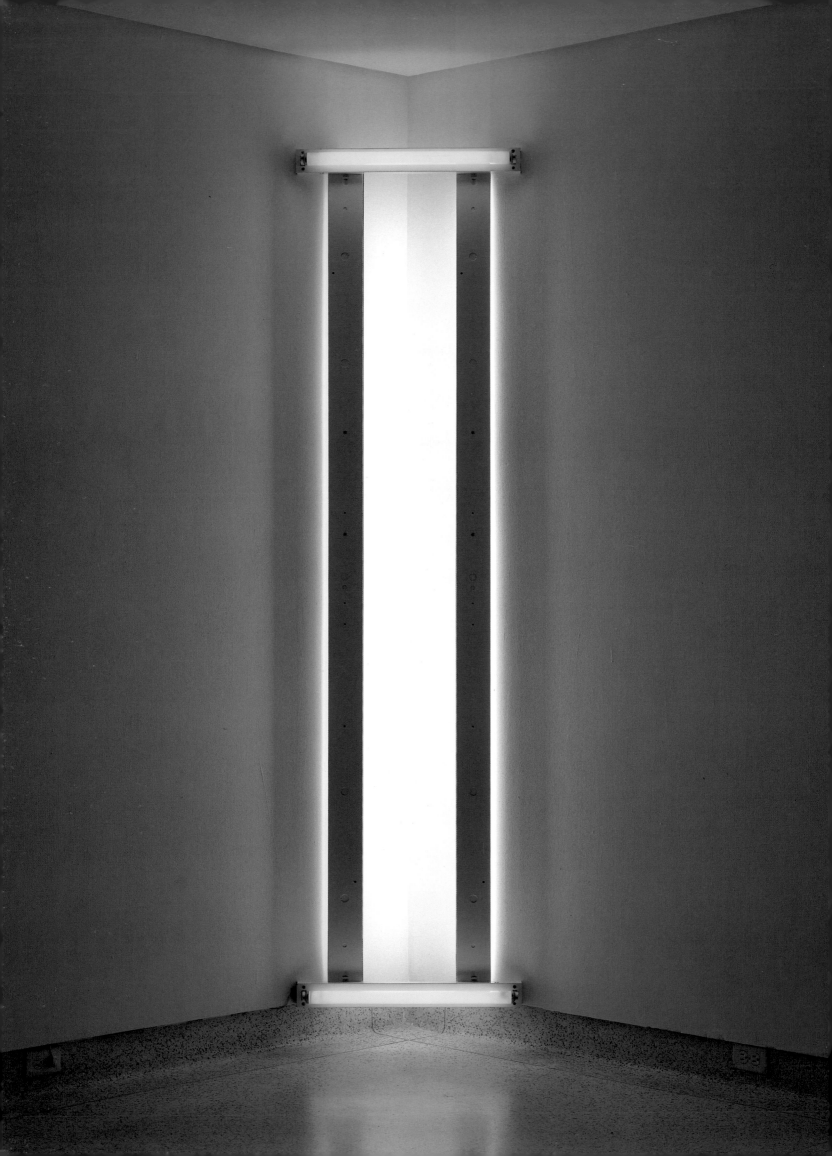

Dan Flavin

AMERICAN, 1933–1996

Flavin was one of the first artists to explore the sculptural possibilities of commercially available light fixtures, and he created a distinct body of work that encourages meditation on light, color, composition, and perceptual experience. His light sculptures were introduced in New York in the 1960s, and presented an entirely new alternative to Minimalist painting and sculpture. Although they embodied many of the tenets of Minimalism—ready-made materials arranged in predetermined mathematical units—Flavin's light sculptures were less static and more bound to phenomena affecting the environment and viewer. Flavin's works are frequently untitled and dedicated to artists and friends he admires. Simple and Minimalist in form, *Untitled (to Marianne)* comprises two vertical eight-foot fluorescent tubes—one yellow, one blue—which face into the corner of the room, and two horizontal two-foot blue tubes, which face the viewer. The light tubes become neutral lines of light that Flavin employs in much the same way that a painter uses line. In this work, however, rather than creating the illusion of space through linear perspective, as a painter does, Flavin exploits the optical effects created by the vertical bands of light illuminating the room to give the viewer the illusion of movement and to dematerialize the nearby wall surfaces. The corners of the room appear to compress and expand, pulling the piece forward while pushing back the adjoining walls. At the same time, the horizontal bands of blue light appear to liquefy the floor. Flavin's installation simply, yet powerfully envelops the viewer with the ambient effects of color and light.

L.F./S.M.

Untitled (to Marianne), 1970
Fluorescent lights and light fixture; edition 2 of 5; 96" × 25" × 8". Gift of Leo Castelli Gallery, New York, 79.8.

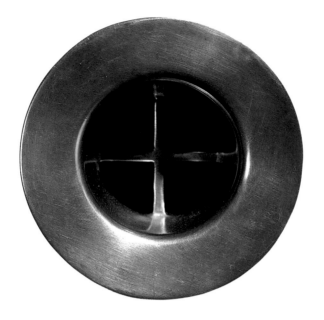

Robert Gober

AMERICAN, B. 1954

Stripped of any function and sunk into the gallery wall, Robert Gober's cast pewter *Drains* can be seen as sculpture—an object that salutes the ready-mades of Marcel Duchamp—or as an aesthetic object that refers to the vocabulary of Minimalism. Although the piece pinpoints no specific connotation, it triggers a variety of associations. It implicitly connotes the human body, not only because its shape alludes to human orifices, but also because it calls to mind eating and bathing, since drains are associated with these activities. Likewise, the drain can be seen as an emblem of cleanliness and purification. The position of the drain, placed at eye level, also evokes in the viewer a sense of inquiry and apprehension: the viewer is confronted with a dark portal that leads into the abyss. In *Drains,* Gober presents a metaphor for loss, or alternatively, for the cycle of life. By transforming the gallery into a tense psychological arena, this installation work considers the relationship of the physical body to the world that surrounds it. Anonymous and yet intimate, Gober's displaced object quietly resonates and forces a shift in how the viewer perceives the volume and orientation of the exhibition space. L.G./K.K.

Drains, 1990
Cast pewter; edition 4 of 8; diameter: 3¾", depth: 1¾", to be installed at a height of 61"; wall dimensions vary with each installation.
Gift of the Peter Norton Family Foundation, 92.7.

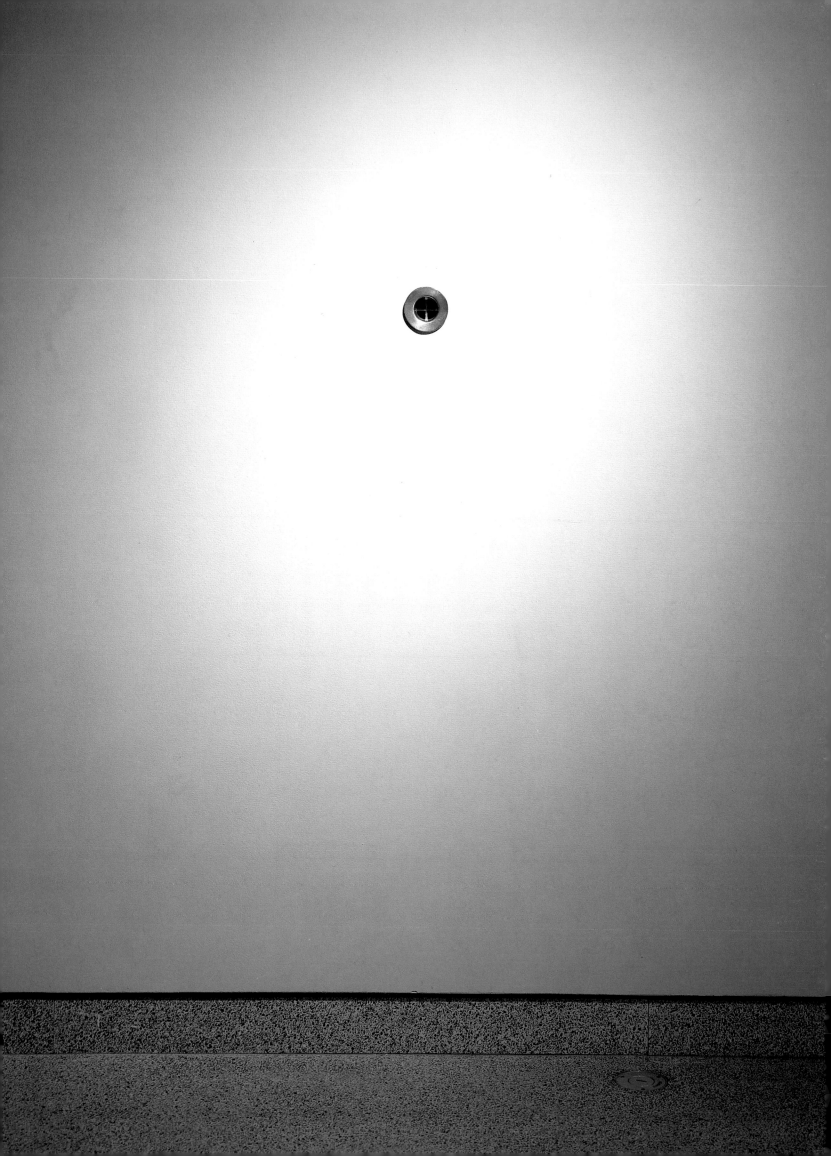

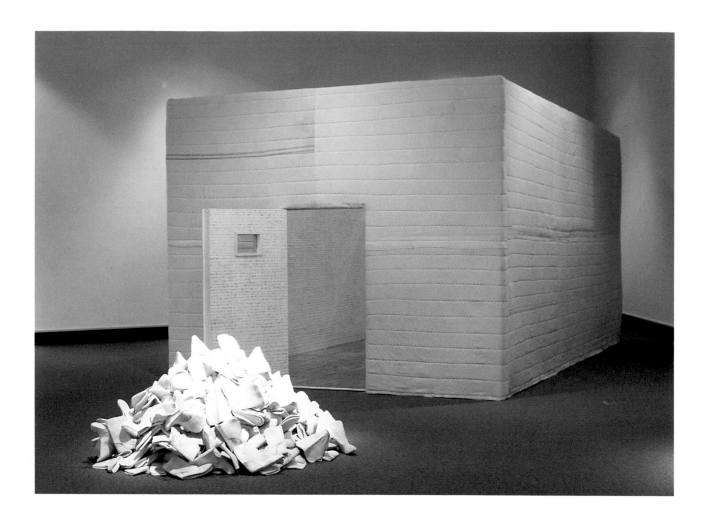

Ann Hamilton

AMERICAN, B. 1956

Hamilton creates all-encompassing environments that envelop viewers by stimulating their senses of sight, touch, sound, and smell. The materials used in *linings* evoke associations that are complex and multilayered and create a sense of presence. At the entrance to the room is a pile of hundreds of felt boot liners, their soft contours revealed under the bright light. Hamilton's boot liners are infused with a number of meanings: their function and material—felt—are associated with insulation and protection and their numbers here suggest many journeys taken. Quilted woolen English hospital blankets soften and cover the exterior geometry of Hamilton's room. The blankets muffle—or, according to the artist, "muzzle"—the interior lining or "voice" of the room. The creation of *linings* was Hamilton's personal response to national debate on issues of censorship in the visual arts. The texture of the wool on the exterior contrasts with the room's interior where the walls and floor are covered with panes of glass. Entering the room, one feels vulnerable and separated

from nature. Native grasses lie underfoot, pressed between a grid of large panes of rectangular glass and the floor. The walls are also covered with hundreds of small panes of specimen glass through which horizontal bands of text, handwritten in blue, water-stained ink are visible. The text is taken from the journals of nineteenth-century naturalist John Muir. In the passages cited here, Muir recounts his body's pace as he walks through nature. Set into the wall of the room is a nine-inch video monitor that continuously plays a slow-motion video of a woman's mouth being filled until it overflows with water—a reference to the mouth as the source of language and as the intermediary between thought and voice. In *linings,* Ann Hamilton uses the metaphorical power of materials and forms to convey our separation from nature and the gaps between private and public, personal and collective experiences. The "linings" to which Hamilton refers are the borders between realms: the meeting points at which we make choices and mediate with the culture at large. S.M.

linings, 1990
Felt boot liners, woolen blankets, wild grasses, glass, ink on paper, and television monitor with video loop; four-sided structure: 120" × 150" × 294"; overall dimensions vary with each installation. Museum purchase with funds from the Elizabeth W. Russell Foundation, 90.23.

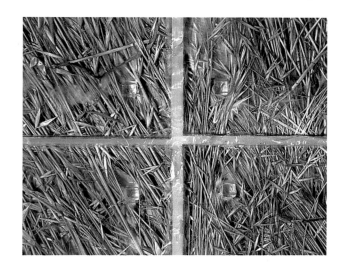

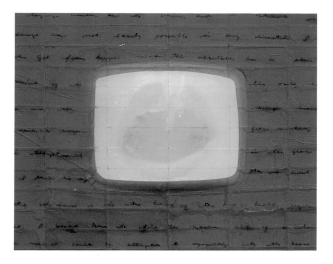

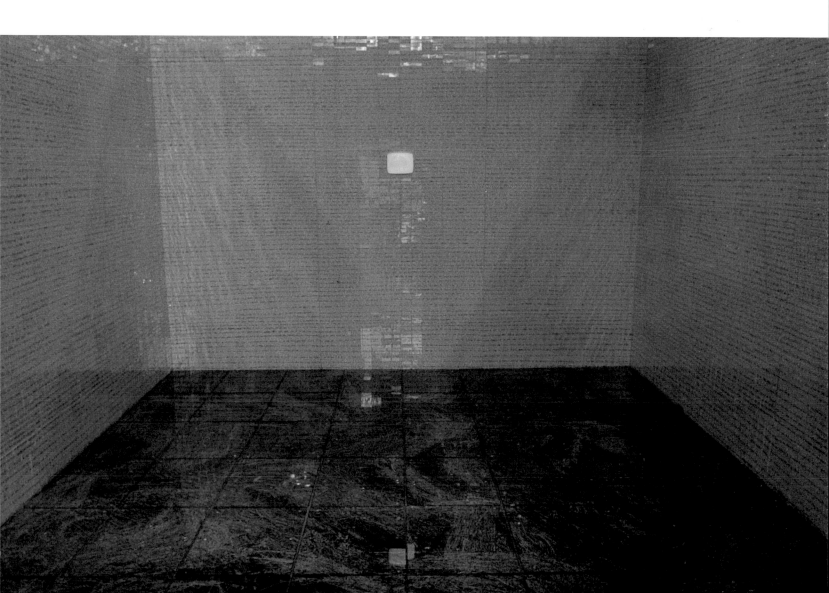

Robert Irwin

AMERICAN, B. 1928

Untitled (1969) embodies Robert Irwin's abiding interest in perceptual and experiential effects. When lit with either natural ambient light or four small floodlights, the literal bulk of the convex disc seemingly melts into the surrounding walls. Rounded edges soften and fade away, leaving an ambiguous center that appears alternately convex and concave. While its mass dissolves, the disc's shadows, which mark the wall in circular patterns, seem solid. During this period Irwin was a leader of the West Coast art movement called Light and Space. Like his Los Angeles contemporaries the artist explored the phenomenon of perception through the use of new plastics and pigments being developed by the aviation and automobile industries. By applying the rigor of science and technology, Irwin has varied the apparent density of the precisely molded plastic through the careful application of a sprayed acrylic. The resulting effect is to "dematerialize" the object while inducing in the viewer a state of intensified perception. In his work today, Irwin continues to explore how phenomena are perceived and altered by consciousness. S.M./K.K.

Untitled, 1969
Acrylic lacquer on formed acrylic plastic; disc diameter: 54", to be mounted at a height of 72".
Museum purchase, 70.5.

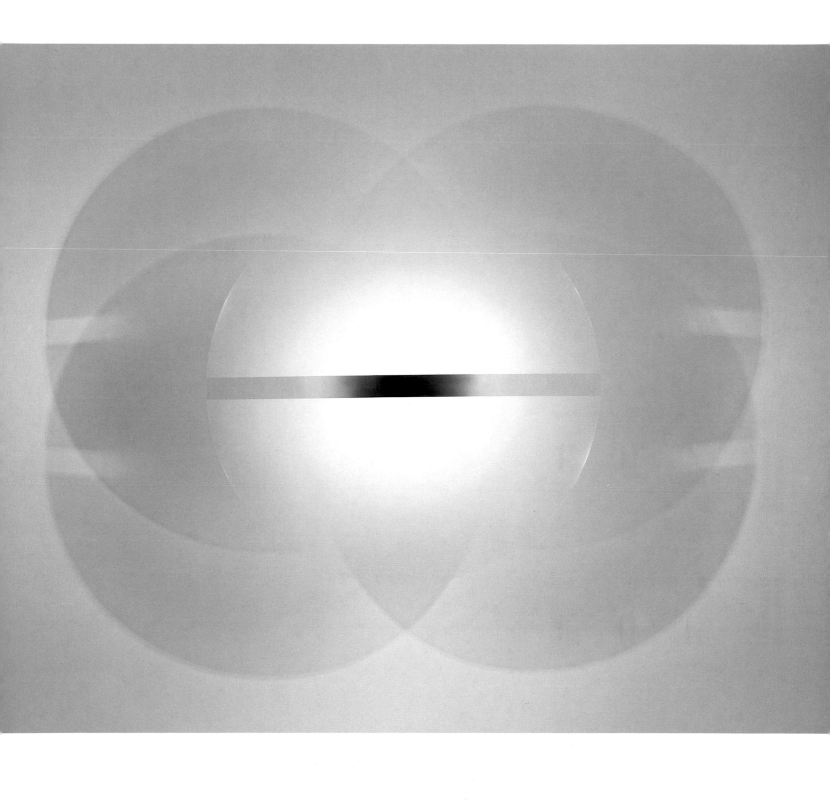

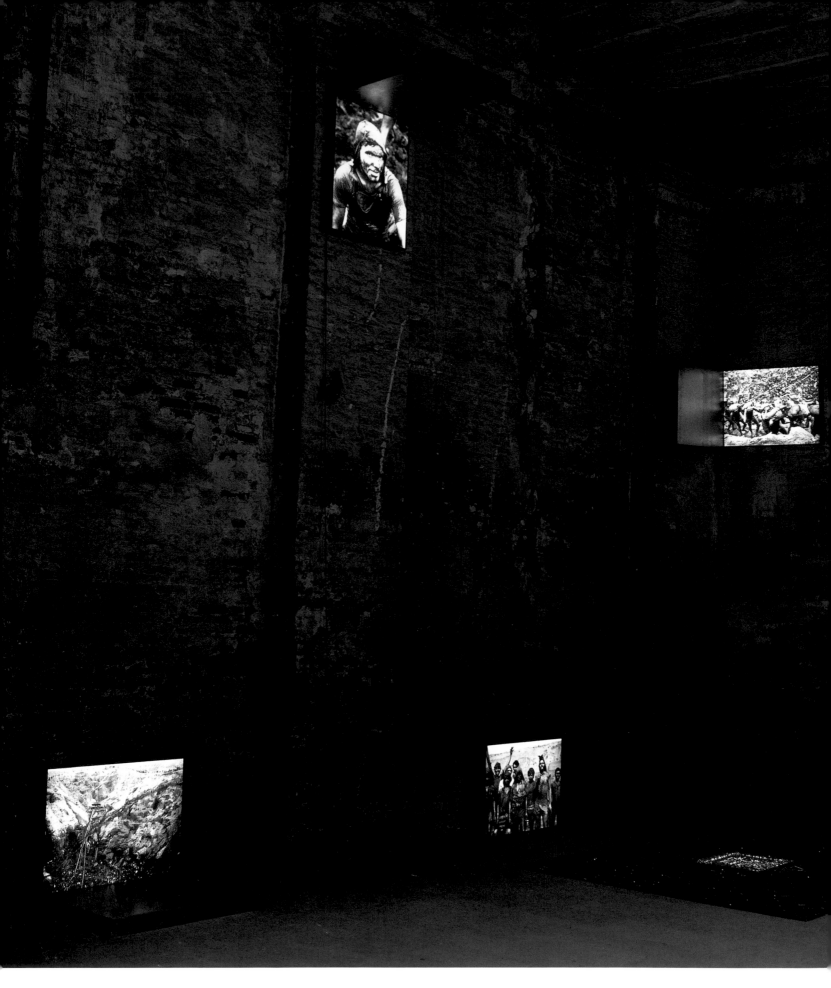

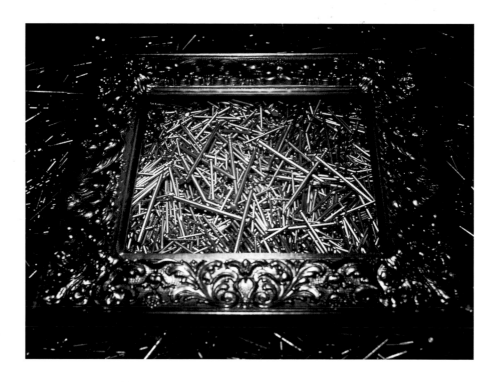

Alfredo Jaar

AMERICAN, B. 1956 (CHILE)

In *Gold in the Morning,* the developed and developing worlds meet in a remote section of the Brazilian rain forest at Serra Pelada. This small mountain range, discovered in 1980 by mining interests, is now Brazil's largest open-pit mine. In this work, Jaar abstracts from events in the workers' lives, transforming the Serra Pelada mine into a metaphor for the larger conditions of power, disenfranchisement, desire, and faith. The artist distills the quotidian hard labor at the mine into five photographic transparencies that elegantly illuminate the darkened room. Jaar deliberately situates the images at the outer edges of the installation—a reference to the marginal site to which those located on the economic, political, and cultural periphery of post-industrial production are relegated. Each light box is paired with a gilded box placed above or below the light box and at a right angle to it, that reflects and dissolves the iconic image of brute labor the transparency depicts. At the center of the installation, a massive bed of nails supports an ornate gold-leaf picture frame, a forceful symbol of the gratuitous excesses of Western capitalism. The bed of nails on which the frame sits denotes the martyrdom of the Christian saints and the Crucifixion, symbolizing the inordinate power still exerted by Catholicism on the Latin American world. M.G./K.K.

Gold in the Morning, 1986 (Installation: *Aperto '86,* Venice Biennale, Italy)
Five light boxes with color transparencies, four metal boxes, nails, and gilded frame; 120" × 264" × 264"; overall dimensions vary with each installation. Museum purchase with matching funds from the National Endowment for the Arts, 90.7.1–11.

Wendy Jacob

AMERICAN, B. 1958

Wall, MCA Downtown was commissioned by the Museum and built as an integral part of the second-floor galleries at MCA's downtown location. In this work Jacob brings to life an inanimate, pure form. The tall, white rectangular wall situated between two equally large windows is easy to overlook in the stark gallery space, and the visitor's first inclination when entering the room is to hunt for the revered "object." Glancing out the gallery window, the viewer's concentration is gradually diverted by a slow, wheezing sound. Only by looking directly at the wall sideways, with heightened attention to the surroundings, can a movement or presence be perceived. The work unfolds gradually—first through a slow bulging of the edge of the wall's surface, then through the movement of the entire mass. The slow heaving movements are at first destabilizing and eerie, but become oddly familiar as the viewer begins to realize that his own rate of breathing is echoed. Concealed within the white latex-painted rubber wall are a vinyl airbag, two blowers, a vacuum, and a timing mechanism, which enable the expansion and contraction of the flexible wall. The Minimalist object disappears into its architectural framework, giving life and presence where it is least expected. Jacob's "breathing" wall raises questions about what is considered art and also what it means to be a human being who finds meaning in such an obscure encounter. The work is dedicated to the memory of the artist's father, C. W. Jacob. S.M.

Wall, MCA Downtown, 1993
Rubber, vinyl, wood, plaster, two blowers, vinyl airbag, vacuum, and timing mechanism; 167" × 71½" × 22½" (depth: 28" when fully extended). Museum purchase, 93.3.

Anish Kapoor

BRITISH, B. 1954 (INDIA)

With subtle and spiritual power, *The Healing of St. Thomas* embodies Kapoor's complex artistic sensibility. The origins of Kapoor's personal and enigmatic forms may be attributed, in part, to his exposure to a variety of cultural and religious traditions. Kapoor, influenced by his native India, often uses raw pigments, and incorporates Hindu ideology and symbols into his works. His works have a sensual quality, and are often concerned with the duality of masculinity and femininity. In this piece, a 12-inch gash of red pigment simply, yet gruesomely, pierces an otherwise pure and pristine white wall. The work's title alludes to the New Testament passage that recounts the Apostle St. Thomas's refusal to believe in the Resurrection of Christ—offering one clue to an interpretation of the piece. Only after thrusting his hand into the wound in Christ's side did "doubting Thomas" accept that Christ had been resurrected from the dead. The shape of Kapoor's "wound" also calls to mind lips or a vagina, lending itself to other symbolic interpretations, both Freudian and Hindu. The vagina is a symbol associated with Kale, the Hindu goddess of fertility. The artist explains that the vaginal shape has "more to do with wholeness than death. It refers to the space beyond the wall, and of course it sees the architecture as a metaphor for the self." *The Healing of St. Thomas* is, as the artist states, "an intervention in the space that brings together the psychological and the physical." A.H.

The Healing of St. Thomas, 1989
Fiberglass, plaster, and gouache; length: 12", sunk into wall at depth of 5"; wall dimensions vary with each installation.
Museum purchase with funds from the Elizabeth W. Russell Foundation, 92.4.

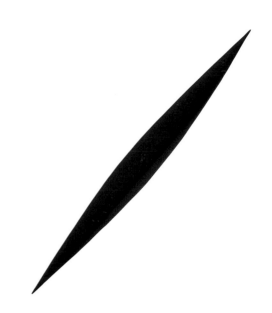

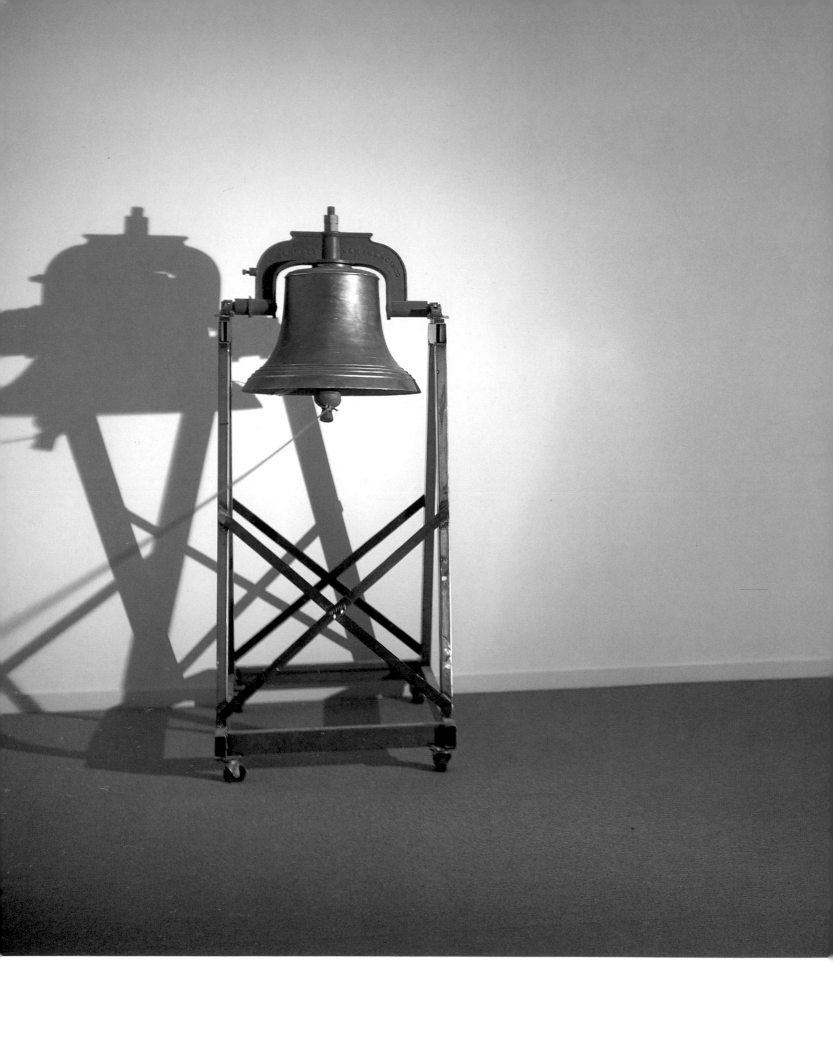

Paul Kos

AMERICAN, B. 1942

Known for their formal beauty, Paul Kos's conceptually grounded installations move effectively between object and environment, video and static image. For some time, Kos has explored the use of the bell form as icon and monument. *Guadalupe Bell* respectfully recounts the miracle of the visitation of the Virgin of Guadalupe to Juan Diego on the Mexican hill, Tepayac, in the sixteenth century. Three recurrent components of Kos's work—sound, light, and action—are elegantly integrated in this work. The ringing of a large bronze bell by the viewer triggers the flash of a strobe light, which in turn illuminates a previously invisible, phosphorescent image of the Virgin silk-screened on the wall. As the sound of the bell fades, so does the Virgin's image. In Kos's work, technology is harnessed to achieve humanist goals. The ideas he conveys in his works are presented with sufficient dazzle as to engage the viewer without overwhelming the statement. H.M.D./M.J.

Guadalupe Bell, 1989
Bronze bell, steel, phosphorescent pigment, and strobe light; bell diameter: 25¾"; overall dimensions vary with each installation.
Museum purchase with contributions from the Awards in the Visual Arts, 89.10.

Sol LeWitt

AMERICAN, B. 1928

In *Isometric Pyramid,* the Renaissance fresco tradition meets the formal abstraction and conceptual concerns of Minimalism. In LeWitt's painting, executed directly on the gallery wall, a central pyramid rendered in orange appears alternately to extend out from and float on the blue field behind it. The colors of the ink washes LeWitt employs—magenta, yellow, cyan, and black—are from a commercial printer's palette. They are applied in a series of layers, using circular motions to blend and work the color so its translucent substance seems to combine with the wall's surface—an effect reminiscent of fresco paintings of the Renaissance. The richly textured appearance and intense color of the work were influenced by LeWitt's study of Italian fresco painting following his move to Spoleto, Italy, in 1980. Just as the paradox of the perception of three dimensions on a two-dimensional canvas fascinated Renaissance artists, LeWitt also explores the fundamentals of linear perspective, projecting the lines of an isometric cube until the lines join to form a pyramid. This process of analysis, combined with LeWitt's precise color formulations, successfully creates the illusion of the form's presence as a three-dimensional object, while at the same time denying the actual existence of a specific object. The painting varies in scale depending upon the architectural setting in which it is installed. This mural-scale drawing evolved from the artist's modestly scaled conceptual drawings from the 1960s and '70s, and demonstrates LeWitt's ongoing exploration of perspective and perception. S.M.

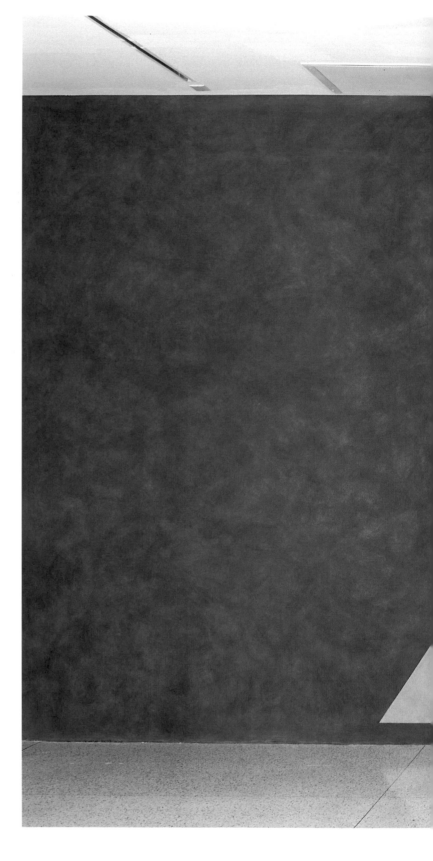

Isometric Pyramid, 1983 (1996 reinstallation)
Colored ink washes; overall dimensions vary with each installation (as illustrated: 134" × 272").
Museum purchase, Contemporary Collectors Fund, 86.32.

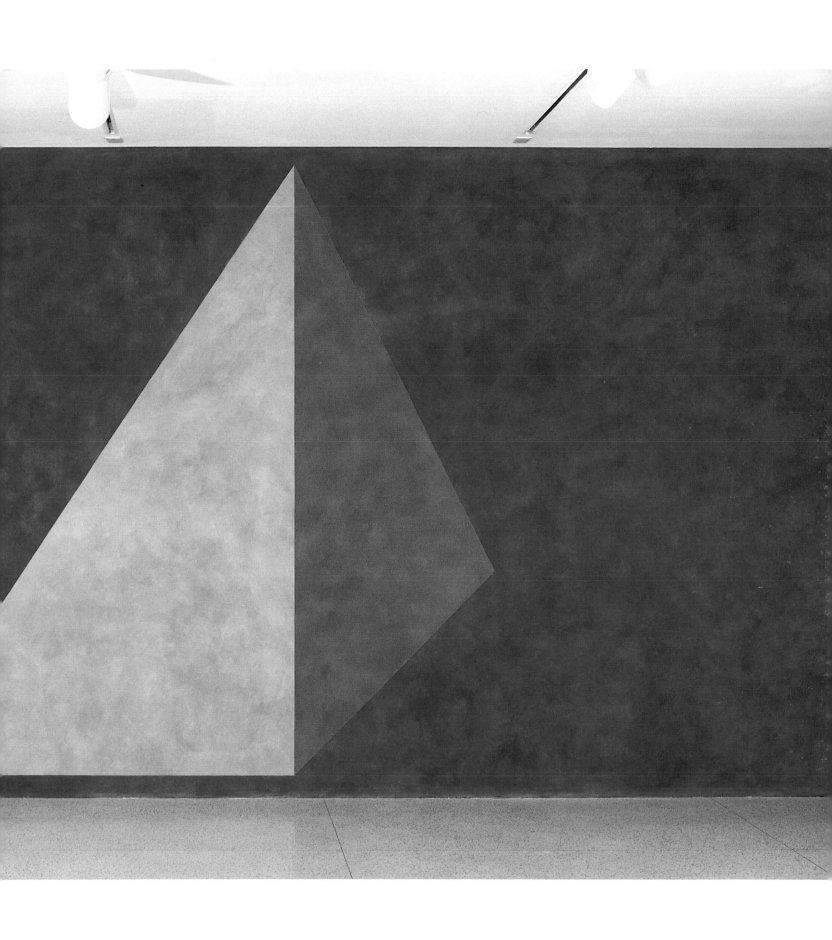

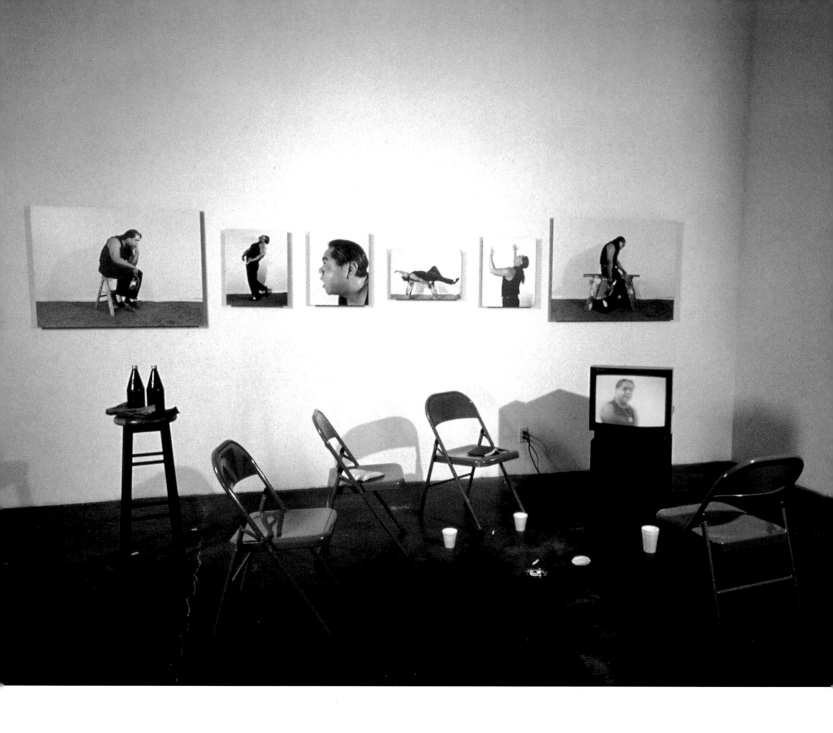

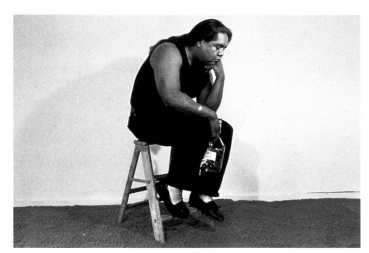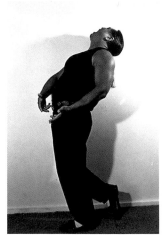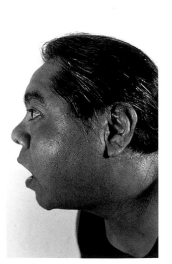

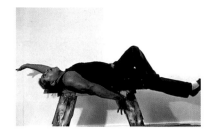

James Luna

NATIVE AMERICAN, B. 1950

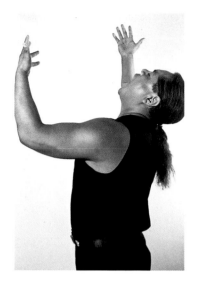

Luna, a performance and installation artist, is best known for work that treats the dilemma of conscience faced by non-Native Americans and the dilemma of identity facing all Native Americans. Luna is a Luiseño/Diegueño Indian who makes his home on the La Jolla Reservation in northern San Diego County. In *A.A. Meeting/Art History,* Luna challenges our tendency to mythologize the Native American by directly addressing his own and his culture's battle with alcoholism. Conceptual installation practices meet Indian concepts of ritual and performance in the very literal use of everyday objects. Folding chairs, empty beer bottles, ashtrays filled with cigarette butts, used Styrofoam coffee cups, and Alcoholics Anonymous books clutter the white gallery space. Arranged on the wall is a series of photographs related to the performance video being played on the TV monitor. In both the photos and the video, Luna strikes classic poses from art history. He emulates Rodin's *Thinker,* the contorted figures in Picasso's *Guernica,* and the defeated Indian in *End of the Trail*—

James Earle Fraser's monumental sculpture that was exhibited at the 1915 Panama Pacific Exhibition in San Francisco. Luna parodies this popular image—often seen today represented on belt buckles and in commercial prints—by straddling a sawhorse instead of a real horse, shoulders hunched forward, holding a bottle of liquor in his right hand in place of a warrior's spear. In *A.A. Meeting/Art History* Luna tightly interweaves issues of autobiography and cultural identity, expertly balancing a sense of anger with humor. Luna allows viewers to empathize with the problems of Native Americans and prompts them to reexamine their own cultural assumptions. S.M.

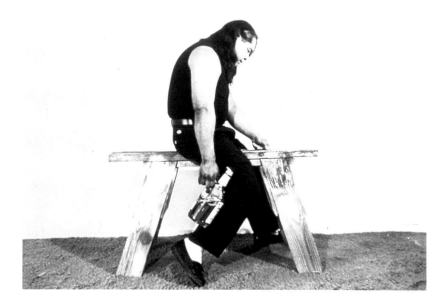

A.A. Meeting/Art History, 1990–91
Six photographs by Richard A. Lou, television monitor with video loop, chairs, stool, ashtrays, cups, bottles, cigarettes, and books; photographs: 30" × 40", 20" × 16", 14" × 20"; overall dimensions vary with each installation.
Gift of the Peter Norton Family Foundation, 92.5.

Maria Nordman

AMERICAN, B. 1943 (GERMANY)

In her works, Nordman explores the sensate aspects of the environment—light, shadow, temperature, color, tactility, and scale—and investigates the sociology of human interactions. *Untitled La Jolla* comprises an artist's statement and installations at two different sites. For one site, the artist selected the Museum for the placement of a self-contained unit that includes a white wall, a table, four chairs, and a bed. The tops of each piece of furniture are painted in rich hues of blue and red. For the companion site, Nordman chose a private home with a garden for the installation of a 6-by-12-foot gate made of cedar slats. All of the elements in the piece—the furniture and the gate—were designed by the artist and built by Japanese master carpenter Makoto Imai. Chance, change, and the randomness of time and space are integral to the viewer's experience of this work and its quiet interaction with the fundamental condition of its sites.

S.M.

a work in two related parts each 6' × 12'

—one is of white Port Offuls cedar—first growth

—another is of cedar with canvas and acrylic

realized in the tradition of joinery
having several-thousand year development history in Japan
related to building methods of parts of the Northern hemisphere.

two forms of time-emplacement

*This work is not for "installation"—both the person and the light of the sun
are in transit*

—cedar wood slating (no canvas)
for exterior placement for a day at a time

**at a time and in a location bordering
between two places**
a court and a street,
a building and a street
a personal and interpersonal
place of work

—canvas and wood
for placement within the museum
near a window to a large landscape for one month

**between use and not use
naming and not naming**

the elements of the work are not pre-determined in meaning
the persons arriving in the specific context
of the work determine
the naming or not naming of these elements

—MARIA NORDMAN

Untitled La Jolla, 1993
Acrylic on canvas and white cedar; canvas panel: 72" × 144" × 5⅝"; cedar gate: 72" × 144" × 7½"; eight chairs,
each: 15" × 16" × 16"; two beds, each: 13½" × 36" × 68½"; two tables, each: 28" × 33" × 33".
Gift of RSM Company, Cincinnati, Ohio, 96.8.1–14.

Patricia Patterson

AMERICAN, B. 1941

Beginning in 1960, Patterson's extended visits to Inish-more, an island located in Ireland's Galway Bay, intro-duced her to the island's picturesque, starkly rugged landscape and the warm, colorful character of its people. Patterson, born in New Jersey to Irish-American par-ents, was powerfully affected by the people of Inish-more, the Irish countryside, and the Gaelic language. *The Kitchen* is one of many of the artist's works that combines installation and painting, and which features the same table, chairs, checkered kitchen floor, alarm clock, and other treasured objects signifying the island-ers' family mealtime rituals and life in general with the Hernon family. The objects carefully arranged along the mantel are duplicates of those seen in the Hernon home, and include a watercolor of Nan Hernon and a drawing of the family dog. The placement of these ob-jects resonates with a sense of order and permanence, suggesting the static unchanging quality of the islanders' lives. These objects also evoke the presence of their owners. This sense of presence is enhanced by the scene in the painting, *Cóilín and Patricia,* hung on the gallery wall facing the hearthside table. Here, Cóilín embraces the artist in a moment of joviality, indicating the artist's warm relationship with the Hernon family. A world of memories, nostalgia, and affection is achieved not only in the artist's use of portraits and personal objects, but through the use of bright, saturated colors. Patterson captures the spirit of the lively people of Inishmore by using the same colors found on the doors, windows, and furniture of island residents such as the Hernons— a counterpoint to the gray sky and whitewashed stone buildings that dominate the surrounding landscape. For more than thirty years, in cultural portraits such as *The Kitchen,* Patterson has distilled the essence of the char-acter of the people and sense of place of Inishmore. She has sought to understand and to successfully portray this unique culture and landscape. S.M.

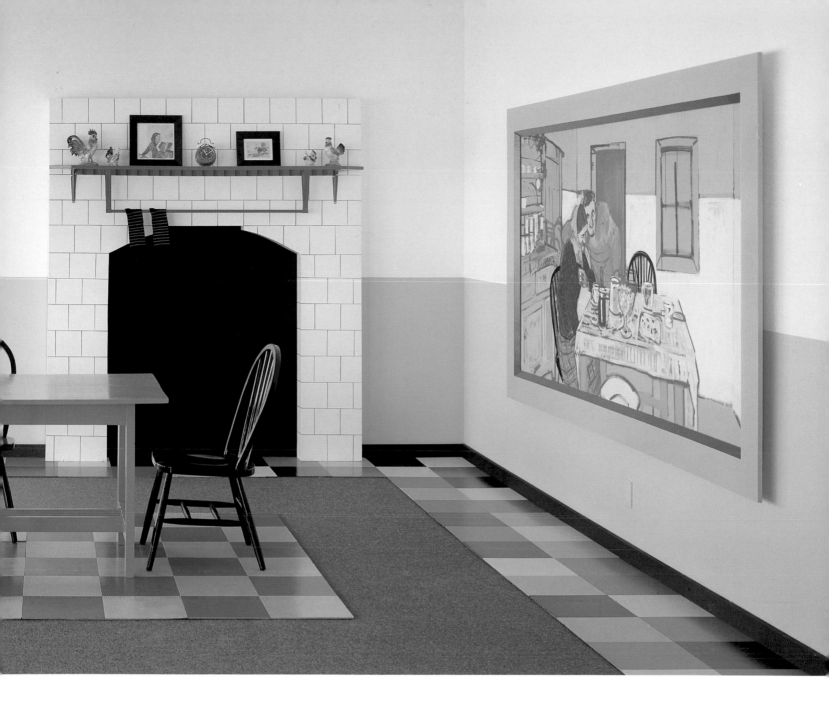

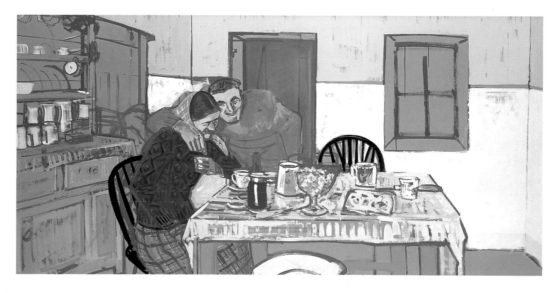

The Kitchen, 1985
Table, chairs, mantel, objects, floor tiles, and casein on canvas; painting: 60" × 107"; overall dimensions vary
with each installation (as illustrated: 84" × 144" × 180"). Museum purchase, 90.11.1–43.

Zeemansblik and Feldstechermann, 1987–88
Sheet zinc on wooden frame, pinewood, cardboard, and plywood;
zinc panel: 28¾" × 46½"; sculpture with pedestal, height: 75½",
diameter: 19⅝". Museum purchase, 90.25.1–2.

Markus Raetz

SWISS, B. 1941

The spare, deceptively modest elements of this work require an attentive and receptive viewer. Raetz's installations engage the viewer in a poetic investigation of visual and perceptual experience through shifts in scale, materials, and perspective. The artist—who was born in Bern, Switzerland, where he now lives and works— spends part of each year working on the Côte d'Azur in southern France. He often draws and paints small-scale views of the ocean. Intending the pun, he calls this series of works "Sea Views." *Zeemansblik* is the Dutch word for "sailor's look" or "mariner's view," but the word *blik* means both "tin" and "view." In this piece, Raetz has cut zinc sheets into the easily recognizable shape of the field of vision of a pair of binoculars. The zinc surface of the work reflects light and absorbs color from the environment. When the viewer observes the piece, any change in position or the amount of light in the room creates the illusion that a subtle and endlessly changing seascape is painted on the zinc surface. The zinc form has been slightly creased, creating a horizontal ridge that reads as the horizon line between ocean and sky. The companion piece in this installation, *Feldstechermann*—"binocular man" in German—is a simply carved wooden figure that looks through binoculars. *Feldstechermann* looks directly at *Zeemansblik*, and the space between the two pieces is almost electrically charged as the viewer observes who is looking and what is seen. Raetz's works call into question our understanding and perception of reality, which is subject to review as our vision of it changes. L.F. 67

Men Seldom Make Passes

Alexis Smith

AMERICAN, B. 1949

In her work, Smith often melds words and objects to analyze myths about the American Dream. Using found items and familiar texts, Smith charts types and stereotypes from recent American history. In this piece, the artist juxtaposes Dorothy Parker's cautioning quip, "Men seldom make passes at girls who wear glasses"—which has become a part of the cultural vocabulary of Americans—and the mysterious allure of Marilyn Monroe's sunglassed visage. Smith's piece comprises many layers: on top of a 10-by-15-foot solarized mural

of Monroe painted directly on the gallery wall are placed two collages, the angular, silvery blue-green frames of which function both as "art" for the wall and stylish "shades" for the Hollywood star. The collages/sunglasses are composed of images of well-padded football players on top of which Smith has layered lipstick traces, a letterman's letter, an eye-exam chart, and Parker's familiar phrase. In the piece, Smith concurrently asks the questions: What is sexy? and Who's gazing at whom?

K.K.

Men Seldom Make Passes at Girls Who Wear Glasses, 1985 (1996 reinstallation)
Wall painting with two framed mixed-media collages; two panels, each: 27" × 33" × 3¾"; overall dimensions vary with each installation (as illustrated: 139¼" × 182" × 3¾"). Museum purchase with partial funds from Ansley I. Graham Trust, Los Angeles, 95.9.1–2.

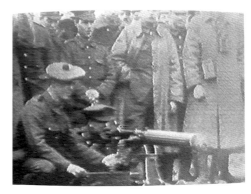

Francesc Torres

AMERICAN, B. 1948 (SPAIN)

At first glance, Torres's work seems like a makeshift encampment for some future engagement of "Video Wars"—a large weapon is surrounded by buckets filled with water, and six video monitors are mounted on tall bases and placed in an arc. *The Dictatorship of Swiftness* is a symbolic tableau incorporating aspects of various worlds: military, industrial, chemical, and electronic. The placement of the monitors suggests theatrical, penal, and religious architecture: a theater in the round, a security control station, and a cathedral apse. Each of the monitors shows one of three different video loops: a speeding race car flipping over and crashing on the left-hand monitor, a mix of clips of the same car tumbling on the four central monitors, and a sequence showing a soldier being shot and recoiling in a *danse morte* on the right-hand monitor. In the clear Plexiglas base of each monitor a toy car and a military helmet are displayed—symbolic artifacts of the sequences depicted in the videos. Water-filled buckets complete the arcane staging. In this piece, Torres pits the older mechanical world against today's newer and swifter electronic reality. These opposites are conflated into a single tableau, the materials, sounds, and movements of which suggest a range of institutions, media, and events that have shaped the late-twentieth-century world in which we live.　　　R.J.O.

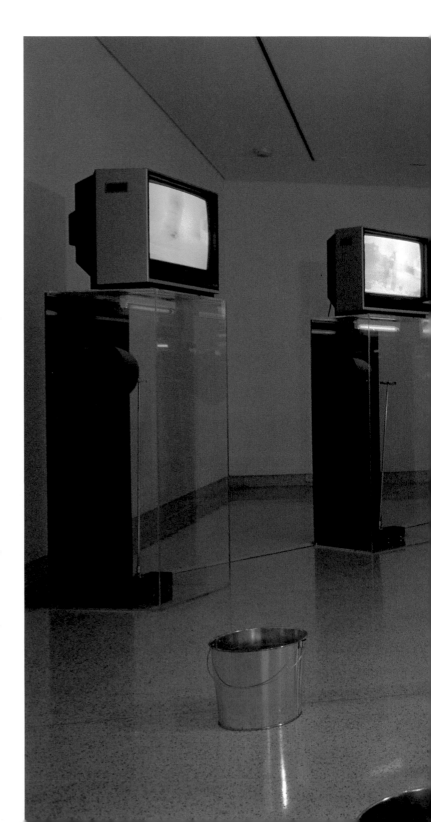

The Dictatorship of Swiftness, 1986
Six video monitors with video loops mounted on Plexiglas bases containing toy cars, army helmets, and fluorescent tubes; military field gun, 24 metal pails filled with water; monitor and base, each: 71" × 20" × 19¼"; overall dimensions vary with each installation. Museum purchase with matching funds from the National Endowment for the Arts, 87.19.1–61.

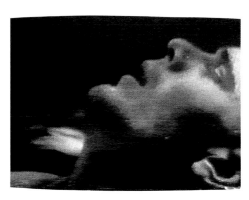

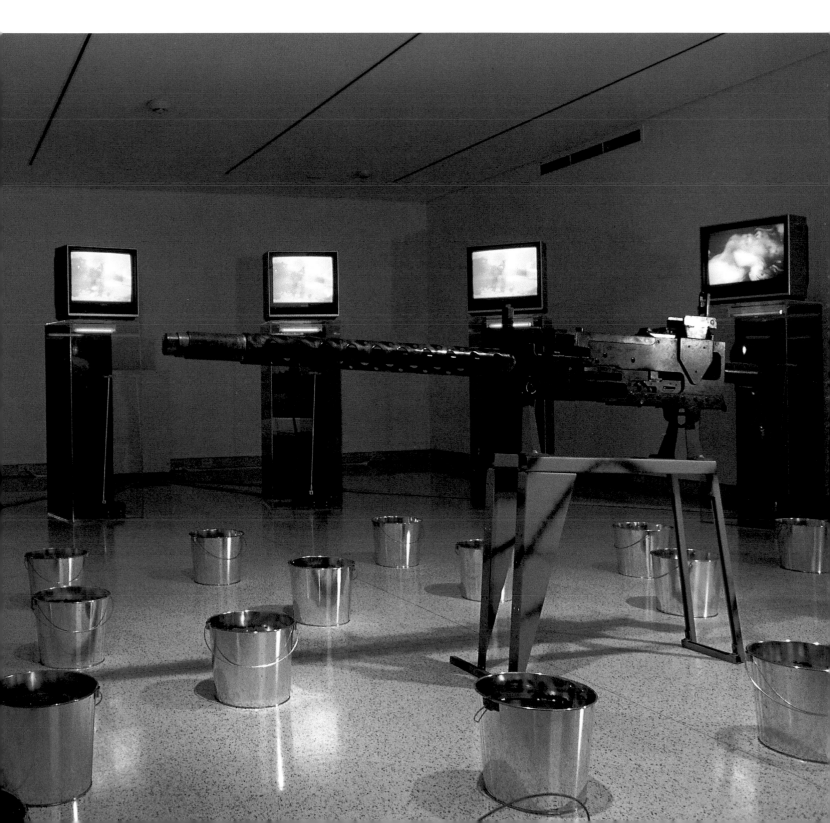

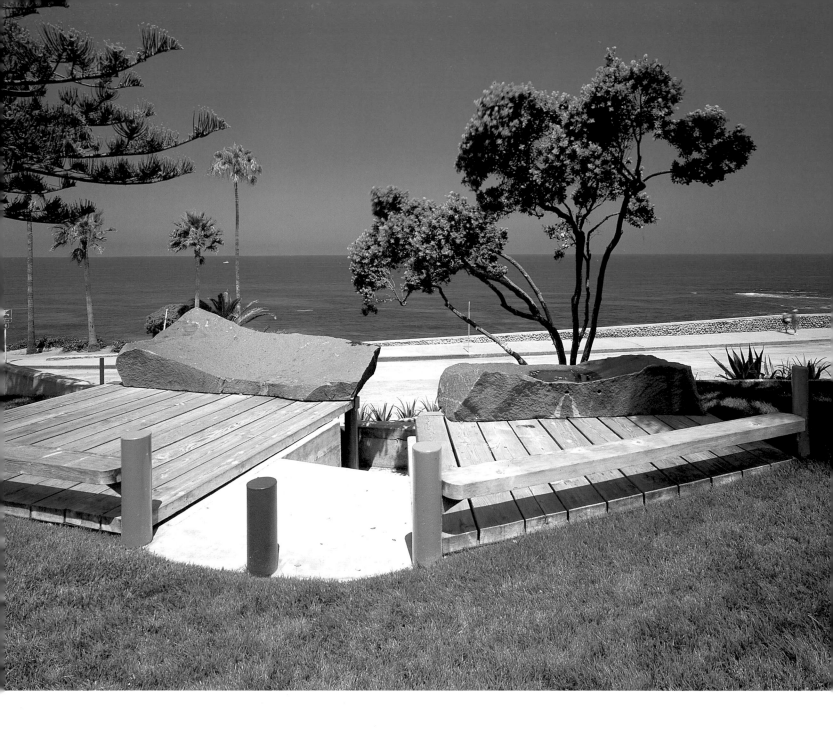

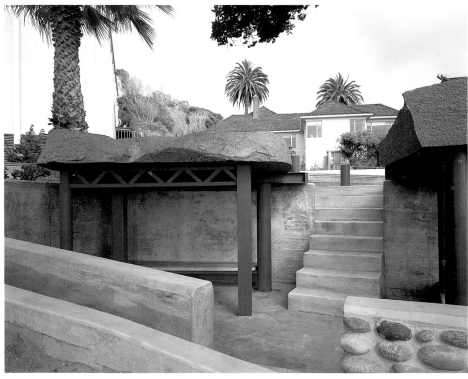

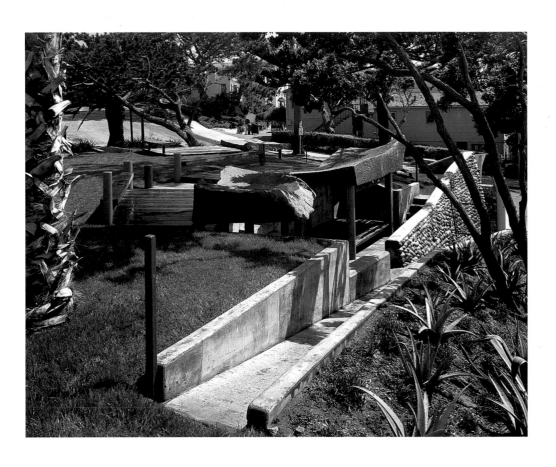

George Trakas

AMERICAN, B. 1944 (CANADA)

In *Pacific Union,* Trakas invites visitors to sit, meet, and meditate as they move among the many elements and varied terrain of the work. The piece is located in what had been a little-used part of the gardens of the historic La Jolla home of philanthropist and businesswoman Ellen Browning Scripps that now belongs to the Museum. Tucked into the southwest corner of the ocean-front garden, areas of which date back to the early years of this century, *Pacific Union* is remarkably rich in its variety of spaces and magnificent vistas. Steps, wooden walkways, and benches are integrated into a series of wood, metal, and stone structures—sometimes imposed on the landscape, but most often working in close concert with the topography, flora, and existing man-made elements of the site. *Pacific Union* is raised above street level and surrounded by a high wall imbedded with the distinctive rounded beach stones found elsewhere in the garden. Trakas's reworked site beckons the viewer to explore its foliage, to perch atop slabs of natural granite, or to huddle underneath them in private denlike hutches. From either of these vantage points, extraordinary views of the dramatic rocky coastline are framed. In *Pacific Union,* art and nature happily coincide: the experience of the piece unites the viewer with the sights, sounds, and smells of the Pacific. R.J.O.

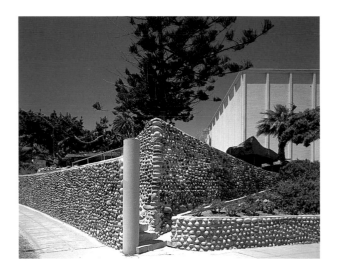

Pacific Union, 1986–88
Mixed-media outdoor site installation composed of wood, steel benches, granite slabs, metal barbecue, fieldstone paths, cast-concrete walls, and plant material; approximate overall dimensions: 6,000 sq. ft. Museum purchase with matching funds from the National Endowment for the Arts, Art in Public Places Program, 88.35.

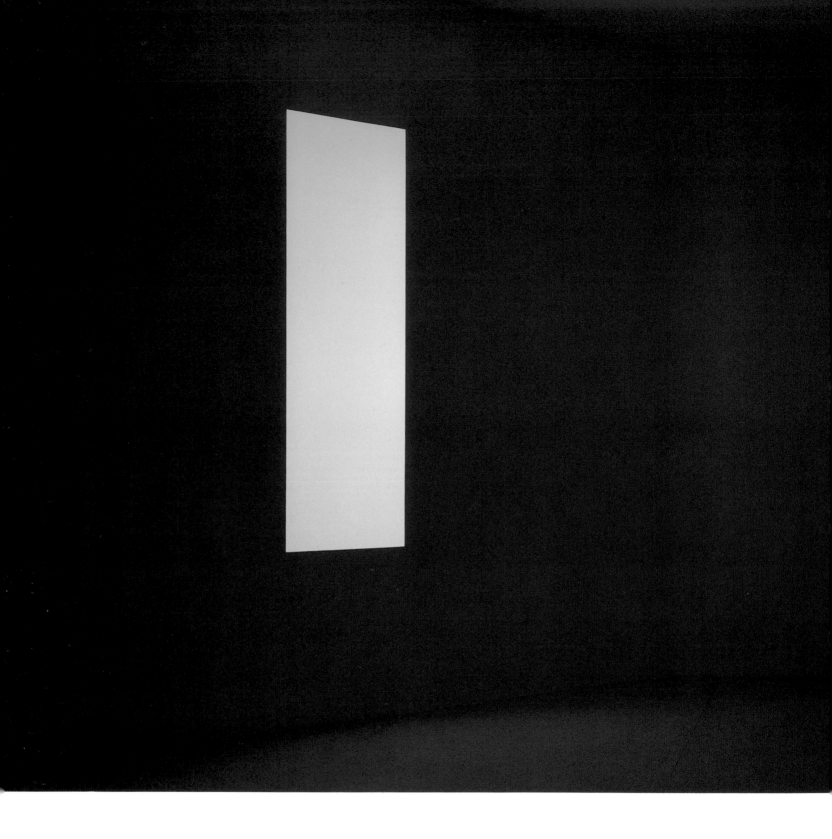

James Turrell

AMERICAN, B. 1943

The pictorial meets the sculptural in Turrell's *Stuck Red* and *Stuck Blue.* For each installation, a rectangular opening was neatly cut into a wall installed a short distance from an existing wall. Hidden in the narrow chamber between the two walls are colored fluorescent tubes. Their intense glow fills the chamber space and spills into the gallery. Optically, solid and void are inverted: the negative spaces of the apertures appear solid while simultaneously the walls appear to disintegrate. Whereas in earlier projection pieces Turrell used light to suggest three-dimensional objects, in these shallow-space constructions the light is used to visually flatten the area of the room from three dimensions to only two. Turrell uses light as a means to create a perceptual environment, but also to heighten viewers' perception. As the existence and impression of two and three dimensions vie for prominence, the viewer alternately perceives reality and is deceived. The body seems to feel the space as vaporous and thick; the eye (mis)reads optical effects as haptic sensations. In *Stuck Red* and *Stuck Blue,* Turrell's carefully orchestrated environment reveals the possibilities of visualization and explores the act of seeing. K.K.

Stuck Red, 1970 (1990 reinstallation)
Stuck Blue, 1970 (1990 reinstallation)
Construction materials and fluorescent lights; walls, height varies with each installation (as illustrated: 180"), each width: 168";
apertures, each: 90" × 26". Museum purchase with funds from the Elizabeth W. Russell Foundation, 90.5, 90.6.

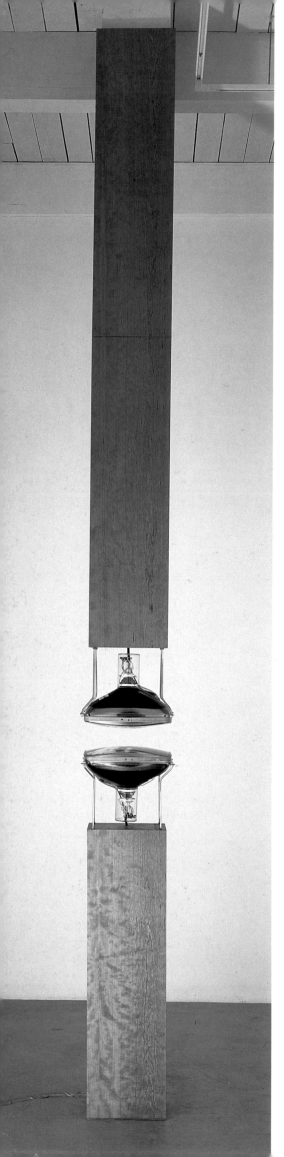

Bill Viola

AMERICAN, B. 1951

Viola uses the latest in video and computer technology to pursue the depths of the psychic landscape. In his work, the electronic image is a means of sculpting time and memory, and engaging the viewer in a real-time experience. In *Heaven and Earth,* Viola treats the universal theme of the cycle of life. The piece comprises two video monitors, one mounted on the bottom of a vertical wood column attached to the ceiling and facing downward, the other mounted facing upward on the top of a column whose base is attached to the floor. The two monitors face one another, always positioned precisely two-and-one-eighth inches apart, at the viewer's eye level. The monitors have been removed from their customary casings, revealing their internal wiring, and one small red light at the base of each monitor indicates an energy source. A video image of the hollowed face of an elderly woman, Viola's mother in her final hours, is displayed on the top monitor; the lower monitor shows a video of a newborn child, Viola's second son, born just nine months after the artist's mother's death. The videos are played in slow motion, simulating a silent, dreamlike world and inducing a hypnotic state in the viewer. The image on one screen reflects on that of the other, gently blending the faces together. The space between the two monitors becomes an integral element of the piece, suggesting passages, time, and interchange in the cycle of birth, life, and death. S.M.

Heaven and Earth, 1992
Two-channel video installation; edition 1 of 2; lower column: 57" × 14½" × 11"; upper column, width: 14½", depth: 11"; height varies with ceiling height; space between monitors fixed at 2⅛".
Museum purchase, Contemporary Collectors Fund, 93.1.1–6.

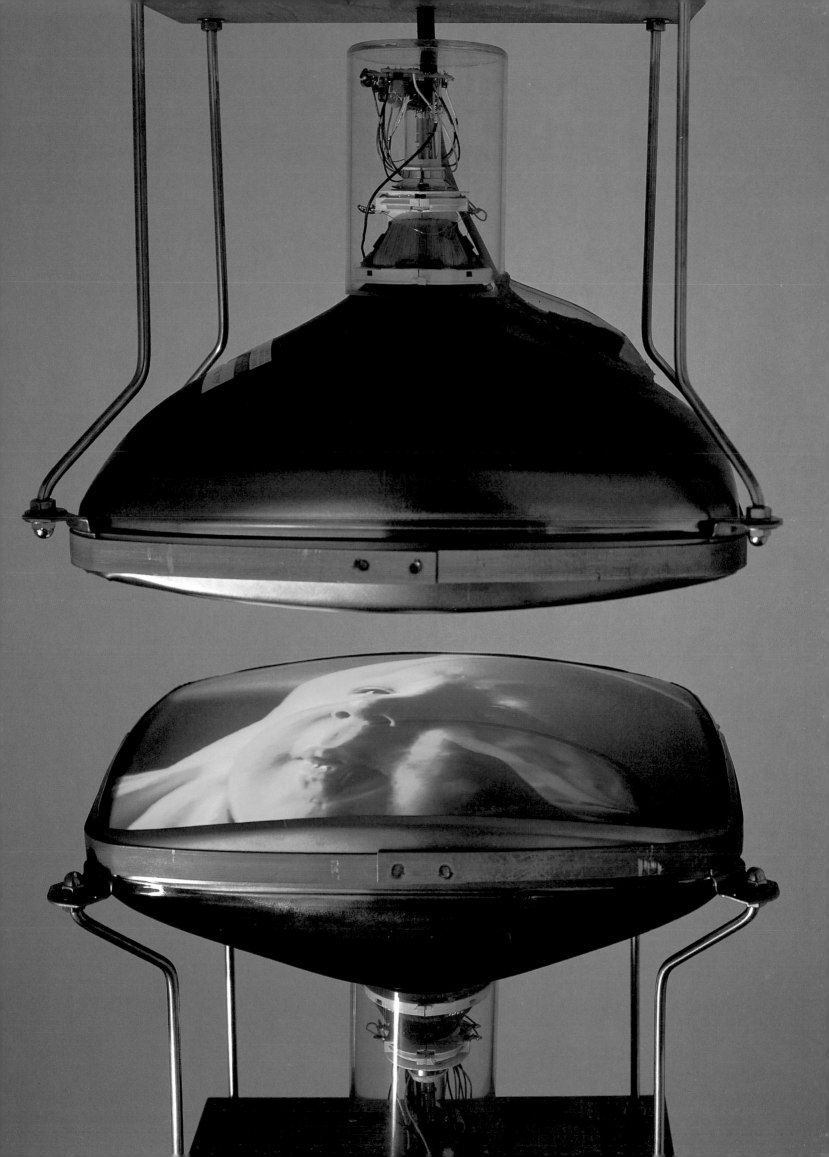

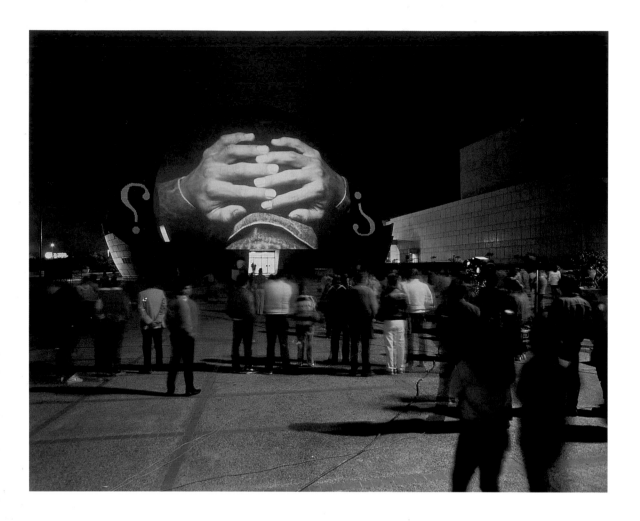

Krzysztof Wodiczko

AMERICAN, B. 1943 (POLAND)

In *The Border Project: San Diego/Tijuana*, Wodiczko conceptually connected the United States and Mexico on two consecutive nights in January 1988 by projecting slide images onto the San Diego Museum of Man and the Centro Cultural Tijuana. The images referred to economic and political issues integral to the history of the border region. On the first night, Wodiczko transformed the Spanish Baroque Museum of Man building into a giant consumer of heroic proportions and a larger-than-life laborer—images representing property ownership and slavery. Two giant hands extending from elegant cuffed sleeves, each holding a silver utensil—the right hand a knife, the left a fork—were projected on the building's facade at either side of the entrance. The particular placement of the projected hands caused the building's dome to be read as a head and its entrance as a giant open mouth. Projected on the tower of the building was another pair of hands. The wrists were bound, and the hands, extending from the bare muscled arms of a laborer, clutched a basket overflowing with fruit. Dangling from the right wrist was a short scythe commonly used by migrant workers to harvest produce

—a tool that requires constant backbreaking labor. In this scenario, Wodiczko presented the consumer demanding and defending his right to consume without regard for the laborer, whose handcuffed wrists offer the fruits of his labor. Wodiczko also used the architecture of the building to add another layer of meaning to the work: the history of Mexican domination by the seventeenth-century Spanish conquerors.

On the second night, across the border in Mexico, Wodiczko projected an image of the back of an unidentified man's head, fingers interlocked on his neck, onto the round surface of the theater of the Centro Cultural Tijuana. This position suggests submission and is typically assumed by someone being arrested—an allusion to the many Mexican nationals who are arrested while illegally crossing into the United States. In each work, the artist transformed the architecture of civic institutions into a public statement about the double agenda of the United States, which on the one hand relies on immigrant labor to support its massive agriculture industry and, on the other, demands the cessation of illegal border crossings. S.M.

The Border Project: San Diego/Tijuana: Projection on the San Diego Museum of Man, Balboa Park, San Diego, California, 1988
Color transparency in light box, photograph by Philipp Scholz Rittermann; 41½" × 31½" × 5¾". Museum purchase, 88.28.

The Border Project: San Diego/Tijuana: Projection on the Centro Cultural Tijuana, Baja California, Mexico, 1988
Color transparency in light box, photograph by Philipp Scholz Rittermann; 31½" × 41½" × 5¾". Museum purchase, 88.29.

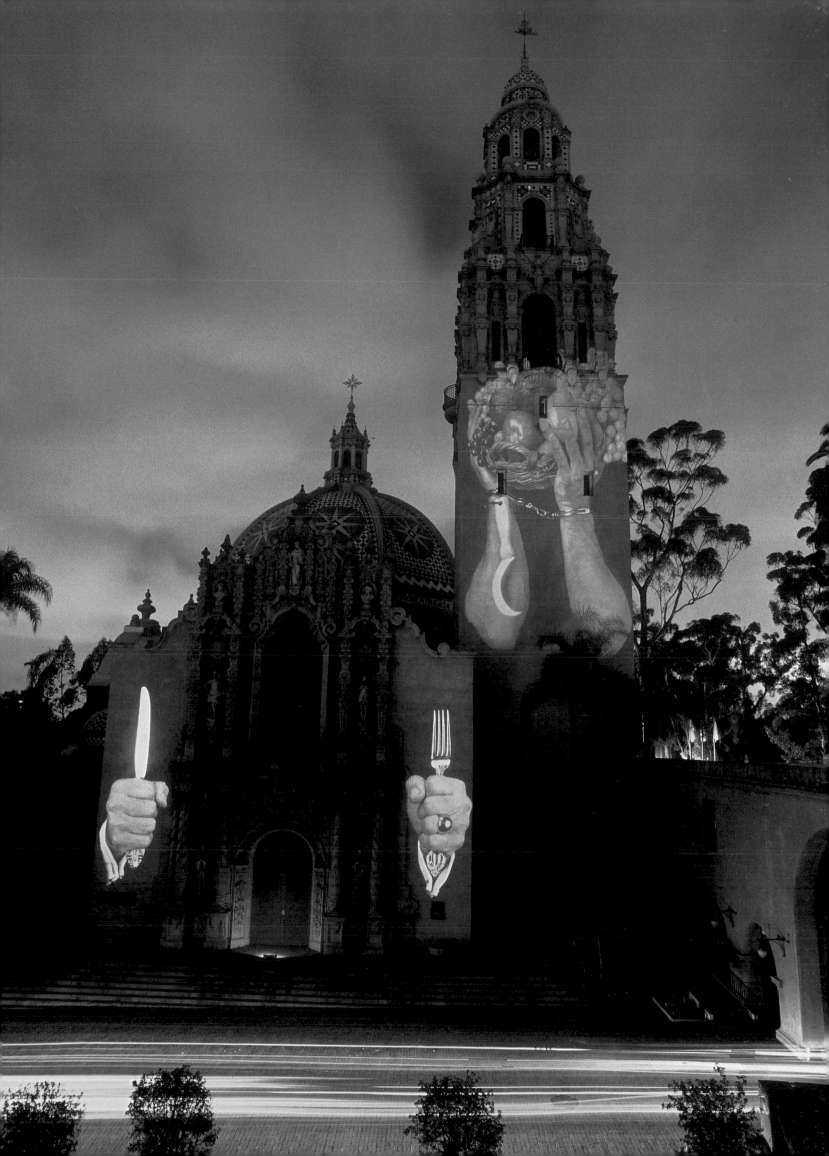

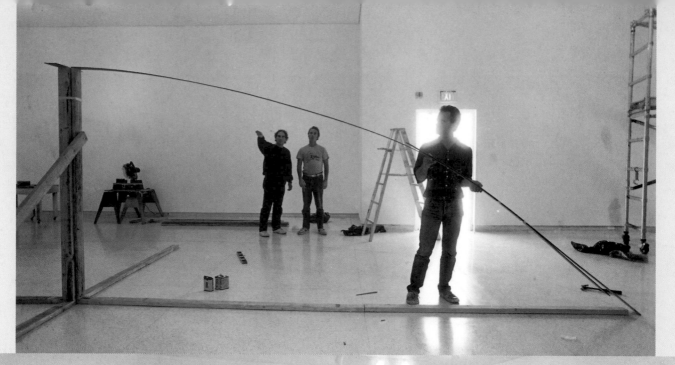

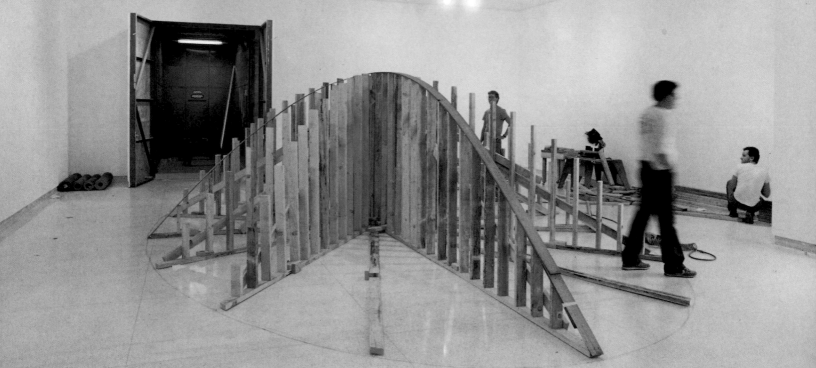

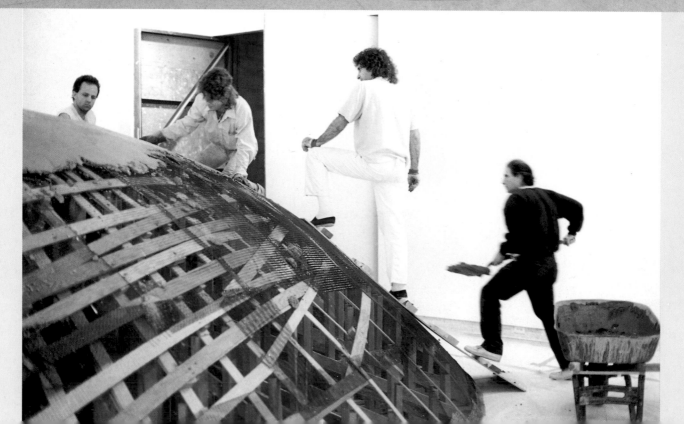

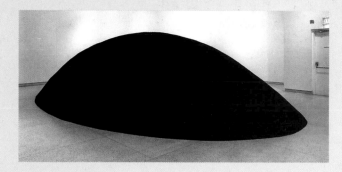

Exhibition chronology, 1969–1996

This chronology documents the Museum's decades-long commitment to supporting and facilitating the work of artists who are challenging art conventions. As far back as 1969, MCA commissioned its first installation exhibition: conceptual artist Michael Asher's *Untitled (White Room),* an environment in which the object was conspicuously absent. Other seminal exhibitions soon followed, such as *Body Movements: Mowry Baden, Chris Burden, Bruce Nauman* in 1971. Throughout the 1970s, '80s, and '90s, MCA has continued to present exhibitions by artists who have helped define and redefine installation art. Over the past fifteen years the Museum has also sponsored an artists-in-residence program that has generated many installation works.

One of the earliest and most ambitious installation projects at MCA was Robert Grosvenor's 1971 floating sculpture *Kinetic Ocean Piece.* The piece was launched from the coastline nearby the Museum into the Pacific Ocean and anchored 200 feet from the shore where it floated on view for six weeks. The influential *Parameters* series that MCA presented from 1984 to 1995 was funded through annual grants from the National Endowment for the Arts and resulted in thirty-five projects by international, national, and regional artists. One of the first artists sponsored by this series was Maria Nordman, who used both the interior and exterior architecture of MCA La Jolla in her 1985 exhibition *Trabajos en la Ciudad.*

MCA has also commissioned works off-site, such as Krzysztof Wodiczko's public slide projections of giant images onto the facades of the San Diego Museum of Man in Balboa Park and the Centro Cultural Tijuana, Mexico, or the series of artist-designed billboards commissioned under the aegis of MCA's artistic initiative *Dos Ciudades / Two Cities.* Beginning in the 1980s, MCA used nontraditional satellite spaces in downtown San Diego for temporary exhibitions, often commissioning site-specific or installation works for these spaces. One of the most important of these was *911: The House Gone Wrong,* a 1987 project by the Border Art Workshop/Taller de Arte Fronterizo that focused on border politics. The Museum's use of a series of temporary downtown spaces eventually evolved into the establishment of a permanent downtown facility, opened in 1993.

This chronology does not represent a complete record of all the exhibitions presented at MCA since 1969, but features those exhibitions in which artists created at least one new installation work. In some cases, the work was acquired for the permanent collection; in others, the work was temporary and now exists only in photographic documentation.

OPPOSITE and ABOVE: Jene Highstein installing *Mound (Turtle),* 1976 (1986 reinstallation)

Michael Asher: Untitled (White Room)

7 November–31 December 1969

For this project, Michael Asher created a completely white room that was transformed through sound and lighting effects. The room seemed to pulsate and exist without defined corners. An oscillator, amplifier, and speaker produced a constant tone which could be felt rather than heard. Fundamental to the experience of the work was a contradiction described by Asher as ". . . non-visual material treated and organized according to principles derived from formal-visual aesthetics." Curated by Larry Urrutia.

David Thompson, *Untitled,* 1970

 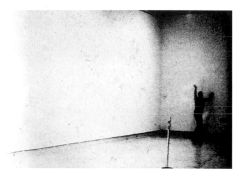

Barry Le Va, *Velocity Piece,* 1970

Projections: Anti-Materialism
15 May–5 July 1970

This exhibition of "non-object art" explored the possibility of impermanent and unpurchasable art, designed for viewing only at the time and place for which it was created. *Projections: Anti-Materialism* included written statements by Robert Barry that evoked visual images; a temporary wall painting by David Deutsch; a colored- and reflected-light environment by Charles Emerson; an audiotape of *Velocity Piece,* which documented a physical endurance performance by Barry Le Va; a fine-line drawing in four colors on four walls of the Museum by Sol LeWitt; and works concerned with visual and physical barriers by David Thompson. Twenty page catalogue. Curated by Larry Urrutia.

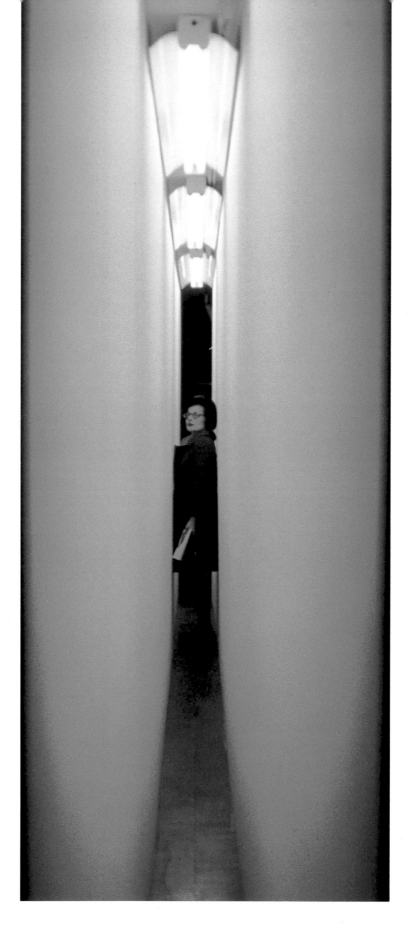

Bruce Nauman, *Green Light Corridor*, 1970–71

Body Movements: Mowry Baden, Chris Burden, Bruce Nauman

26 March–25 April 1971

Artists Mowry Baden, Chris Burden, and Bruce Nauman installed works that required the active participation of the viewer, in mind and body, to complete the meaning of the pieces. Through their interaction with the pieces, viewers recognized the "awareness potential" of their own bodies. Mowry Baden created a number of installations for the show. In one piece, participants were strapped into harnesses attached to the floor, which confined them to walking a circular path. A work by Chris Burden required two participants to be dependent on each other's support in order to stand precariously on a narrow bar. Participants could walk into Bruce Nauman's *Green Light Corridor,* a narrow light-filled space situated in a narrow gallery. Curated by Larry Urrutia.

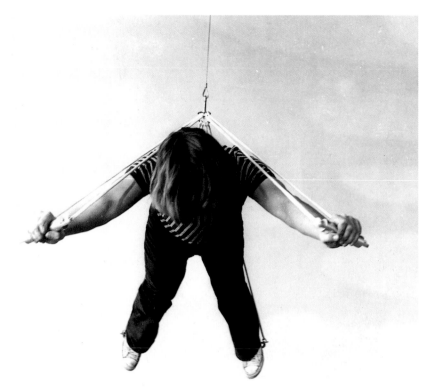

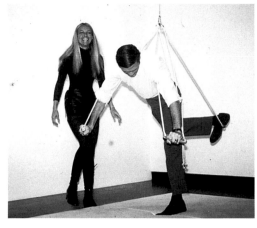

Chris Burden, *Untitled,* 1971

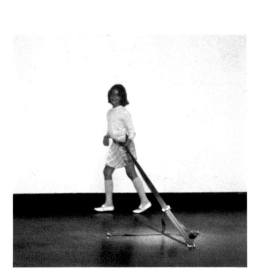

Mowry Baden, *Seatbelts,* 1970

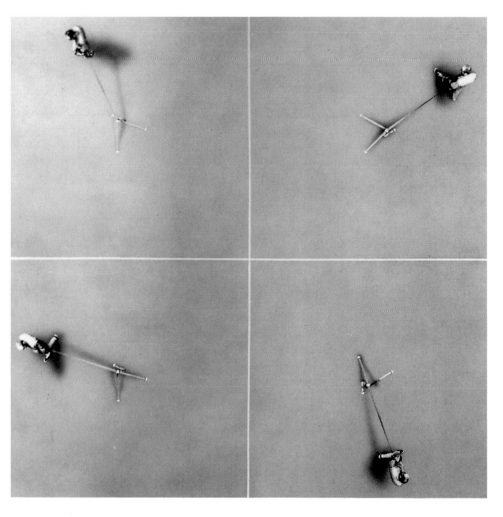

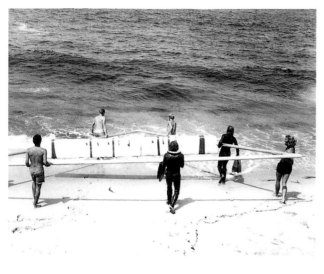
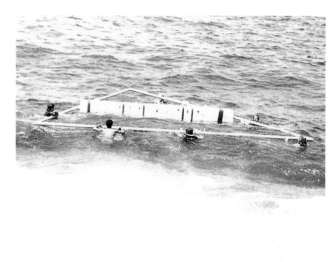
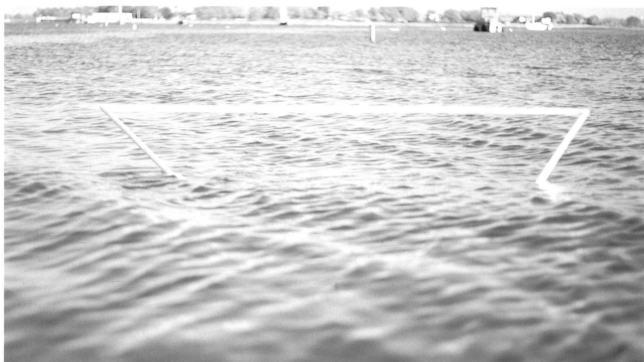

Robert Grosvenor: Floating Sculpture for La Jolla (Kinetic Ocean Piece)

22 August–1 October 1971

Grosvenor's work, made of aluminum tubing, was launched into the Pacific Ocean and anchored approximately 200 feet offshore. The floating sculpture could be seen from the gallery windows that overlook the ocean on the west side of the Museum. This large-scale piece, which achieved its full effect by gently moving in concert with the ocean waves, was similar in nature to earthworks by Robert Smithson and Michael Heizer. Curated by Larry Urrutia.

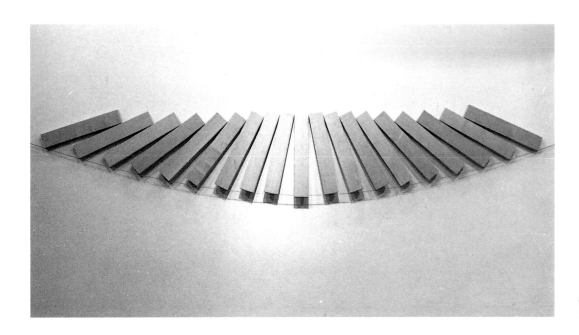

Guy Dill, *Untitled*, 1971

Laddie John Dill, *Untitled*, 1971

Earth: Animal, Vegetable and Mineral
9 October–5 December 1971

Featuring work by Vija Celmins, Guy Dill, Laddie John Dill, and Newton Harrison, this exhibition addressed the theme of the earth. It included assemblages of wood and wood by-products by Guy Dill; a construction of glass, sand, and light by Laddie John Dill; drawings of the ocean's surface by Celmins; and an outdoor environmental piece with live ducks and snails by Harrison. Curated by Larry Urrutia.

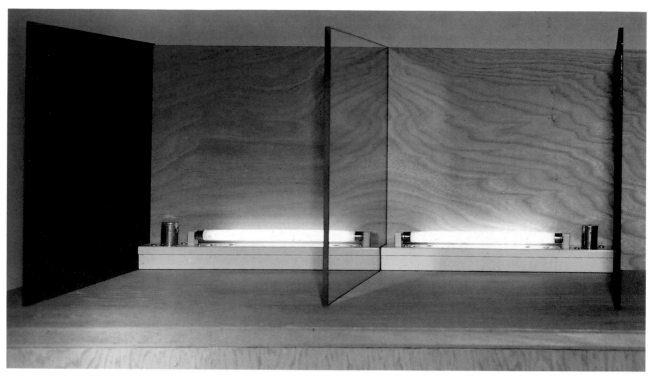

Ron Cooper, *Separator Variation Model,* 1973

Ron Cooper

13 May—1 July 1973

Cooper's work reflects his interest in the physical qualities of light, such as optical effects produced by intersecting beams of light and optical reactions to color saturation produced when fluorescent and neon lights are combined. This exhibition included glass and fluorescent light installations and diagram drawings. Twenty-four page catalogue. Curated by Jay Belloli.

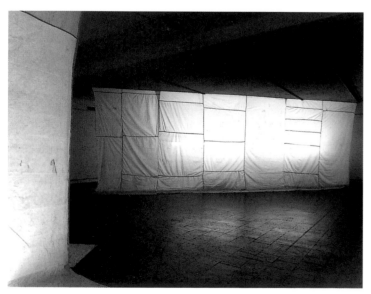

Joel Glassman, *Corral: Double Negative Space (For Fluorescent Light and Sound),* 1973

Joel Glassman, Carlos Gutierrez-Solana, Paul Kos

13 October—5 December 1973

These three artists from the San Francisco Bay Area were interested in altering their surroundings. Joel Glassman's installation, *Corral: Double Negative Space (For Fluorescent Light and Sound),* consisted of fluorescent lighting and the sound of dripping water, which emanated from within a "negative space"—an environment of drop cloths. Glassman's video, *Symbolic Logic of Now,* also revealed his interest in sounds and visual elements. Carlos Gutierrez-Solana's object-based work used materials such as brilliantly colored ribbons, cloth, fur, wire, and rope, which he placed in rectilinear configurations, taking advantage of their inherent forms. Paul Kos's installation, *rEVO-LUTION Notes for the Invasion MAR MAR MARCH,* included an audio component—a recording of typewriter keys pounding out a march rhythm. The cassette player and other objects were displayed in a case at the far end of the room. Two-by-four-inch planks of wood were placed at one-foot intervals on the gallery floor and the viewer had to step between each plank in order to inspect the case, echoing the audiotape with his or her own marchlike step. The exhibition also included Kos's videotape, *Battle Mountain,* in which he used simple images combined with repeated words to reinforce the sense of defeat and destruction resulting from the American Indian confrontation at Battle Mountain, Wyoming. Twenty-four page catalogue. Curated by Jay Belloli.

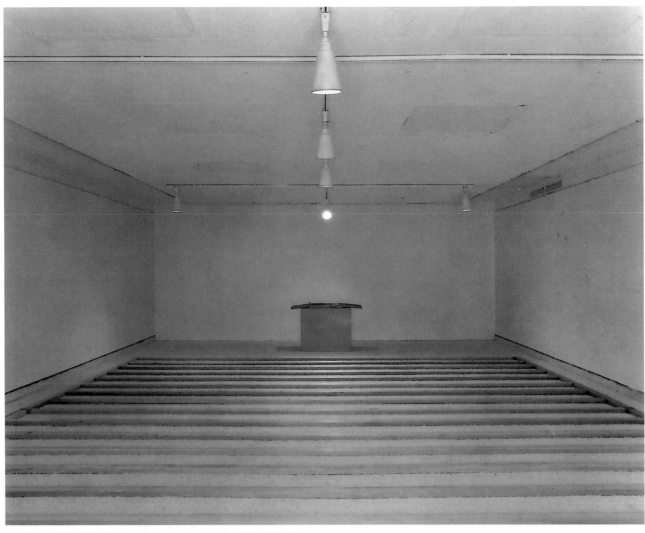

Paul Kos, *rEVOLUTION Notes for the Invasion MAR MAR MARCH*, 1973

DeWain Valentine: V Line and Cantilevered Planes

27 June–5 August 1975

In these installations, the viewer was enveloped by spaces infused with diffused colored light; as the artist has stated, "ultimately the whole space became a container of transparent color and light." *Cantilevered Planes* (1975) was composed of acrylic sheets cantilevered through a false wall so that the ends were exposed to daylight. The beveled outer edges of each sheet were vividly defined by refracted daylight as if rimmed with neon, and the planes appeared to float in the air. *V Line* (1975) was installed in a 20-by-30-foot gallery. At two points in the ceiling, two lengths of acrylic tubing one inch in diameter began a course through the gallery, meeting at the bottom of the space to form a V shape. Again, the acrylic conducted daylight from the outside and carried it through the tubes, elegantly illuminating the darkened space. Twenty-eight page catalogue with essay by Peter Plagens. Curated by Sebastian Adler.

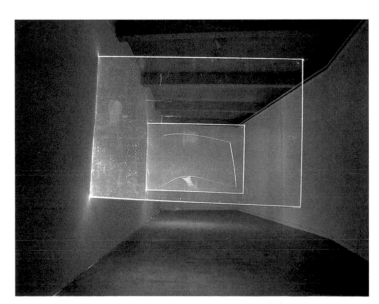

DeWain Valentine, *Cantilevered Planes*, 1975

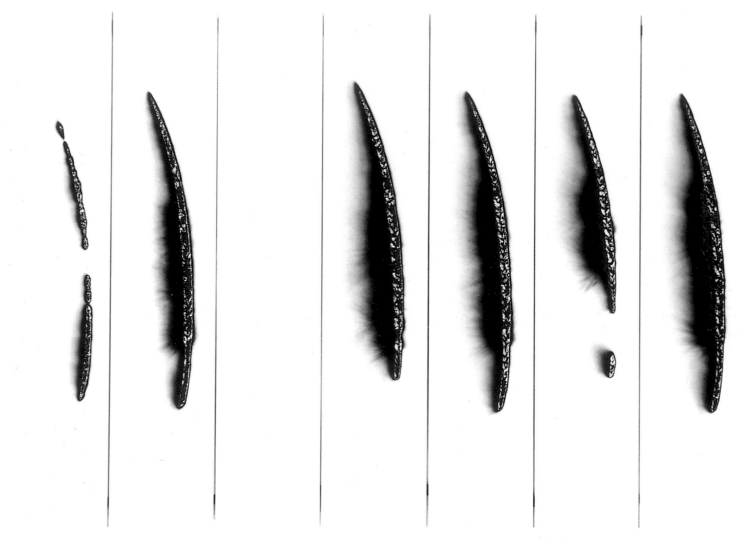

Sunlight Convergence/Solar Burns, 1971–72

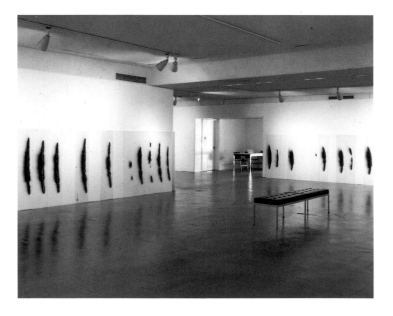

Charles Ross—The Substance of Light: Sunlight Dispersion, The Solar Burns, Point Source/Star Space

6 February–14 March 1976

This exhibition featured works by conceptual artist Charles Ross dating from 1966 to 1976. Among the works featured were Ross's map drawings and *Sunlight Convergence/ Solar Burns.* This piece comprised a series of painted boards the artist had used to record burn marks. Each day for one year, September 1971 to September 1972, the artist placed a wooden plank at the focal point of a large stationary lens to record the heat of the sun on that day. The burn marks created by the prism-directed sunlight traced the movement of the sun in relation to the earth from New York City. Thirty-six page catalogue. Curated by Richard Armstrong.

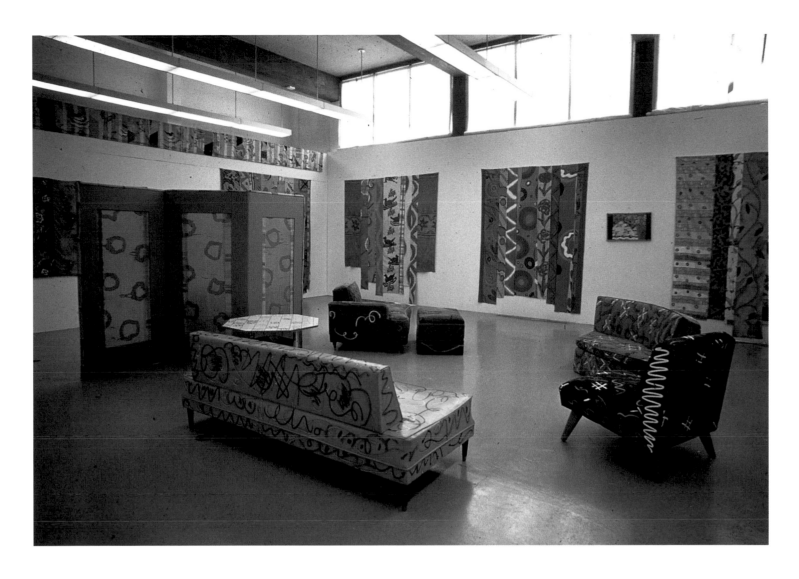

Kim MacConnel: Collection Applied Design

19 March–2 May 1976

Paintings on fabric and paper and twelve pieces of
furniture redecorated by the artist were included in this
exhibition. The artist treated the pieces of furniture as
blank canvases on which he painted new decorations.
MacConnel also sewed together cloth fragments to create
wall hangings. Some of the swatches of cloth were left
unaltered and others were painted over and decorated
with drawings and patterns, many copied from contem-
porary Chinese pattern books. This exhibition explored
non-Western design ideas that the artist incorporated into
his process of art making. Eight page brochure. Curated
by Richard Armstrong.

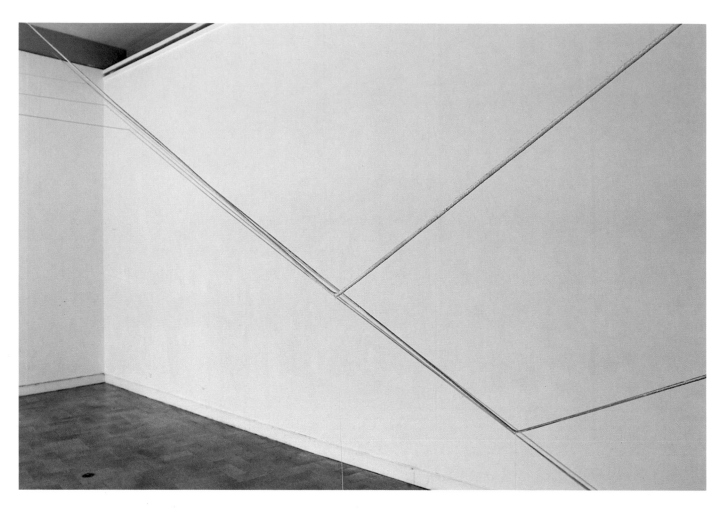

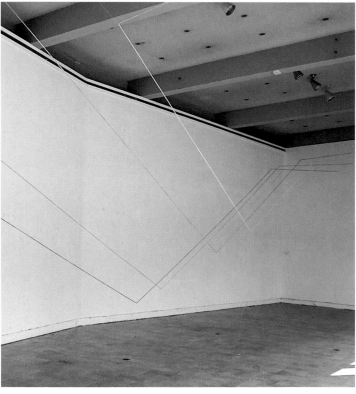

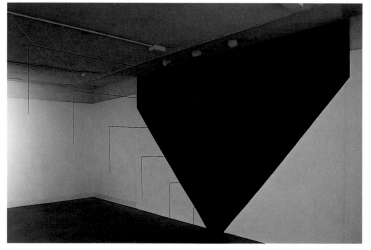

Rope Drawings by Patrick Ireland: An Exhibition

28 January–20 March 1977

In his colored-rope installations Patrick Ireland (the name under which critic Brian O'Doherty exhibits his work) underscored how sight and spatial relationships are unique to each participant's viewpoint. When confronted with the rope drawings, the viewer was forced to take part in "intentional wandering," noting contrasting vantage points in order to complete their forms. The exhibition traveled to Seattle Art Museum and Contemporary Arts Center, Cincinnati. Thirty-two page catalogue. Curated by Richard Armstrong.

Synchromesh: Michael Brewster

9 December 1977–22 January 1978

In this installation, two tones were sounded, dominating the 7,660 cubic feet of the Museum's gallery space and subordinating the expected visual experience of the museum to an auditory one. In this acoustical installation, Brewster's fourteenth since he had begun working with audio as an artistic medium in the early 1970s, different sounds and fluttering noises were created as the two tones "collided with reflected waves at certain nodal points." In his early sculptures, which used flashing lights placed in a variety of sites, as well as his audio works Brewster investigated visual and acoustical perceptions. Curated by Richard Armstrong.

Sol LeWitt

16 September–4 November 1979

Graphite and colored pencil wall drawings were made on-site in the Museum as part of a major retrospective of LeWitt's work organized by the Museum of Modern Art, New York. These intricate and subtle drawings followed the architecture of the building and conformed to the height and width of the particular walls on which they were drawn. These works were conceived by LeWitt but executed by his assistants, and thus in the process each drawing gained the nuances of the hand of the individual who executed it. One hundred eighty-four page catalogue. Curated by Alicia Legg (Museum of Modern Art).

Richard Artschwager's Theme(s)

18 January–2 March 1980

This was the first comprehensive examination of Artschwager's work and surveyed his paintings, drawings, and sculptures dating from 1962 to 1979. In conjunction with this traveling exhibition, the artist created an installation at MCA: numerous black oval-shaped "blps" [*sic*] were placed throughout the Museum in unexpected locations —by the reception desk, in stairways, and in closets. One-hundred-four page catalogue. Co-organized and co-curated by Richard Armstrong (MCA), Linda Cathcart (Albright-Knox Art Gallery, Buffalo), and Suzanne Delehanty (Institute of Contemporary Art, University of Pennsylvania, Philadelphia).

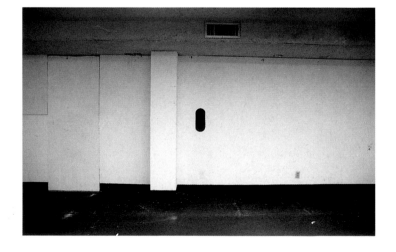

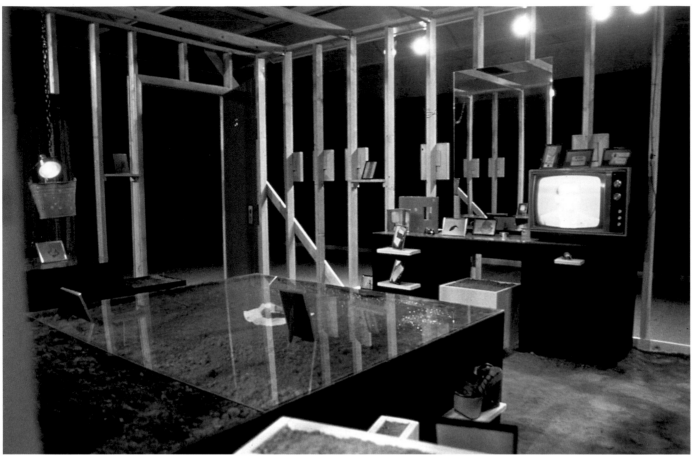

Billingsgate (A Motel), 1982

Ornithopera (The Devil's Condo), 1981

Rooms and Stories:
Recent Work by Terry Allen
16 April–29 May 1983

For the exhibition, two installation works were re-created and the Museum commissioned *Anterabbit/Bleeder (a biography),* a new installation and related theater piece. Allen's 1981 bird opera, *Ornithopera (The Devil's Condo),* which dealt with stereotypes about Southern life, included a rooster, three hens, and two crows, who lived together in the constructed environment for the duration of the exhibition. A video of the devil playing the piano was shown on a video monitor and the birds played out scenarios dealing with racial tensions. In another work, *Billingsgate (A Motel),* Allen reinvented a Billings, Montana, motel room where he had stayed in 1981. He re-created the dimensions of this room and included a TV on which the shows Allen had watched during his stay were replayed. Found objects—a Dr. Pepper can, shaving cream, a plastic Jesus standing in a bucket—and photographs of missing details—toilet paper, the contents of each drawer—presented a visual narrative of Allen's Montana experience. *Anterabbit/Bleeder (a biography)* had two parts: an installation for a gallery space and a theater piece that took place in the Museum's auditorium. The subject of *Anterabbit/Bleeder* was the tortured and infamous life and death of Bleeder, a hemophiliac. The installation included text, drawings, sculpture, music, and parakeets. The text used in the installation was also the dialogue in the theater piece performed by Jo Harvey Allen, which involved musicians, a hula dancer, and another actor as the "bleeder." Eighty-eight page catalogue. Curated by Robert McDonald and Lynda Forsha.

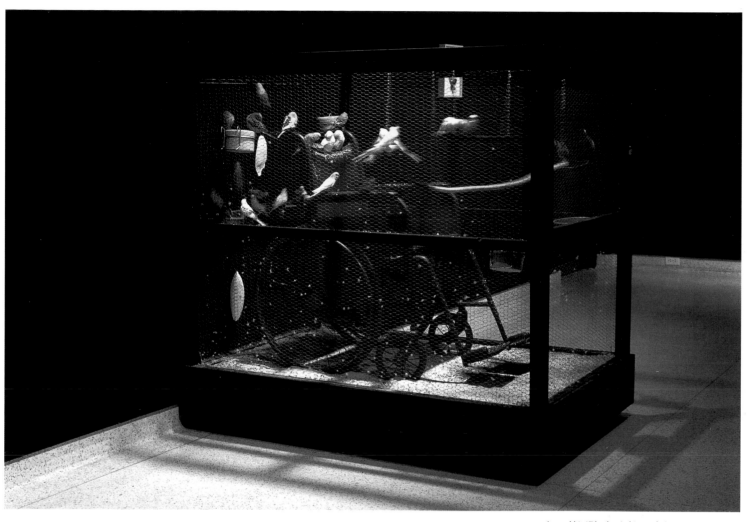

Anterabbit/Bleeder (a biography), 1983

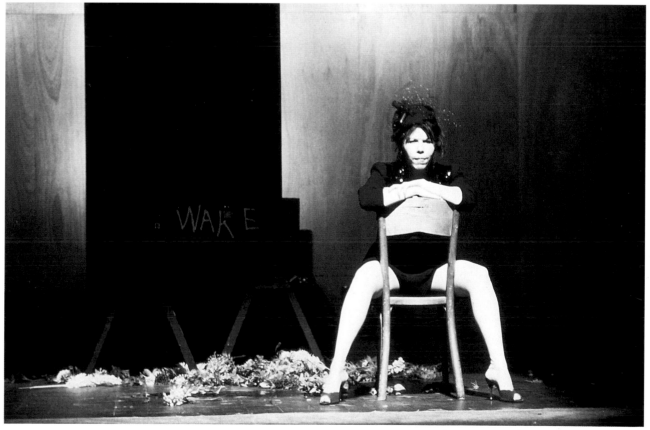

Anterabbit/Bleeder (a biography), 1983 (from theater piece)

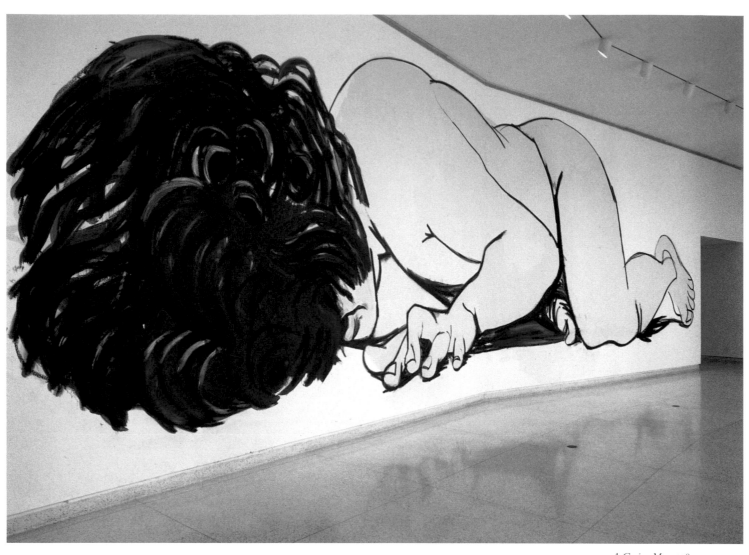

A Crying Man, 1984

Hair's Breadth:
New Wall Drawings by Mike Glier
25 January–4 March 1984

In his wall drawings, freestanding images, and banners Glier presented contemporary conflicts and disasters, revealing his concern with social and political issues and expressing his philosophy that we are "as close to positive resolution as we are to seeing an end to everything." Glier believes that artists should try to provide answers to contemporary social problems, and in this exhibition he painted two walls: one representing "complaints" and the other, the artist's "solutions." In another work, *A Crying Man,* he portrayed a fallen wrestler in a position of vulnerability and public humiliation. Curated by Hugh M. Davies and Burnett Miller.

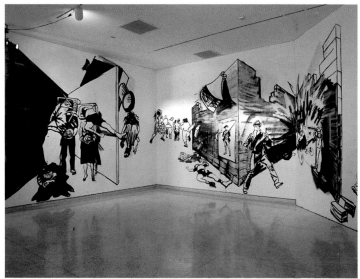

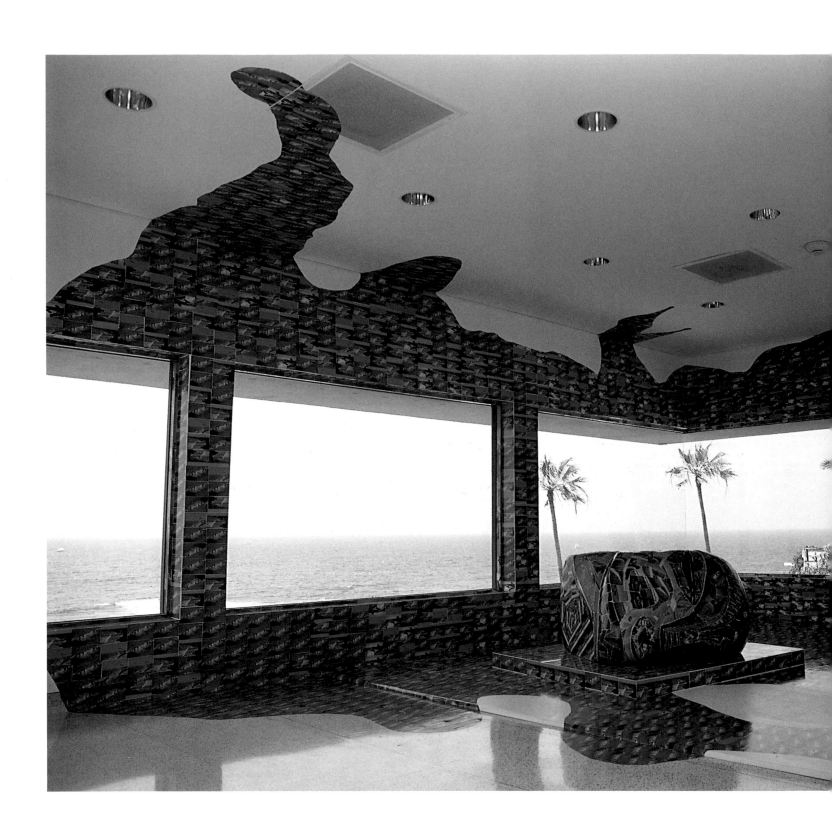

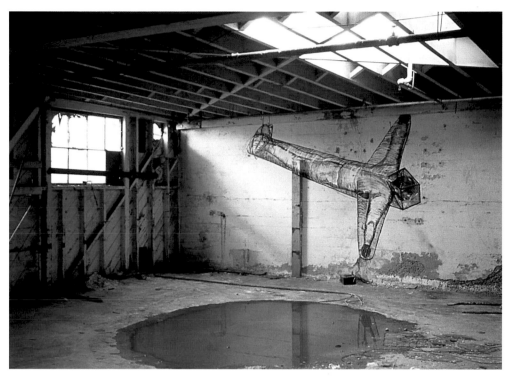

Georges Rousse, *Untitled*, 1984

Daniel Tremblay, *The Lost Wave*, 1984

French Spirit Today
16 June–3 August 1984

This group exhibition featured French artists working in various media. Four of the artists created site-specific installations. Georges Rousse used an abandoned dry cleaning plant in the village of La Jolla, which was subsequently demolished, as the site for his work, painting directly on the plant's floors and walls. Rousse transformed a pool of water inside the building, the result of a leaky roof, into a lake by adding blue pigment. Large-format color photographs documenting the installations were then exhibited at MCA. Daniel Tremblay transformed the Museum's ocean-view gallery with thousands of postcard views of La Jolla's beaches, which the artist affixed on the walls and floor around the gallery windows. Installed in rhythmic patterns, the overall form of the post-

cards was read as a giant wave crashing through the panoramic windows. François Boisrond and Hervé Di Rosa collaborated on a wall mural in the Museum, each bringing to the work his own distinct style and narrative. Images drawn from cartoons, science fiction, television, music, and the artists' personal repertoires of characters and imaginary landscapes were combined, creating a collage that was a collision of sensibilities and ideas. Ninety-two page catalogue. Co-curated by Lynda Forsha (MCA), Jean-Louis Froment (Centre d'arts plastiques contemporaines, Bordeaux, France), and Selma Holo (Fisher Art Gallery, University of Southern California, Los Angeles).

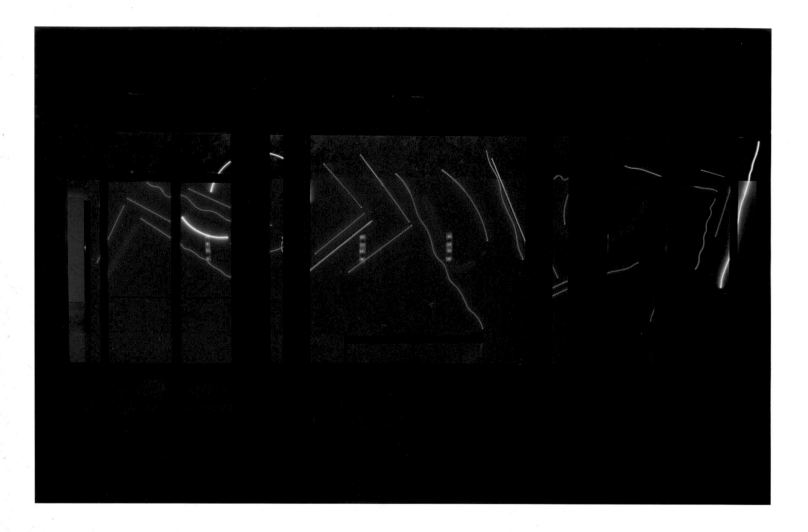

Stephen Antonakos:
Neons and Works on Paper
18 August–7 October 1984

Antonakos's works on paper since 1964 were surveyed
in this exhibition, which also included several major neon
installations created specifically for MCA. The evolution
of Antonakos's understanding of neon light can be traced
in his works on paper, especially studies for his neons from
1964 to 1974. Works on paper dating from 1974 to 1984
that were featured in the exhibition included collages and
"cuts" as well as pencil and colored pencil drawings. While
closely linked to his neons, these pieces were conceived as
entirely independent artworks. As part of the exhibition,
Antonakos created *Incomplete Neon Square for La Jolla,* a
permanent outdoor work that is installed on the southeast
side of the Museum building. Forty-eight page catalogue.
Curated by Hugh M. Davies.

The Video Porch: Rob Wellington Quigley
Completed December 1984

The Video Porch was the first project MCA commissioned for the *Parameters* series and was designed as a permanent space for viewers to watch educational videos and videos produced by artists. San Diego architect Rob Wellington Quigley was asked to design the project. He transformed a previously unused area of the Museum through the addition of soft illumination, rubberized floors, and comfortable Eero Saarinen–designed "womb" chairs. Quigley also draped scrims over sections of walls that had been partially removed to reveal materials from the original structure, the home of Ellen Browning Scripps, designed in 1916 by Irving Gill and converted in 1941 into an art museum. Brochure. *Parameters 1.* Curated by Hugh M. Davies.

Maria Nordman:
Trabajos en la Ciudad
12 February–17 March 1985

Responding to the particular environment of the Museum's oceanfront site, Nordman created *De Ondas,* a site-specific installation through which she altered viewers' sensory and spatial perceptions. A finely crafted wood-and-canvas structure was attached to an open doorway facing the sea that led from the Museum's Farris Gallery to a stairway to the street. Drawn to the natural light pouring through the wooden passageway, viewers passed from inside to outside, where they encountered colorful benches made by the artist attached to the walls surrounding the staircase. Nordman created conditions for the viewer to interact with the individual components and to explore the effects of changing light within an environment. Twenty page catalogue. *Parameters 2.* Curated by Ronald J. Onorato.

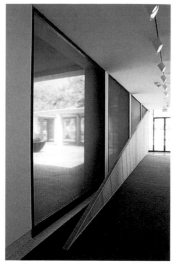

Mario Lara, *LJMCA Project*, 1985

Frank D. Cole, *Tower of Power*, 1985

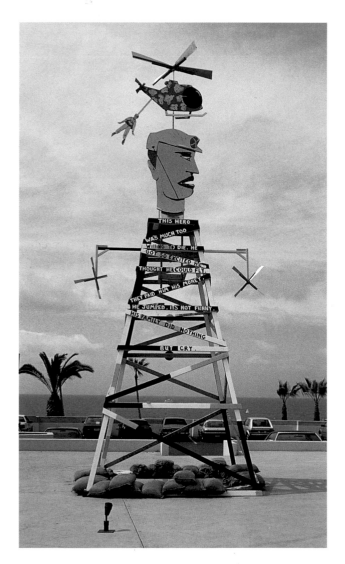

A San Diego Exhibition: Forty-Two Emerging Artists
23 March–28 April 1985

This regional survey featured works by San Diego artists and included five installations created specifically for the exhibition. Frank D. Cole located his work outdoors on the Museum terrace, where the ocean view provided a backdrop for *Tower of Power.* Louis Hock's installation involved switching the signage on the public restrooms, thereby forcing women and men to use each other's gender-specific facility (urinals, more or fewer stalls, full-length mirrors, etc.) for the duration of the exhibition. Images of nude buttocks were projected onto the alcove wall between the restrooms and onto individuals as they entered and exited. For his architectural installation, Mario Lara constructed a diagonal wall cloaked in colored trans-lucent fabric in a hallway with windows opening on the Museum's entry courtyard; the changing light of day and the viewer's movement through the hallway completed the work. Roy McMakin and James Skalman each produced installations that borrowed from historical and vernacular architectural styles. McMakin filled a gallery overlooking the ocean with tables, chairs, and cabinets he designed based on the visual forms, materials, and techniques of furnishings from the early twentieth century. Simple shapes—ovals, rectangles, and triangles—that appeared on the furniture were repeated on the windows and walls, carrying on a visual dialogue of their own. James Skal-man's painterly installation drew inspiration from tract housing and archetypal 1950s-style backyard barricades. Thirty-six page catalogue. Curated by Hugh M. Davies, Lynda Forsha, and Burnett Miller.

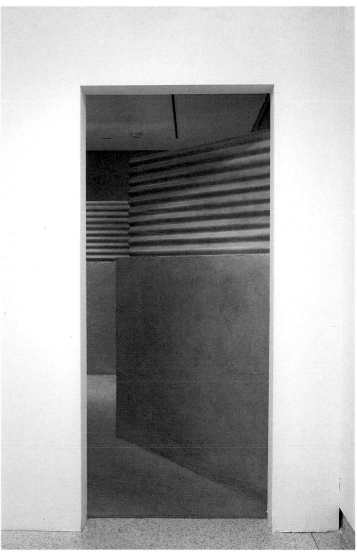

James Skalman, *Untitled,* 1984

Roy McMakin, *Informal Dining Room Set,* 1985

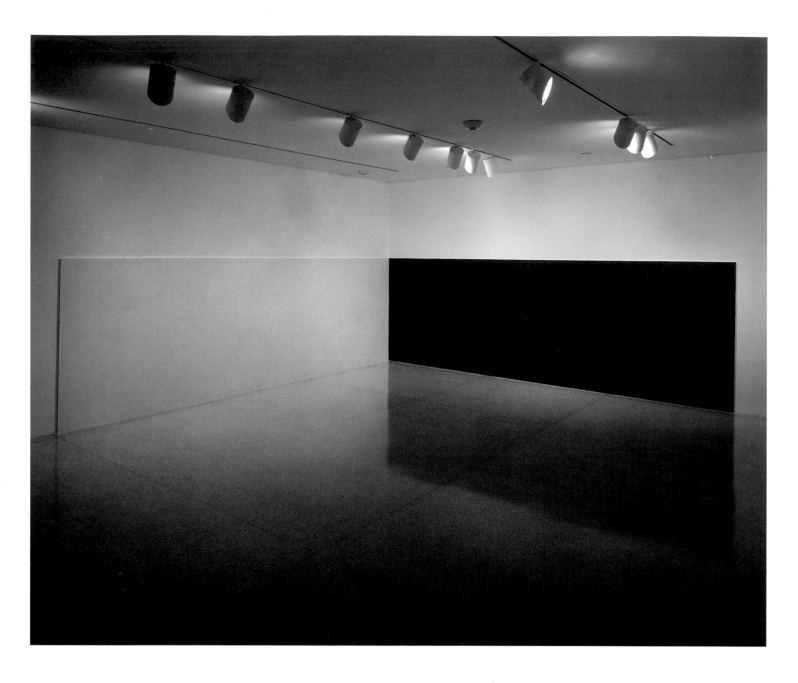

Peter Lodato: La Mer
24 August–6 October 1985

Lodato's installation, *La Mer,* was augmented by an exhibition of his recent paintings and drawings. In *La Mer,* two rectangular planes made of plaster—one white and one purple—were installed against two walls to form a juncture in the corner of a windowless gallery. Gold leaf applied to the top edge of the work reflected light against the wall, illuminating the space above the piece. By giving the work a French title—"the sea"—and by playing with light and spatial perception, the artist effectively suggests the view of the Pacific Ocean seen outside the Museum. Poster and brochure. *Parameters 4.* Curated by Lynda Forsha.

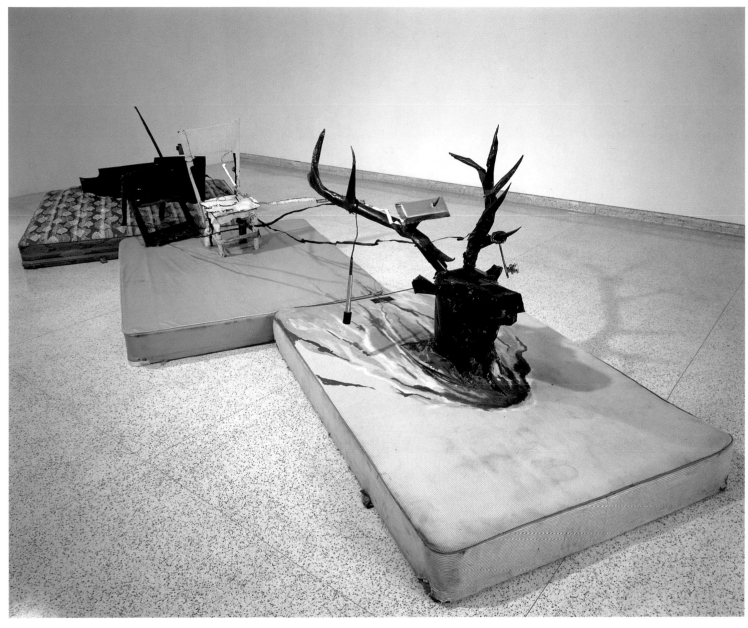

Still Waters, 1985

Natural Produce, An Armed Response: Sculpture by Bill Woodrow

12 October–1 December 1985

In August 1985, British artist Bill Woodrow was artist-in-residence at MCA, during which time he created the works in this exhibition. In these pieces Woodrow transformed found objects into poetic tableaux filled with visual puns, in which he linked personal imagery and symbolism with his responses to a new city and culture. These still lifes—critical of the contemporary social, moral, and political climate—provided viewers with a powerful message about cultural confrontation. Twenty page catalogue. *Parameters 5.* Curated by Lynda Forsha.

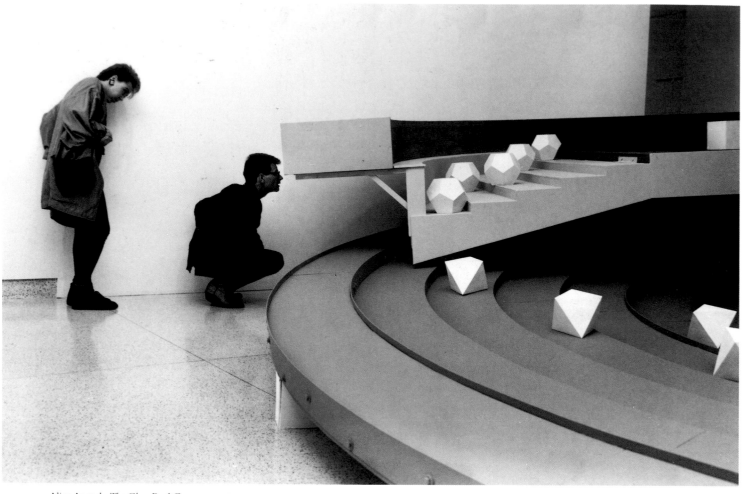

Alice Aycock, *The Glass Bead Game: Circling 'Round the Ka'ba*, 1986

Sitings: Alice Aycock, Richard Fleischner, Mary Miss, George Trakas
5 April–25 May 1986

Sitings brought together a parallel body of work by four artists in mid-career, each using a different approach in their large-scale, site-specific environmental sculpture. The traveling exhibition consisted of two parts: a selection of drawings by each artist that was exhibited at all venues, and a major project by one of the four artists commissioned specifically for each venue: Museum of Contemporary Art, San Diego (Alice Aycock); High Museum of Art, Atlanta (Richard Fleischner); Dallas Museum of Art (Mary Miss); Tel Aviv Museum, Israel (Alice Aycock); and Louisiana Museum of Modern Art, Denmark (George Trakas). In addition, MCA commissioned George Trakas to create the permanent site-specific work, *Pacific Union,* for its permanent collection. One-hundred-fifty-two page catalogue. Curated by Hugh M. Davies and Ronald J. Onorato.

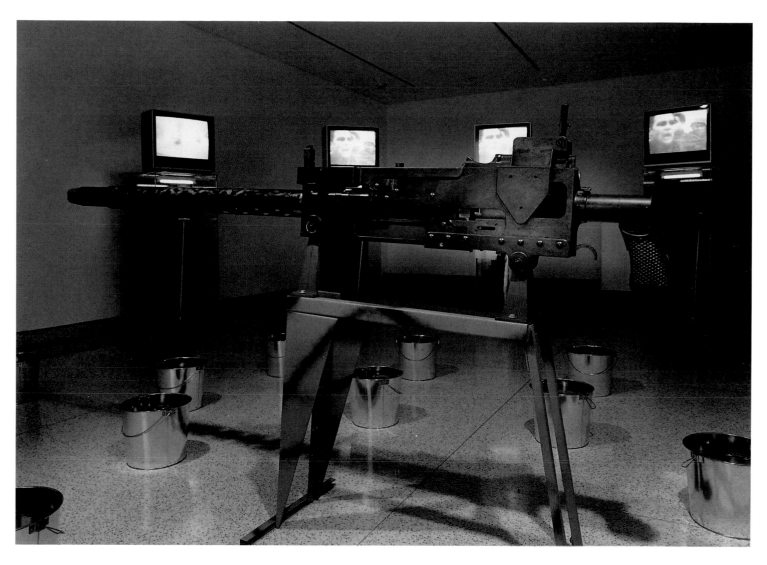

Francesc Torres:
The Dictatorship of Swiftness
31 May–3 August 1986

For this exhibition, Torres was commissioned to create *The Dictatorship of Swiftness,* a work in which he continued his investigation of the socio-political implications of violence and human aggression. The room-size installation was subsequently acquired by MCA for its permanent collection. The exhibition traveled to Long Beach Museum of Art and 80 Langton Street, San Francisco. Six page brochure. *Parameters 6.* Curated by Lynda Forsha and Ronald J. Onorato.

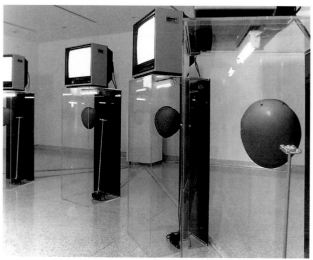

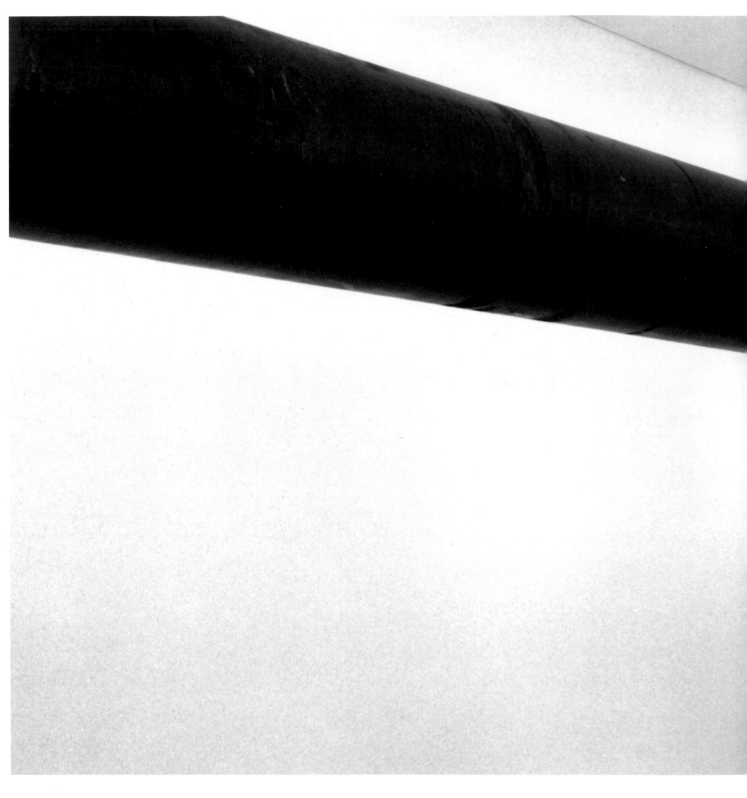

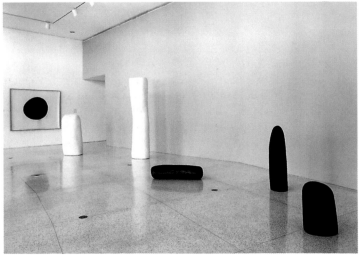

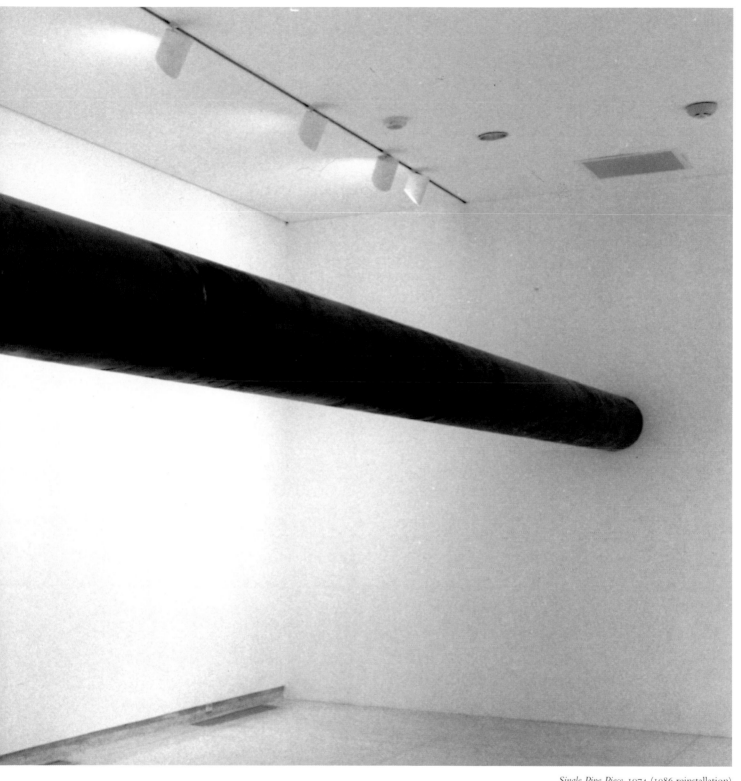

Single Pipe Piece, 1974 (1986 reinstallation)

Jene Highstein
13 December 1986–1 February 1987

Highstein is a leader of a generation of post-Minimalist sculptors focused on sculpture as a catalyst for transforming space. This was Highstein's first major museum exhibition and surveyed the artist's work from 1973 to 1986. The works featured included sculpture, drawings, and re-creations of two major installations in which the artist manipulated viewers' sense of space and scale. In *Mound (Turtle)* (1976), the artist applied black concrete to a wood-and-wire armature. *Single Pipe Piece* (1974) comprised a

very large seamless steel pipe (16 inches in diameter and 39 feet long) that was moved into the Museum building by crane and installed at a height of slightly less than six feet in the 18-by-39-foot gallery, making the form appear to have pierced the gallery space. The exhibition traveled to Rose Art Museum at Brandeis University, Waltham, Massachusetts. Forty-four page catalogue. Curated by Hugh M. Davies and Lynda Forsha.

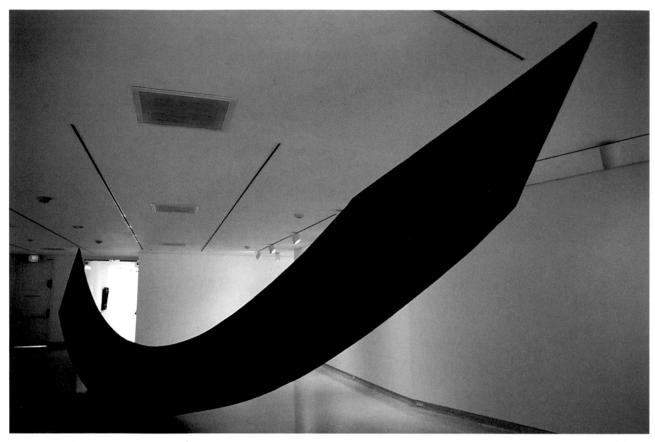

Untitled, 1987

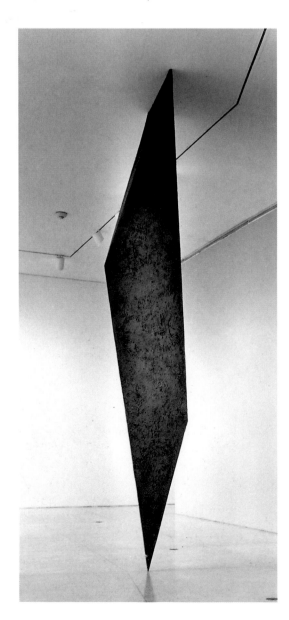

Mauro Staccioli

6 February–5 April 1987

This was Italian artist Mauro Staccioli's first show on the West Coast and second exhibition in the United States. MCA invited him to produce temporary works on the Museum's Prospect Street facade, in the front entry gallery, and on the oceanfront terrace. Because of its positioning on the terrace, Staccioli's *Untitled* (1987) appeared to expand beyond its physical limitations to aggressively penetrate the space around it. This work exemplifies the interdependent relationship between sculpture and the environment that Staccioli achieves in his work. This piece remained on view until the Museum expansion commenced in late 1994. The exhibition also included a number of the artist's preparatory drawings for these works. Poster/brochure. *Parameters 10.* Curated by Madeleine Grynsztejn.

Untitled, 1987

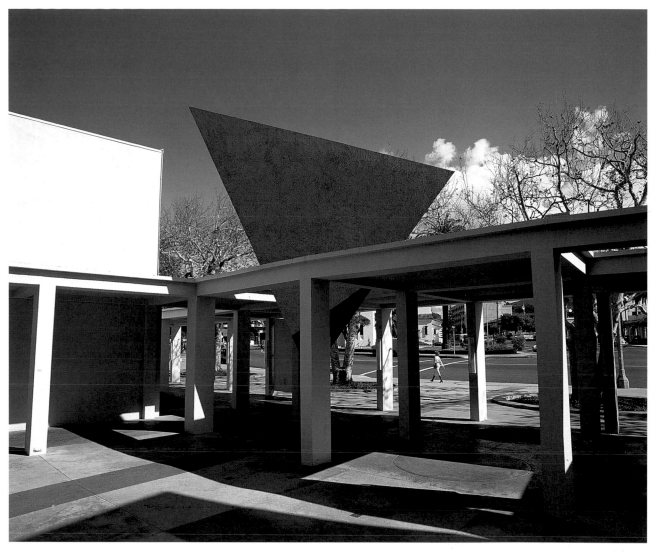

Untitled, 1987

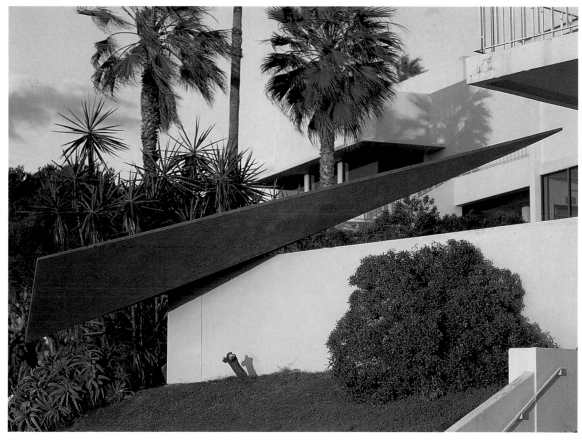

Untitled, 1987

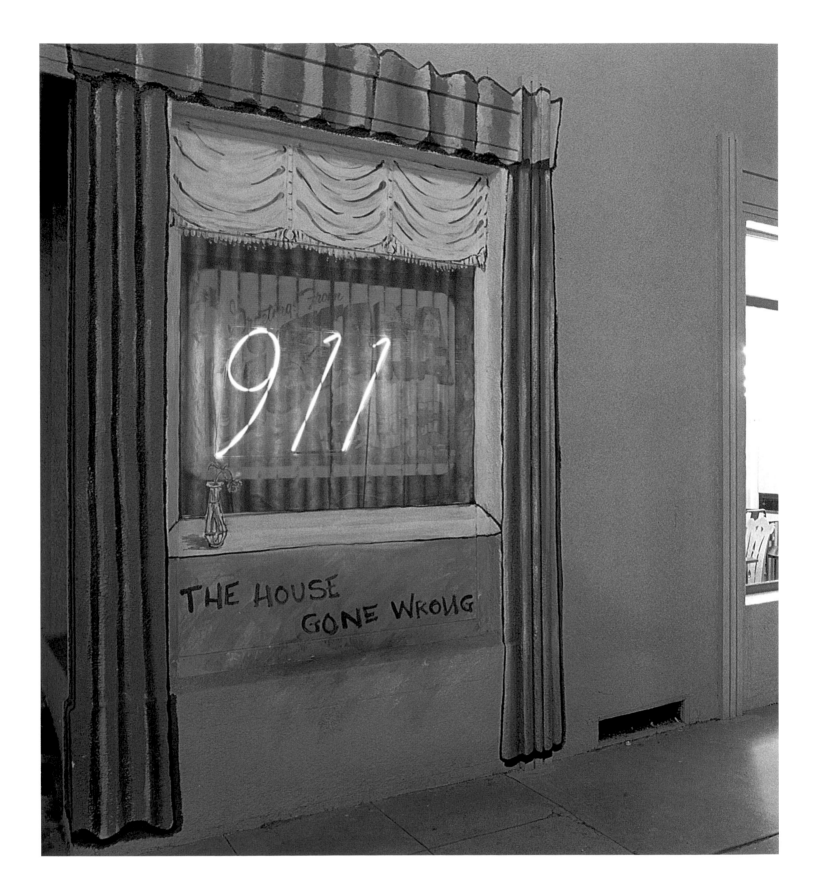

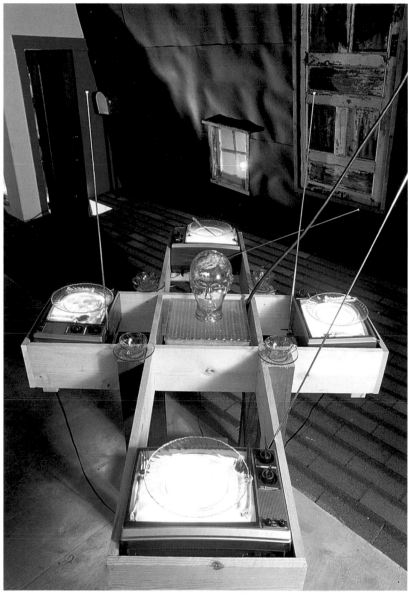

911: The House Gone Wrong
3 April–28 June 1987

This work at the Museum's first downtown "storefront" space was created by the Border Art Workshop/Taller de Arte Fronterizo, an artists' collective in San Diego and Tijuana. Member artists at the time included David Avalos, Sarah Jo Berman, Victor Ochoa, Guillermo Gómez Peña, and Michael Schnorr. Robert Sanchez also assisted with the installation. The installation comprised several rooms in which the artists depicted unsettling domestic scenes. Overtones of United States–Mexico border politics permeated the piece. Elements of the work included cardboard rooms, grassy walls, and a cross-shaped table set with skeletal utensils and transparent plates, which were lit from underneath by the glow of television footage shown on video monitors inset into the hollow table. In conjunction with the exhibition, MCA presented two related performances: one by Sarah Jo Berman, the other a collaboration between Emily Hicks, Victor Ochoa, and Guillermo Gómez Peña. *Parameters 8.* Curated by Ronald J. Onorato.

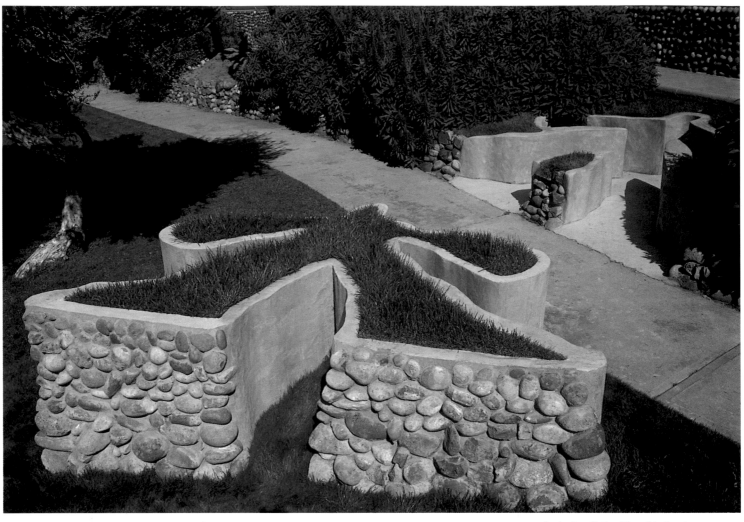

Garden Installation (Grass Man), 1987

Vito Acconci: Domestic Trappings
5 June–2 August 1987

Domestic Trappings was the first exhibition to critically analyze major themes in Acconci's work over two decades: architecture, home, and domestic relationships. The exhibition included a number of installations. In conjunction with the exhibition, Acconci was commissioned to produce an outdoor site-specific work in the Museum's oceanfront garden that remained on view until the Museum expansion commenced in late 1994. The exhibition also included documentation of Acconci's performances, audio works, videotapes, and recent participatory environments. The show traveled to Neuberger Museum, State University of New York at Purchase; Aspen Art Museum, Colorado; and Laumeier Sculpture Park, St. Louis. Ninety-two page catalogue. Curated by Ronald J. Onorato.

Ladder Lounge Chairs, 1985

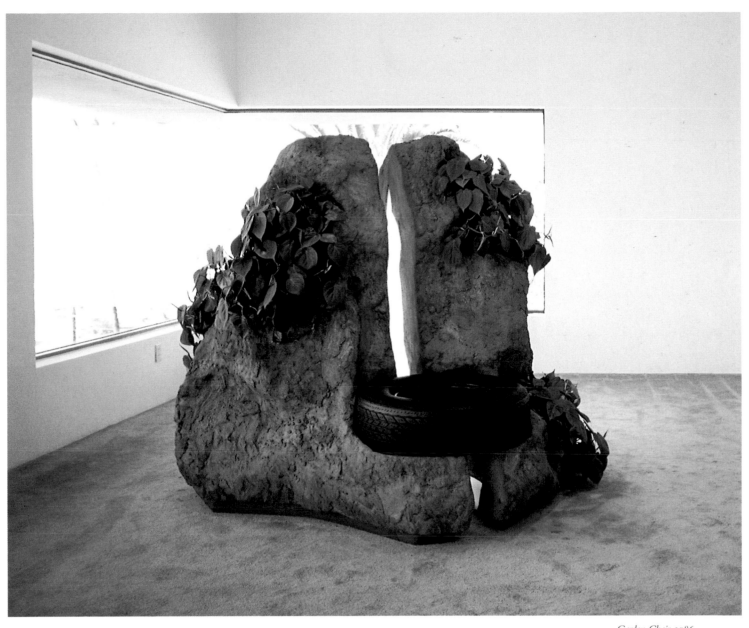

Garden Chair, 1986

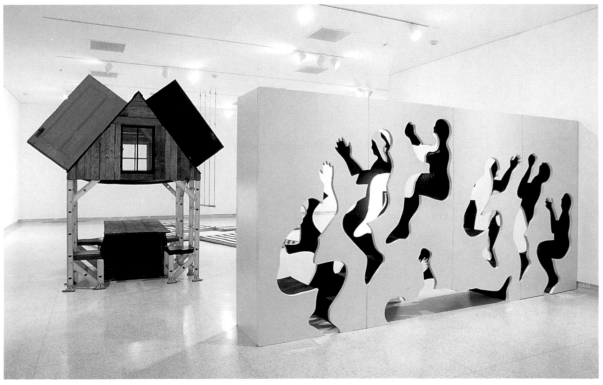

Making Shelter (House of Used Parts), 1985 and *People's Wall,* 1985

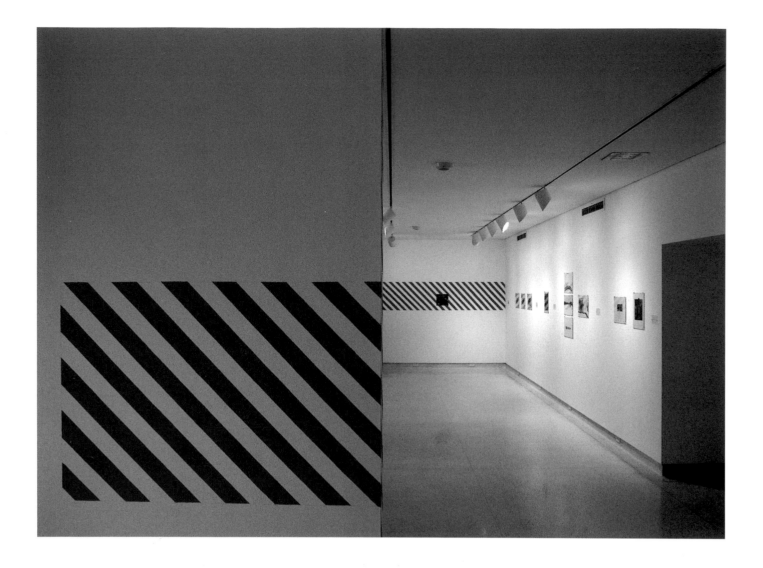

Thomas Lawson
2 October–15 November 1987

This exhibition included works painted directly on the gallery walls and previously painted stretched canvases. These works addressed how recent art has used representation in distinct ways, especially as a reflection on the visual realm. Lawson's installation drew from the mass media, advertising, roadside signage, maps, and other real-life imagery. Curated by Ronald J. Onorato.

James Skalman: "Containment"
6 December 1987–7 February 1988

This San Diego–based artist took the raw space of the Museum's second downtown "storefront" gallery at 838 G Street and transformed it into an environmental artwork by using vernacular architectural forms and materials, and sound to subtly inflect the viewer's experience. Following the presentation of *"Containment,"* Skalman's adaptations of the space were left in place, and the downtown gallery continued to be used for subsequent exhibitions. *Parameters 13.* Curated by Lynda Forsha and Ronald J. Onorato.

Krzysztof Wodiczko
28 January–13 March 1988

In this exhibition, transparencies taken by photographer Philipp Scholz Rittermann to document *The Border Project: San Diego/Tijuana* were displayed in light boxes, along with documentation of other past Wodiczko projects. In *The Border Project* Wodiczko used xenon arc slide projectors to project enormous images onto the facades of two public buildings. The underlying themes were undocumented Mexican workers in the region and their illegal passage across the United States–Mexico border. The projections occurred on two consecutive evenings: January 29 at the San Diego Museum of Man in Balboa Park, San Diego, and January 30 at the Space Theater of the Centro Cultural Tijuana, Mexico. Poster and brochure. *Parameters 14*. Curated by Madeleine Grynsztejn.

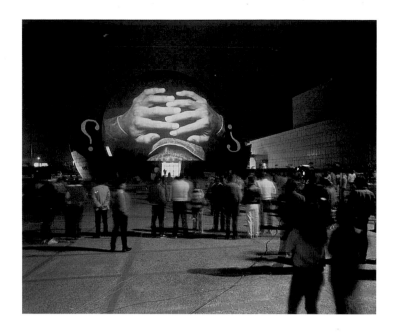

James Skalman, *"Containment,"* 1987

Untitled, 1988

Douglas Huebler

27 May–7 August 1988

Huebler is considered one of the founders of Conceptualism. Since the late 1960s, he has explored issues of artistic originality, the power of reproductions, and the use of visual art as a language. Among the works featured in this exhibition were two wall installations Huebler created specifically for MCA. In *Untitled* (1988), he combined text and graphics in a striped motif spanning forty-two feet in the entrance area of the Museum. The second MCA

installation, *Secrets,* was a participatory piece, in which the artist invited viewers to write a personal secret on a piece of paper and place it anonymously in a designated container on the wall. After placing one's secret in the container, the viewer was invited to take someone else's secret by choosing one of the anonymous slips. Fifty-two page catalogue. *Parameters 16.* Curated by Ronald J. Onorato.

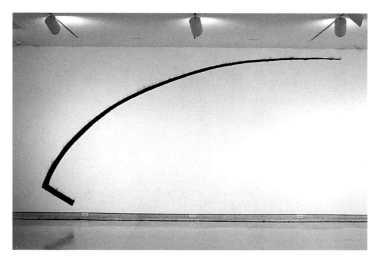

Phoenix Drawing, from the *Sycamore Canyon* series, 1988

Eric Snell

19 August–2 October 1988

During his week in residence at MCA, British artist Eric Snell gathered local wood and brush that he used to make three large-scale installations and several smaller works. For each piece, he burned the wood with a torch and then used the charred stick as his drawing tool. He also produced a series of works made from magnets and compasses. In one work, he placed small compasses in a circle on the floor. Because the compasses touched each other, their magnetic forces were disturbed, which created another linear circle formed by the aligned needles. Snell's works, though constructed from a highly restricted range of materials, display surprising ingenuity and suggest poetic transformations that eloquently connect art to nature. *Parameters 17.* Curated by Lynda Forsha.

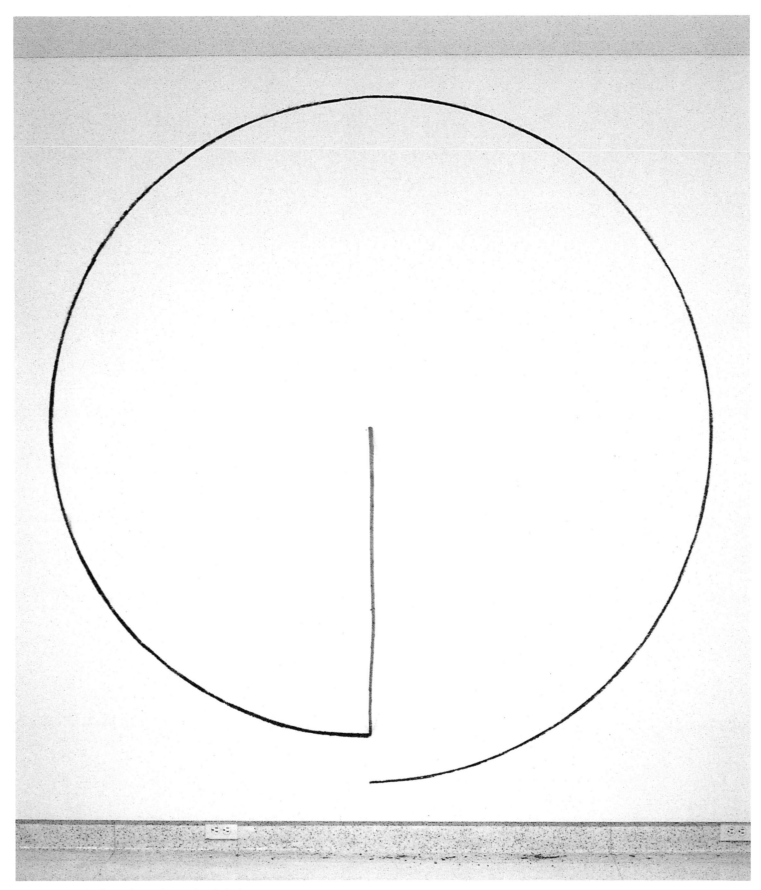

Eric Snell, *Spiral*, 1985 (1988 reinstallation)

David Antin: SKY POEM 2
3 September 1988

In a performance/literary event intended to extend over time, poet and performance artist David Antin created SKY POEM. The first stanza of the work had appeared in 1987 in the sky over Santa Monica. In La Jolla, a team of aerial skywriters reproduced the second stanza in the clear blue noontime sky over the beach and the Museum of Contemporary Art. The smoke of the planes spelled out the poem, with intentional breaks. Curated by Madeleine Grynsztejn.

> IF WE MAKE IT TOGETHER OR
> FIND IT WILL THEY BREAK IN
> OR OUT OF IT OR LEAVE IT
> AS THEY FIND IT STRICTLY ALONE

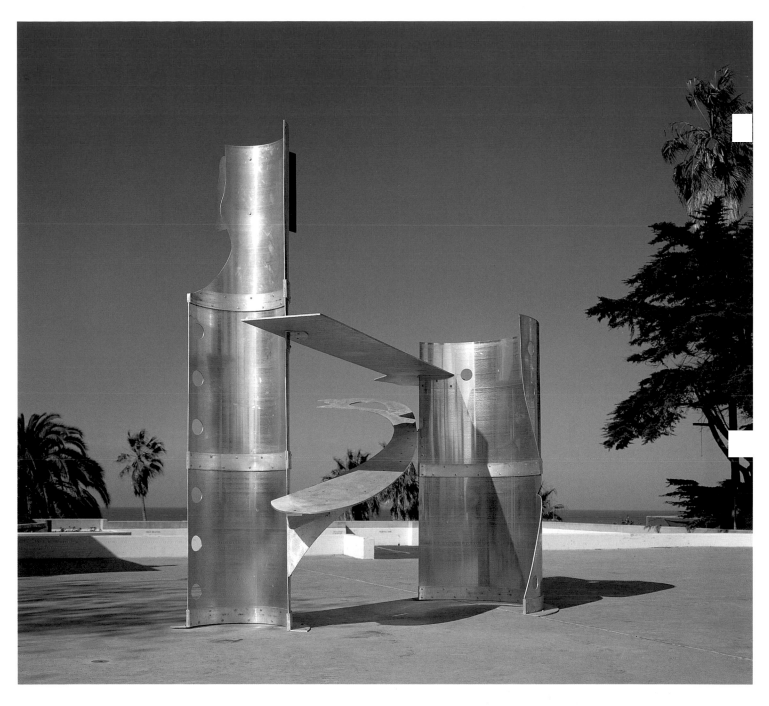

Mac Adams: The Fountainhead
2 December 1988–29 January 1989

Adams initially gained recognition for his narrative photography and mixed-media installations, several of which were on view in this exhibition at MCA. Adams also created a new aluminum outdoor sculpture, *The Fountainhead,* in which the artist offered wry commentary on the disjunctive relationship that exists between the abstract object and its expressive image. Created for the public plaza to the north of the Museum's entrance, *The Fountainhead* first appeared to be just an abstract sculpture. Adams had bolted together the extruded and rolled pieces of aluminum in such a way, however, that when the sculpture precisely eclipsed the sun, its shadow formed the silhouette of a man in profile, liquid spewing from his mouth. Twelve page catalogue. *Parameters 18.* Curated by Lynda Forsha.

Camera Obscura, 1989

Complementary Pairs, 1987 (1989 reinstallation)

Vernon Fisher

3 February–2 April 1989

Fisher's witty and keenly literal fusion of language and imagery in paintings that function as visual stories brought this Texas artist's work to the forefront of contemporary narrative art in the mid-1970s. MCA's survey of Fisher's work at mid-career included drawings, paintings, photography, sculpture, text, and found objects that the artist often combined as multipaneled assemblages, sections of which were painted directly on the wall. He re-created two previous installations for this exhibition. A third room-size installation was commissioned specifically for the La Jolla location: through the use of a diopter lens inserted into a blacked-out window, Fisher transformed the Museum's ocean-view gallery into a large-scale camera obscura. The external seascape of sunlight, crashing waves, and seagulls was displayed in the darkened room as an inverted image. The exhibition traveled to Albright-Knox Art Gallery, Buffalo; Contemporary Arts Museum, Houston; Center for the Fine Arts, Miami; and Modern Art Museum of Fort Worth, Texas. Ninety-six page catalogue. Curated by Hugh M. Davies and Madeleine Grynsztejn.

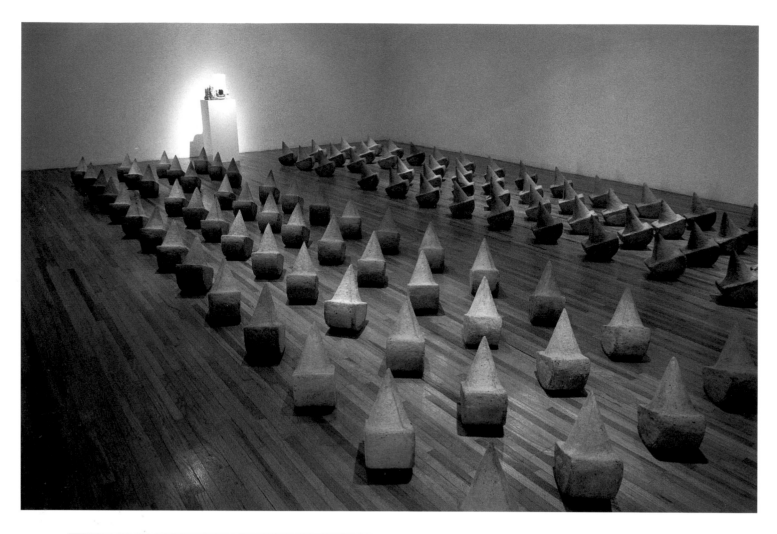

Barbara Westermann:
Westwall/Crossing the Siegfried Line
22 April–9 July 1989

This installation by German sculptor Barbara Westermann was originally created for MCA's downtown space at 838 G Street. A different configuration of the installation was later moved to the garden in La Jolla, where it remained on view through 1993. *Westwall* derived its name from a series of cone-shaped ramparts erected by the Germans during World War II to defend the western edges of the projected Nazi empire. Two hundred similarly cone-shaped cement blocks symbolically re-created the threatening, but in the end innocuous barrier that was rendered meaningless after the Nazi defeat. Curated by Madeleine Grynsztejn.

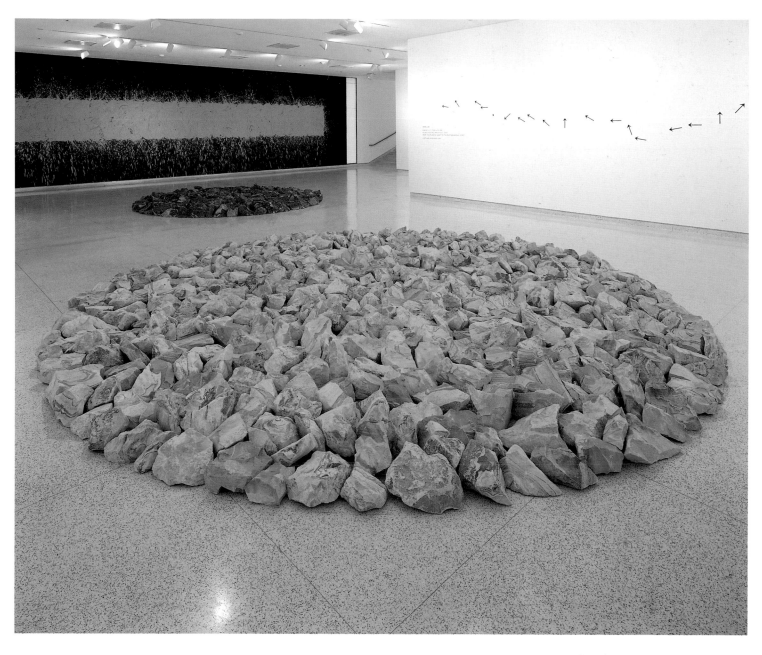

Richard Long: Surf Roar
19 August–15 October 1989

During his two-week residency in La Jolla, Richard Long, a prominent British conceptual artist, created the installation works featured in this exhibition. The artist made two circular floor sculptures of stone—one composed of Baja La Cresta granite, the other of a lighter-colored Utah sandstone—and two large-scale wall drawings using mud made from natural material collected locally. The exhibition also included two wall texts that incorporated text and diagrams in which Long described walks he had taken. Twenty-four page catalogue. Curated by Hugh M. Davies.

Alfredo Jaar, *The Fire Next Time,* 1989

Alfredo Jaar

14 January–1 April 1990

Chilean-born, New York–based artist Alfredo Jaar often uses photographic transparencies set in large-scale light boxes, which function as vehicles for photographic display, as sculptural elements, and as an architectural unit. The centerpiece of this traveling exhibition was Jaar's monumental installation, *Gold in the Morning,* later acquired by MCA. The subject matter of this work—photographs of Brazil's Serra Pelada mine—related to conditions of power and powerlessness, particularly in the developing world. Jaar also investigated the impulses behind political imagery, and deconstructed conditions for viewing and understanding these representations. The exhibition traveled to San Jose Museum of Art; Seattle Art Museum; Carnegie Mellon Art Gallery, Pittsburgh; Laumeier Sculpture Park, St. Louis; and The New Museum of Contemporary Art, New York. Ninety-six page catalogue. *Parameters 19.* Curated by Madeleine Grynsztejn.

AVA 8: Awards in the Visual Arts

19 August–15 October 1989

This touring exhibition featured the work of ten artists from across the United States who were recipients of awards from the eighth annual Awards in the Visual Arts competition, administered by the Southeastern Center for Contemporary Art in Winston-Salem, North Carolina. Two installations were included in AVA 8. Patrick Dougherty created a site-specific installation in MCA's entry courtyard using locally collected oleander and eucalyptus branches that he wove through the entrance colonnade. The whirlwind of branches twisted around a tree and spanned the courtyard to the roof. Paul Kos's installation *Guadalupe Bell* was later acquired for MCA's permanent collection. One-hundred-ten page catalogue. Coordinating curator, MCA, Lynda Forsha.

OPPOSITE: Patrick Dougherty, *Triage,* 1989

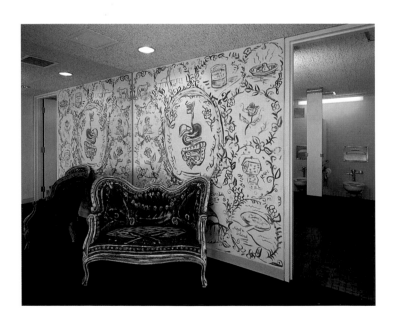

Jean Lowe: Ladies' Room
July 1990–late 1994

MCA commissioned Lowe to make a semipermanent installation for one of the Museum's public restrooms. In the resulting work, *Ladies' Room,* Lowe offered a satirical reprise of the cycle of human consumption and waste. A rococo-inspired settee and an ornate mural filled the bathroom's entry lounge. Camouflaged within the decoration of the hand-painted sofa were images of whole hams, crown roasts, and sausage links, and the painted "wallpaper" mural traced cycles of food production and consumption: from farm to table, and, ultimately, to the sewer. Lowe's work remained on view until the Museum's expansion commenced in late 1994. Curated by Lynda Forsha.

Seeblick, 1981–85

Markus Raetz
6 April–3 June 1990

MCA presented the first exhibition on the West Coast of the work of Swiss artist Markus Raetz. The exhibition included notebooks, drawings, watercolors, and sculptures made of stone, metal, and wood, as well as installations that engaged viewers in an exploration of perceptual experience. A number of Raetz's installations consisted of natural materials displayed in simple configurations reflected in small mirrors positioned nearby. In the reflected images the abstract configurations were transformed into perceptible figures. Organized by the Museum für Gegenwartskunst, Basel, Switzerland. Coordinating curator, MCA, Lynda Forsha.

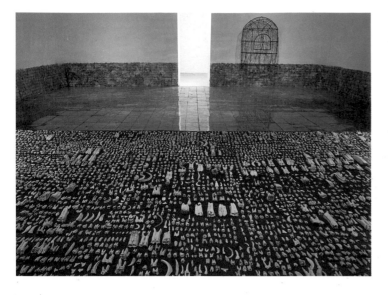

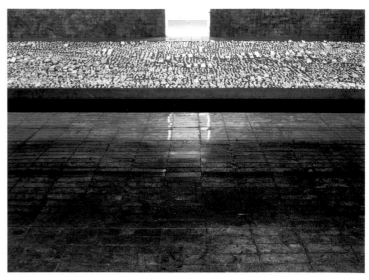

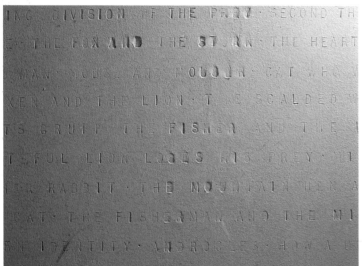

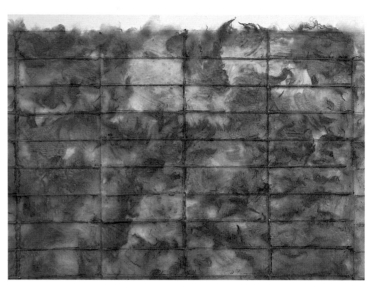

Ann Hamilton:
between taxonomy and communion
6 April–3 June 1990

Hamilton's installations are characterized by a powerful aesthetic sensibility and labor-intensive use of ordinary materials in unexpected ways and daunting quantities. In her work, Hamilton investigates life forces—living and dead, real and unreal—provoking a sense of mystery and near-religious overtones through the use of complex symbolism, ritual, and physical changes in natural materials. This exhibition consisted of one work, *between taxonomy and communion,* that encompassed an entire gallery. The wall by the entrance to the room was incised with the names of animal fables, and the floor was covered with raw sheep fleece with glass panels laid on top. A collection of sixteen thousand animal and human teeth laid in rows on top of a steel table on one side of the room dripped red liquid (iron oxide) onto the floor beneath. An empty birdcage was positioned in the corner of the room. Eighty page catalogue. *Parameters 20.* Curated by Hugh M. Davies and Lynda Forsha.

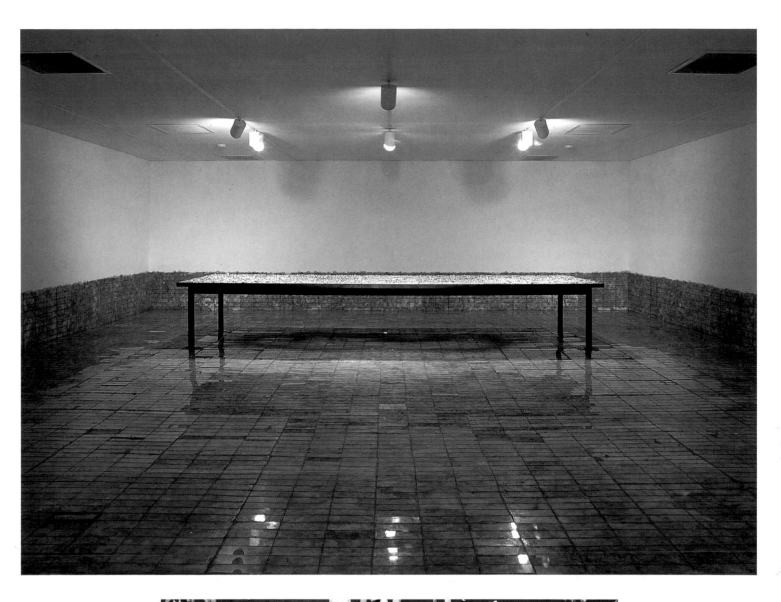

Jean Lowe, *Master Bedroom,*
1989–90

Mags Harries, *Border Garden,* 1990

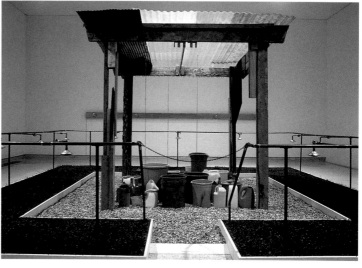

Deborah Small, *Empire-Élan-Ecstasy,* 1990

Satellite Intelligence:
New Art from Boston and San Diego
9 June–5 August 1990

New works by artists from Boston and San Diego were
selected in a curatorial process that combined unbiased
openness with local expertise. Six artists from each city
were shown together, first at MCA La Jolla, then at
the List Visual Arts Center at the Massachusetts Institute
of Technology in Cambridge. The Boston artists were
selected by MCA's director and curatorial staff; the San
Diego artists were selected by the List Center's director
and curator. San Diego artists who created installations
were Jean Lowe, Elizabeth Sisco, and Deborah Small
(other San Diego artists in the exhibition were Steve Ilott,
Richard A. Lou, and Anne E. Mudge). The Boston-based
installation artists were Abram Ross Faber and Mags
Harries (other Boston artists were Gerry Bergstein, John
Devaney, Timothy Hawkesworth, and Cameron Shaw).
Thirty-six page catalogue. Curated by Hugh M. Davies,
Lynda Forsha, Madeleine Grynsztejn, and Sarah E.
Bremser (MCA); and Katy Kline and Dana Friis-Hansen
(List Visual Arts Center).

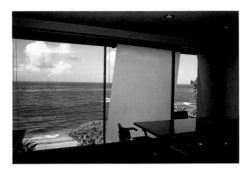
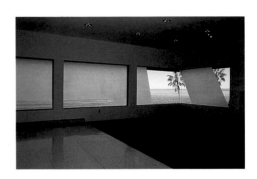

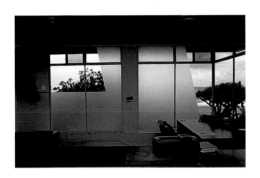

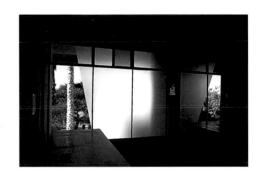

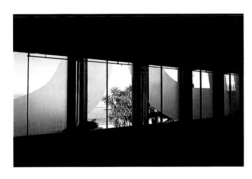
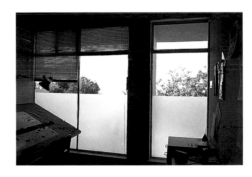

John Knight: Bienvenido
27 October 1990–2 January 1991

In the commissioned site-specific installation, *Bienvenido,*
Knight transformed the Museum's ocean-view windows
—normally transparent planes—into the primary carriers
of his artwork. Knight chose the Spanish word meaning
"welcome" to surround the building on two of its four
sides. The word was written in giant block letters reading
left to right from the exterior, beginning at the northeast
corner. The partial revelation of the letters visible through
the windows when looking from the inside out resulted
in surprising and variegated patterns on the windows,
eradicating one of the Museum's greatest assets, its ocean
views looking westward, while issuing the Spanish word
of welcome, legible only from the outside looking in.
Parameters 21. Curated by Madeleine Grynsztejn.

Alexis Smith, *Nosotros,* 1991

Gerardo Navarro, *500 Years Later, at the Edge of the Western World,* 1991

Daniel J. Martinez, *Guerra de Culturas,* 1991

Alfredo Jaar, *Untitled,* 1990

Billboard Project: Alfredo Jaar, Daniel J. Martinez, Alexis Smith, Gerardo Navarro

February–March 1990, February 1991, April–May 1991, June–July 1991

This exhibition comprised a series of four commissioned billboards located at various public sites along roads in San Diego. Los Angeles–based artist Daniel J. Martinez created *Guerra de Culturas,* an image combining a U.S. dollar bill and a Mexican peso, referring to the economic and physical connections between the two countries. Alexis Smith created a collage of visual images and text that used prototypical California fruit-crate labels and romantic Mexican folk ballads as inspiration to create a work dealing with themes of parting and separation. Gerardo Navarro, then

living in San Diego and Tijuana, created a billboard titled *500 Years Later, at the Edge of the Western World.* This colorful and complex image addressed the ironies of the convergence of modern technology with the values of ancient Mexican cultures, and the increasing influence of the Pacific Rim in the border region. Alfredo Jaar's *Untitled* documents Brazilian miners at a labor rally. The project was part of *Dos Ciudades/Two Cities,* the Museum's four-year-long special artistic initiative. Curated by Madeleine Grynsztejn and Sarah E. Bremser.

137

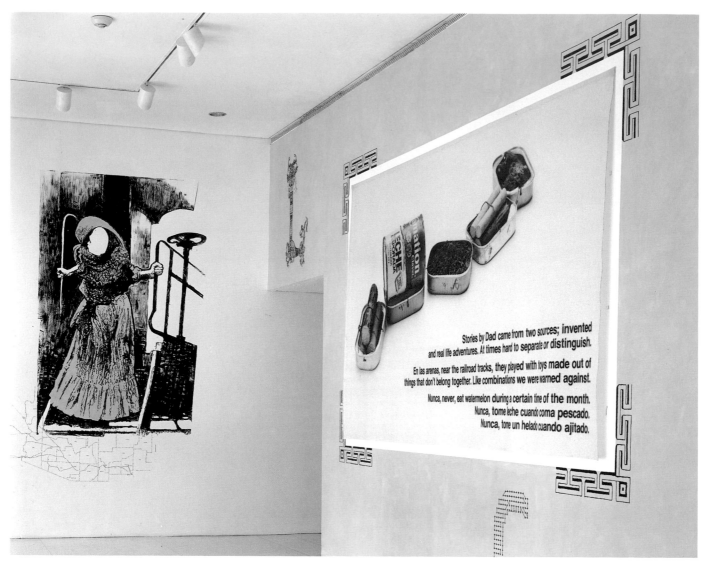

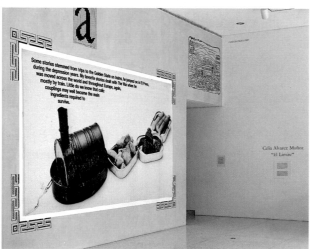

Celia Alvarez Muñoz: El Límite
16 February–2 June 1991

The work of Texas-born artist Celia Alvarez Muñoz is characterized by a witty, wry combination of photographs, painting, assemblage, and tender narratives often derived from her family's oral history. For this exhibition, Muñoz used stories told by her father as inspiration for a new installation, *El Límite.* Based on the *límite de carga* (maximum cargo load) metaphor, the work refers to the cargo train compartments by which Muñoz's father traveled from El Paso to Southern California in search of employment during the Great Depression. Other works in the exhibition demonstrated Muñoz's ties to the oral storytelling tradition of the Mexican-American Southwest, in particular her family's chronicles, which the artist reinvented based on childhood memories filtered through adult melancholy. *Lana Sube,* one portion of the installation *Lana Sube/Lana Baja,* was later acquired for MCA's collection. The project was part of *Dos Ciudades/Two Cities. El Límite* traveled to the Center for the Fine Arts, Miami. Curated by Madeleine Grynsztejn.

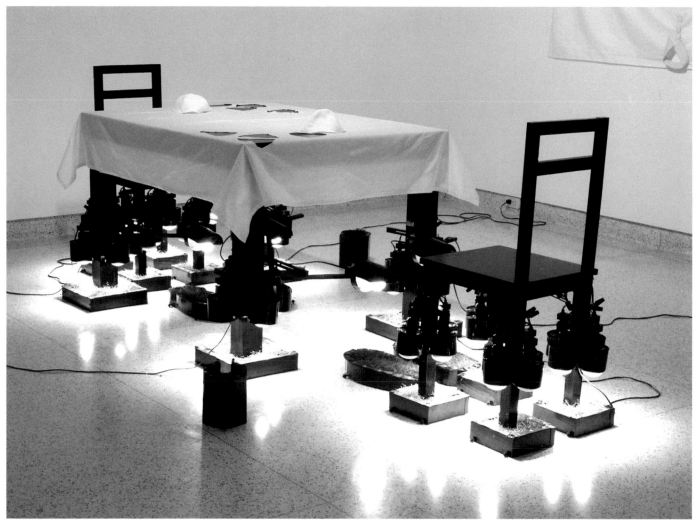

Indoor Sukkah, 1991

Allan Wexler

16 February–2 June 1991

The New York–based artist Allan Wexler examines the domestic habits of society and reinterprets, in unfamiliar ways, ordinary actions such as sitting and eating. The exhibition included two of the artist's room-size installations, *Recycle-Conference Room* and *The Restaurant,* as well as a number of preparatory drawings, models, and experimental installations Wexler referred to as "science pieces," which consisted of ordinary household objects and broken furniture that he reinterpreted through alterations and restoration. *Parameters 23.* Curated by Lynda Forsha.

Coffee Seeks Its Own Level, 1990

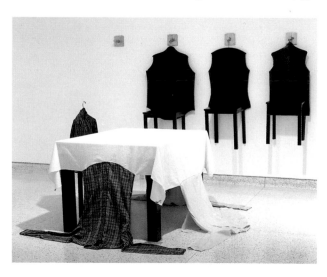

Four Shirts Sewn into a Tablecloth, 1991

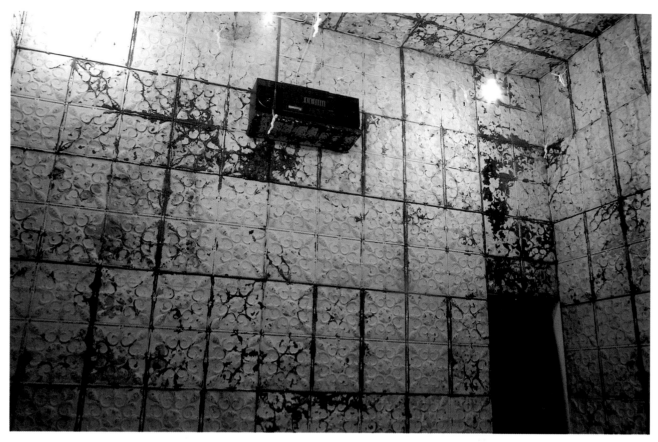

Jesus is the Light, 1990

At the opening, Hammons "choreographed" an improvisational
basketball game and musical performance

David Hammons: Rousing the Rubble

17 August–10 November 1991

Hammons's sculptural materials are charged with meta-
phoric resonance, especially for the African-American
community. In 1989, one of his works, *How Ya Like Me
Now?,* was exhibited in Washington, D.C., and caused
controversy when vandals destroyed the large outdoor
mural that depicted Jesse Jackson as a white man with
blond hair and blue eyes. In the exhibition of this work
at MCA, Hammons transformed the piece into a different
kind of installation, in which he presented the mural in
its damaged form with sledge hammers in front of it.
The show also included an installation, *Jesus is the Light,*
in which a room made of reclaimed pressed tin from an
old building was constructed in the gallery. One hundred
glow-in-the-dark plastic Jesuses were hung from the ceil-
ing. At intervals, the bright lights in the room suddenly
switched off so that the room was pitch black; the plastic
Jesuses above glowed and Aretha Franklin's song, *Jesus is
the Light,* played loudly from boombox speakers. Just as
suddenly, the lights came back on and the music stopped.
The exhibition traveled to various venues. Ninety-eight
page catalogue. Organized by Tom Finkelpearl, curator of
the Institute for Contemporary Art, P.S. 1 Museum, New
York; coordinating curator, MCA, Madeleine Grynsztejn.

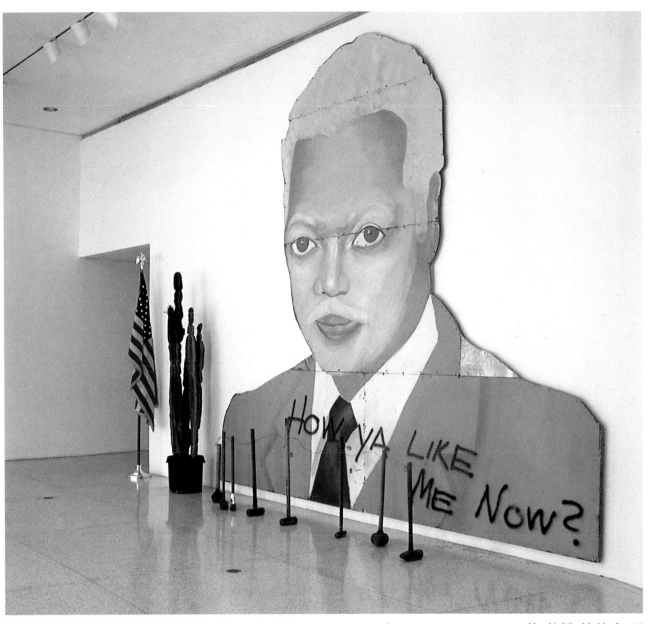

How Ya Like Me Now?, 1988

Afro-American Flag,
1990, flying outside
MCA during *Rousing
the Rubble*

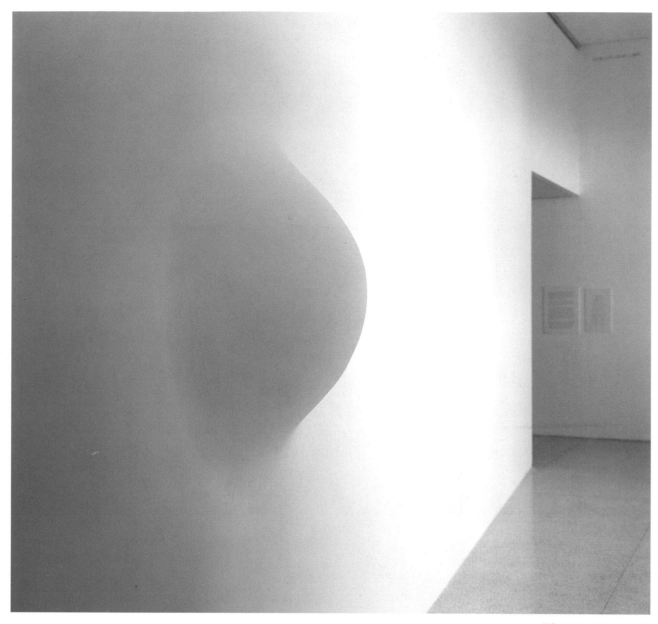

When I Am Pregnant, 1992

Endless Column, 1992

Anish Kapoor
1 February–5 July 1992

This exhibition of works by Indian-born sculptor Anish Kapoor revealed his shift in interest from the exterior surfaces of objects to their dematerialized interiors, and from monolithic objects to installations that physically intervene and transform architectural space. In addition to numerous sculptures, the exhibition included three installations. *When I Am Pregnant* comprised a large white wall installed in the Museum's front lobby gallery, which featured a subtle bulging form that could only be seen when looking at the wall obliquely. *The Earth* was a floor excavation: a circular 30-inch incision was cut directly into the terrazzo floor, the cavity of which was painted with deep blue pigment suggesting an opening into infinite space. *Endless Column* was a red-pigmented floor-to-ceiling shaft that penetrated the center of a gallery, its stark red color activating the neutral white space. The exhibition traveled to Des Moines Art Center; The National Gallery of Canada, Ottawa; and The Power Plant at Harbourfront, Toronto. Fifty-eight page catalogue. Curated by Lynda Forsha.

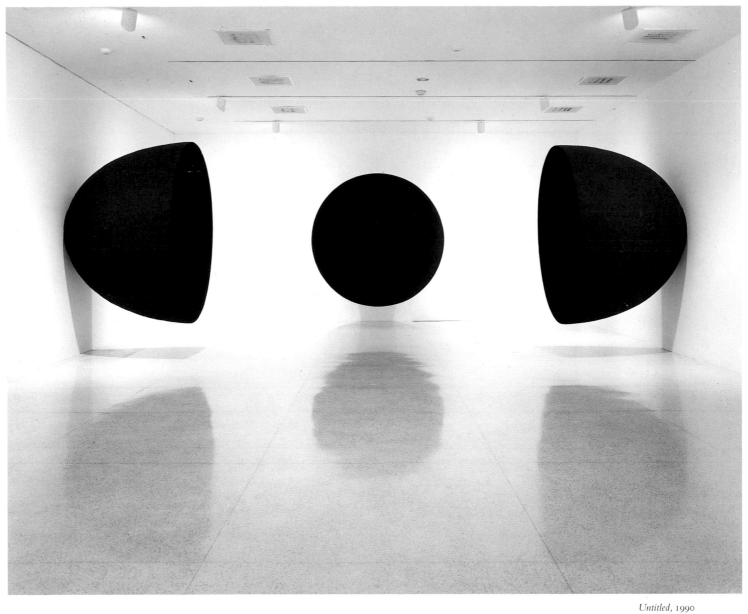

Untitled, 1990

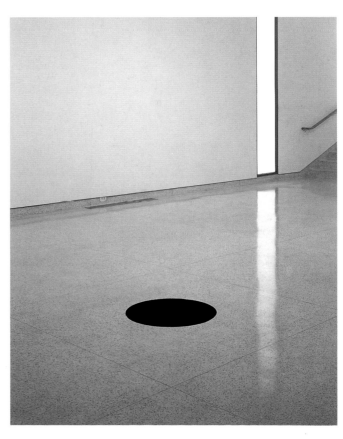

The Earth, 1991 (1992 reinstallation)

Rubbing Band, 1992

Untitled (detail), 1992

Noboru Tsubaki
17 July–26 September 1992

References to ecology, the environment, and nature are at the core of the work of Japanese artist Noboru Tsubaki, who had his first one-person show in the United States at MCA. Tsubaki created a kinetic room installation, *Rubbing Band,* that incorporated unexpected materials: an organic, glowing fiberglass structure with an armlike appendage dragged a bucket of marmalade in an endless circle along the floor. The unorthodox forms and textures of the piece suggested science fiction and a sense of nature gone awry. In another installation, the artist placed surfboard-shaped columns covered with patterned blue-and-white plasticene that extended from floor to ceiling adjacent to *Fresh Gasoline,* an imposing bright yellow sculpture. *Parameters 26.* Curated by Lynda Forsha.

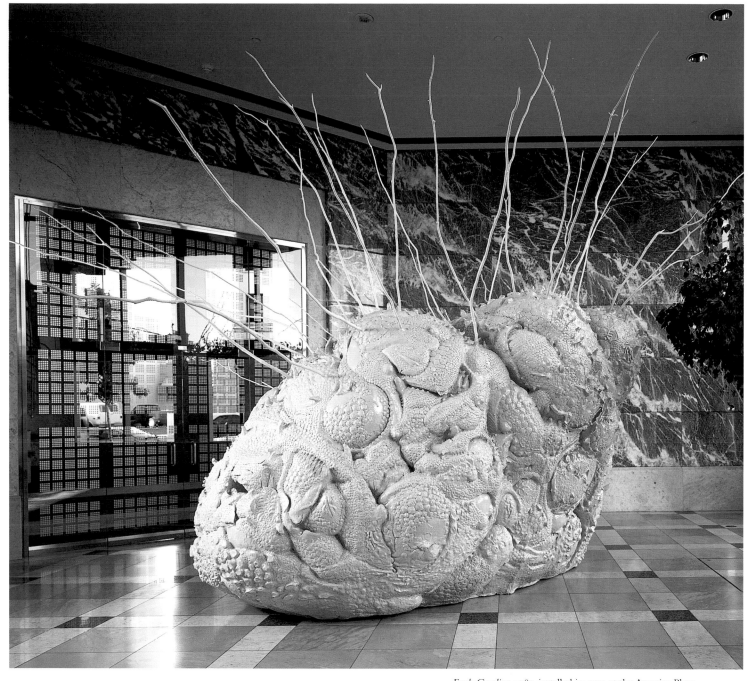

Fresh Gasoline, 1989, installed in 1993 at the America Plaza
office tower adjacent to MCA Downtown

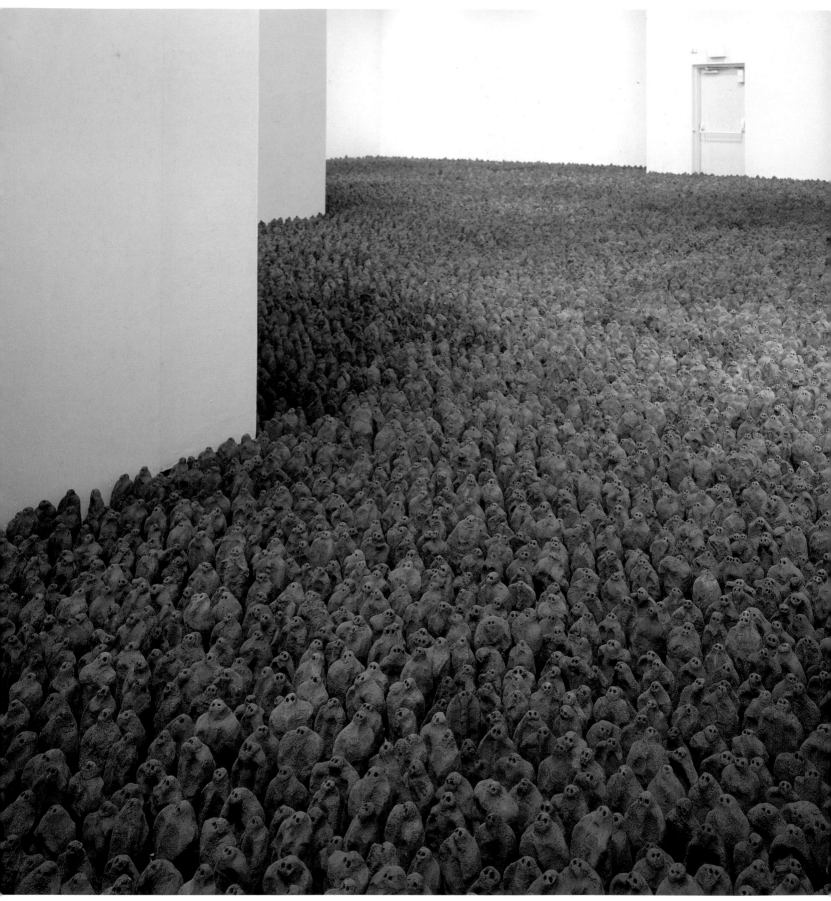

Field, 1991

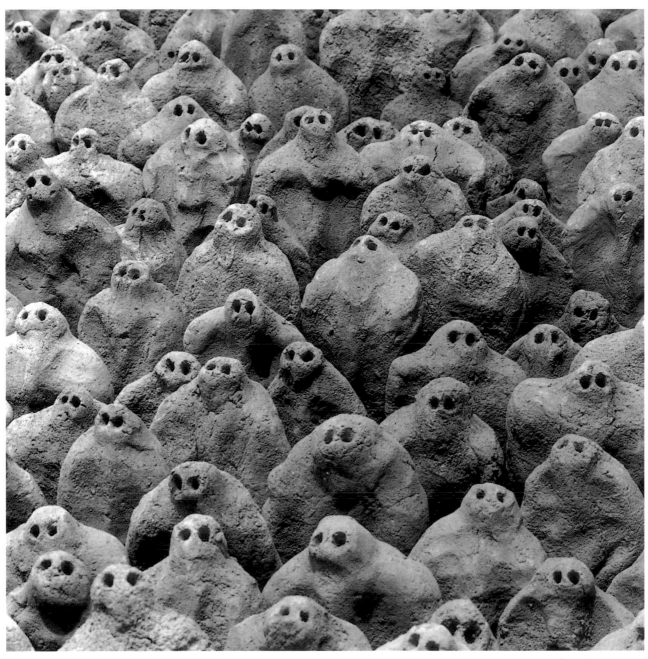

Field, 1991

Antony Gormley
3 October–9 December 1992

This exhibition, which coincided with inSITE92—a community-wide exhibition of installation art in San Diego and Tijuana—included a room installation, *Field*, and a selection of other figurative works by this British artist. *Field* comprised 35,000 handmade kiln-fired terra-cotta figures and occupied an entire gallery. Placed shoulder to shoulder in dense formation across the floor of the gallery, the figures—abstract bodies with two holes made by fingers to indicate the eyes—gazed poignantly up at the viewers, who could look out across the daunting sea of figures but could not enter the room. The installation suggested the world's population explosion, but was also a tribute to the loving craftsmanship of Mexico's potters and ceramic artists, some of whom helped Gormley make the thousands of figures. The international tour of *Field* was organized by Salvatore Ala Gallery. *Parameters 28*. Curated by Lynda Forsha.

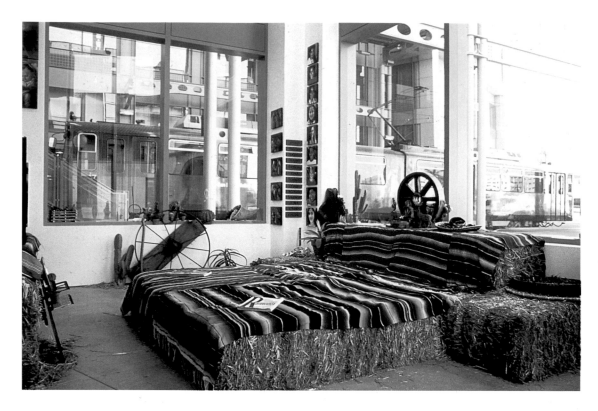

David Avalos and
Deborah Small,
mis.ce.ge.NATION, 1992.

Patricia Ruiz Bayón,
Mestizaje I, 1992–93

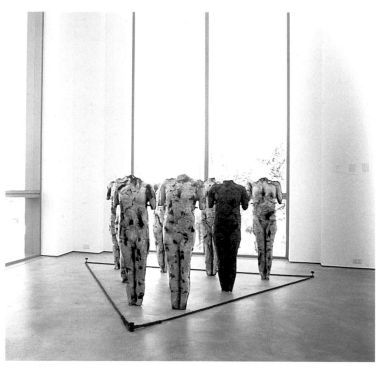

La Frontera/The Border: Art About the Mexico/United States Border Experience
5 March–22 May 1993

This exhibition was co-curated with the Centro Cultural de la Raza, San Diego, in a unique curatorial collaboration, and was the capstone of MCA's multiyear, multidisciplinary project *Dos Ciudades/Two Cities.* The project focused on border issues, and included thirty-seven artists and artist groups who were influenced by and/or addressed border issues. In addition to painting, sculpture, photography, works on paper, and video, installations by Terry Allen, Felipe Almada, David Avalos, Patricia Ruiz Bayón, the Border Art Workshop/Taller de Arte Fronterizo, Carmela Castrejón, James Drake, Louis Hock, the collaborative artists' group Las Comadres, Celia Alvarez Muñoz, Alfred J. Quiróz, Elizabeth Sisco, Deborah Small, and Eugenia Vargas, were included, as well as a public mural by Victor Ochoa. After its premiere at MCA and the Centro Cultural de la Raza, *La Frontera/The Border* traveled to the Centro Cultural Tijuana, Mexico; Tacoma Art Museum, Washington; Scottsdale Center for the Arts, Arizona; Neuberger Museum of Art, State University of New York at Purchase; and San Jose Museum of Art. Two-hundred page catalogue. Co-curated by Patricio Chavez (Centro Cultural de la Raza) and Madeleine Grynsztejn (MCA); Kathryn Kanjo served as coordinating curator (MCA).

Victor Ochoa, *La Frontera (The Border),* 1993

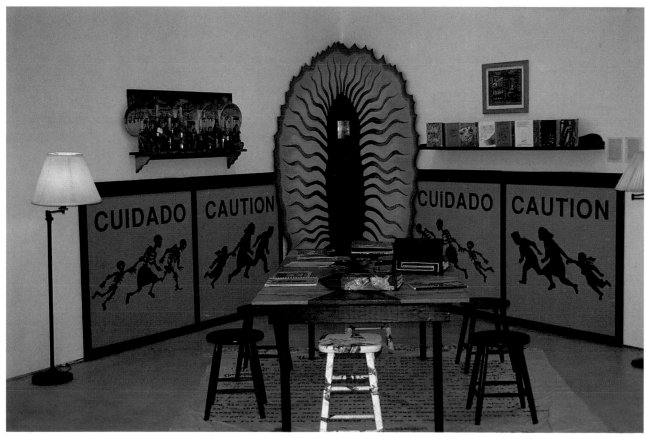

Las Comadres, *The Reading Room,* 1990, recreated from the 1990 exhibition *La Vecindad/Border Boda*

Untitled (Inflatable Sculpture),
1993

Robert Cumming: Cone of Vision
28 May–4 August 1993

Cumming was initially entrenched in the narrative wing
of conceptual art in the early 1970s. His work reflects a
nostalgia for the reassuringly mechanical world of indus-
trialism and a perception of the ordinary as monumental.
His technical versatility is reflected in the range of media
in which he works—from drawings and paintings to video
and written narrative, from photography to sculpture. This
retrospective of the artist's work at mid-career offered a
selection of pieces in various media, and included a large-
scale installation commissioned by the Museum. At MCA
Downtown, the ground-floor gallery with windows facing
onto the street was filled with a giant inflatable sculpture
that read as both a monolithic skull and crossbones and a
light bulb—two images that have preoccupied Cumming
throughout his career. The exhibition traveled to Mu-
seum of Fine Arts, Boston; Contemporary Arts Museum,
Houston; and Contemporary Museum, Honolulu. Eighty-
eight page catalogue. Curated by Hugh M. Davies and
Lynda Forsha.

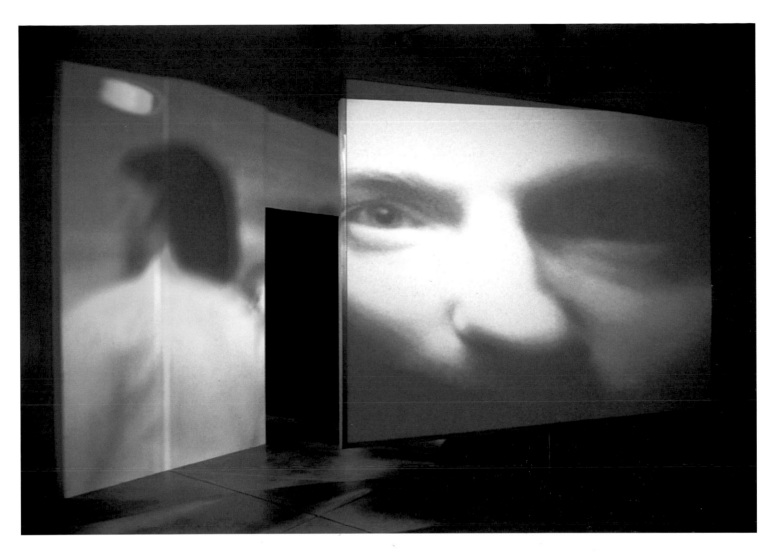

Bill Viola: Slowly Turning Narrative
14 August–20 October 1993

In his room-size video and sound installations, Viola conjures the elusive emotional and spiritual realms of experience in which dream, memory, and the imagination intermingle. In *Slowly Turning Narrative,* installed at MCA Downtown, Viola explored opposing but interconnected forces—conscious versus unconscious, personal versus social, illusion versus reality, abstraction versus representation. A 9-by-12-foot screen, mirrored on one side, turned slowly in the center of a darkened room. Video projectors stationed at opposite sides of the screen played two sets of footage, one color, the other black and white. One video, of a man's face, filled the screen on one side. In a monotone voice, the man recited an unbroken chant: ". . . the one who honors, the one who slows, the one who sanctifies, the one who secures, the one who locks, the one who attracts . . ." At times the words were clear, other times they were obscured by the soundtrack of the second video— children shrieking, fireworks flaring, wind, water, and the ambient muffled sounds of a mall. The installation was created for a traveling exhibition organized by curator Melissa Feldman for the Virginia Museum of Fine Arts, Richmond, and the Institute of Contemporary Art, University of Pennsylvania, Philadelphia. Coordinating curator, MCA, Lynda Forsha.

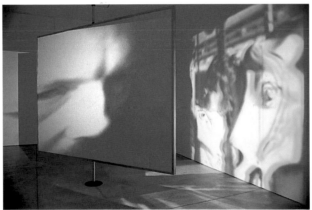

I feel prejudice when trying to get work or when I go down to Ocean Beach to the stores. When I first came here I had that navy-boy image, always kept my hair clean cut. But I got working clothes on now. I guess in that town they don't have many blacks so when I go all eyes are on me. Like I went into this one store and this guy followed me around so I played a trick on him. I went all through the store, he followed and then finally I turned around and said, "Now what are you following me for? You should be watching those rich white guys. They're the ones that'll be stealing from you cause they know you're not keeping your eyes on them."

Technician

I think that the way the family is disintegrating is dangerous. You see that parents are not interested in their kids—they don't take care of them. Children come to school abused, without breakfast, they're just not being taken care of. I see that as very self-destructive. If this keeps perpetuating it could be disastrous for society. Poverty promotes negligence, things snowball and this could lead to our society self-destructing.

Teacher

Tomorrow: Group Material
8 October–31 December 1993

Tomorrow was a site-specific installation at MCA La Jolla created by a collective of artists based in New York who have worked together for over a decade and call themselves Group Material. The artists came to San Diego and conducted interviews with local residents and tourists over the Fourth of July weekend. In shopping malls and on beaches, they questioned people about their concerns and predictions for the country's future. The artists used the answers they collected as the basis of their installation. The gallery walls were painted in broad stripes of acidorange and yellow paint, suggesting both the blistering California sky and its sunny citrus fruit crops. On top of these painted panels the artists transcribed, in standard gray sign-painter's lettering, the opinions and prognoses gathered from San Diegans and tourists, encircling the viewer in a silent chorus of voices. By recognizing the individuals they quoted as co-authors, Group Material broadened the range of opinions typically heard in a museum setting and brought forward the ideas of art as communication and art as a site for political discourse. Brochure. *Parameters 29*. Curated by Kathryn Kanjo.

Our national priority has got to be taking care of the country—domestic policy, forget about watchdogging the world. Not space research, space stations, or star wars. I used to support that but not anymore. We got too much to do on the planet to be building particle accelerators and all that crap. I used to love the whole deal but I can't feel that way seeing the situation of the country.

Artist

I can't say the current leadership is very different from previous administrations except maybe they give the impression of being a little more liberal than what we're used to. Initially a lot a people expected this administration to heal the country overnight which is impossible. This is not Camelot, it's not the Kennedy era when we could still believe that the Democrats were doing the right thing. The Clinton administration has faltered and reversed itself a couple of times on major issues. But hopefully it's one that is more open than what we've been used to in the past twelve years. I think it's up to the people to dictate to leadership and motivate them to take us in the right direction.

Photographer

I think that the way the family is disintegrating is dangerous. You see that parents are not interested in their kids—they don't take care of them. Children come to school abused, without breakfast, they're just not being taken care of. I see that as very self-destructive. If this keeps perpetuating it could be disastrous for society. Poverty promotes negligence, things snowball and this could lead to our society self-destructing.

Teacher

Tomorrow, 1993

Maria Nordman

17 November–31 December 1993

Nordman is known for her use of natural light and her insistence that her work not be photographed or written about. *Untitled La Jolla,* later acquired by the Museum, comprised two installations meant to be displayed at separate locations, one public (resembling a house with furniture-like objects), the other private (a gatelike object displayed away from the Museum). Curated by Kathryn Kanjo.

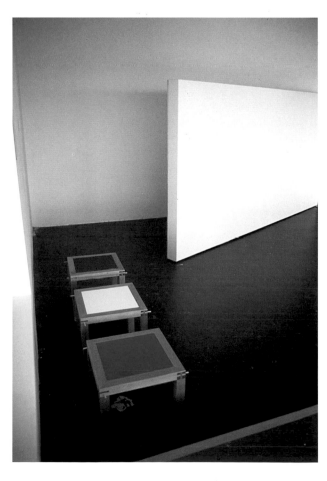

Untitled La Jolla, 1993

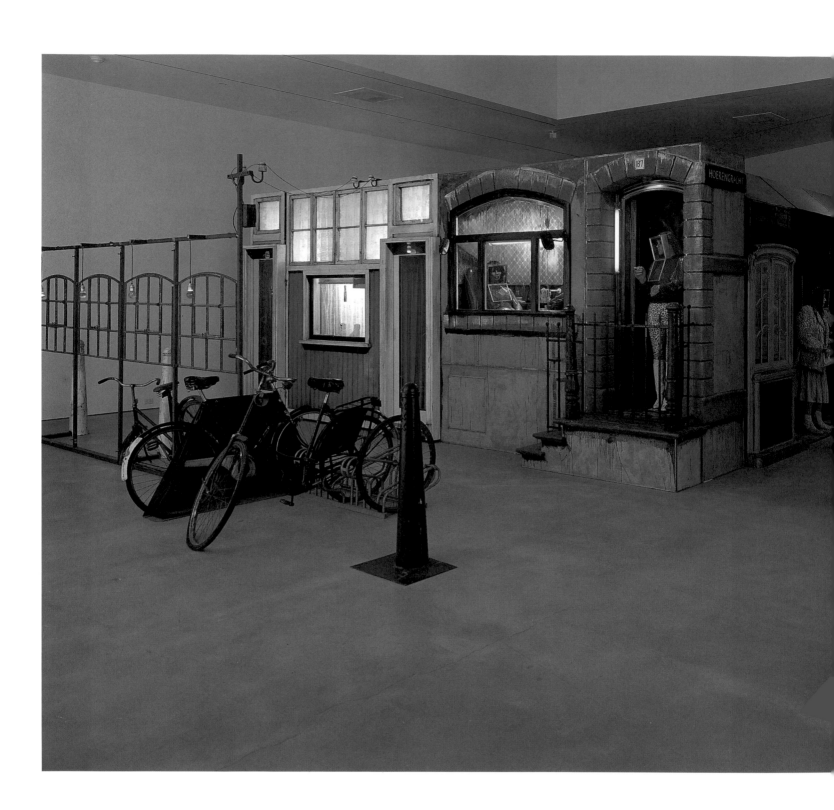

Edward and Nancy Reddin Kienholz: The Hoerengracht

30 October 1993–20 January 1994

Beginning in 1972, Edward Kienholz and Nancy Reddin Kienholz combined their talents to create haunting, poignant mixed-media assemblages and tableaux. *The Hoerengracht,* Dutch for "whore's canal," represented the red-light district of Amsterdam as a full-scale, room-size installation —a tableau seen for the first time in the United States at MCA's downtown facility. Made of actual, photographed, and reconstructed elements, the scene mimics a notorious Amsterdam neighborhood. Viewers wandering through the condensed maze of "streets" and "canals" confronted— and appeared to be confronted by—eleven life-size female figures sitting in the windows. Thirty-two page catalogue coordinated by Andrea Hales. Curated by Hugh M. Davies and Kathryn Kanjo.

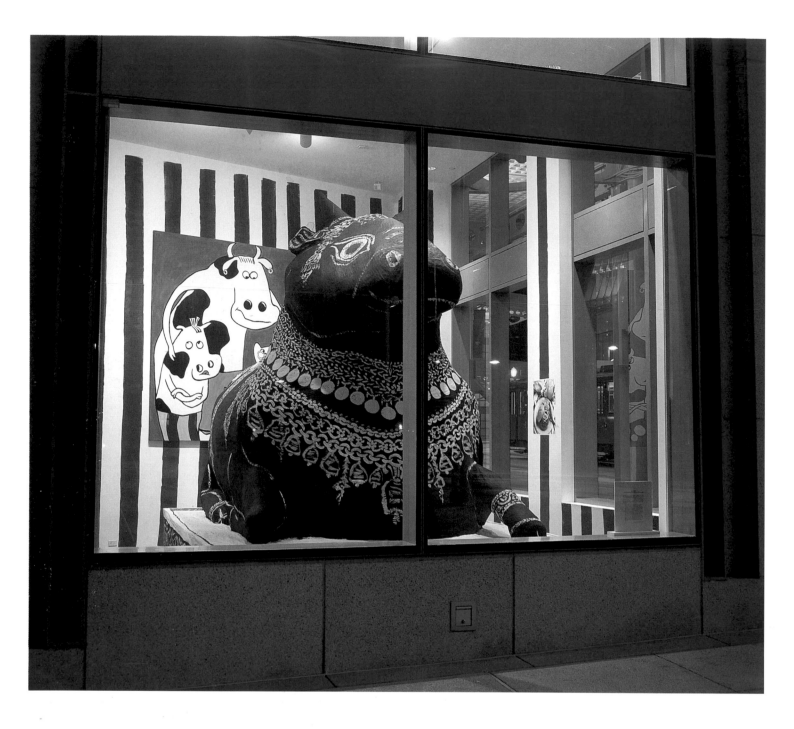

Bull Story: An Installation by Jean Lowe and Kim MacConnel

30 October 1993–6 January 1994

The central figure in Lowe and MacConnel's collaborative installation is Nandi, the benign yet powerful bull of the Hindu god Shiva, worshiped for his powers of fertility, resolve, and faith. In this installation, the artists created a large Nandi figure out of papier-mâché and placed it in the center of a prominent gallery at MCA Downtown, where windows facing the street made the installation visible to the public day and night. The walls surrounding Nandi were painted with red-and-white stripes, suggesting a South Indian temple. Layered on top of the stripes were Western images of the bull—an animal of sport and a source of clothing or food. The cross-cultural examination presented in *Bull Story* aptly combined Lowe's concern with the human alteration of nature and MacConnel's interest in the decorative arts of non-Western cultures. *Parameters 30*. Curated by Kathryn Kanjo.

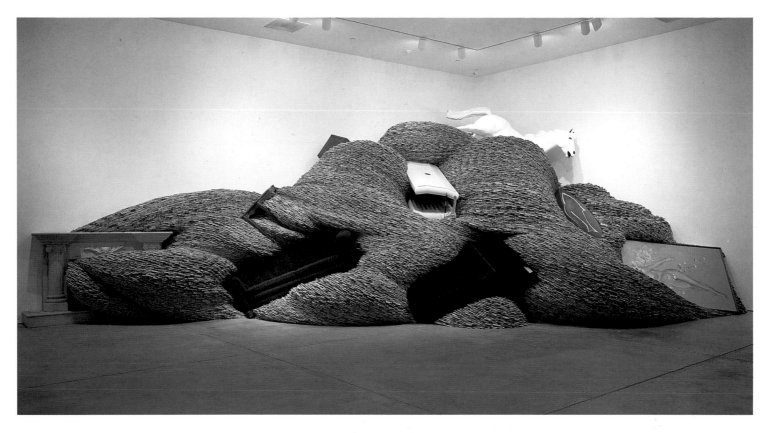

David Mach: Fully Furnished
29 January–7 April 1994

The Scottish-born artist David Mach is known for transforming the indulgences of a consumer society into satirical and monumental sculpture. During his two weeks in residence at MCA Downtown, Mach created *Fully Furnished,* an enormous room-size installation made of 14 tons of surplus *San Diego Union-Tribune* Sunday newspapers and other objects such as a surfboard, a tanning machine, a fireplace mantel, a thrift-store painting of a nude figure, and a giant white plastic stallion. Mach stacked, spiraled, and spilled the newspapers into an impressive whirlwind that seemed to emanate like a plume from the salvaged mantel. The temporary, labor-intensive sculpture offered a wry commentary on the excesses and indulgences of our consumer culture. *Parameters 31.* Curated by Lynda Forsha; project coordinated by Kathryn Kanjo.

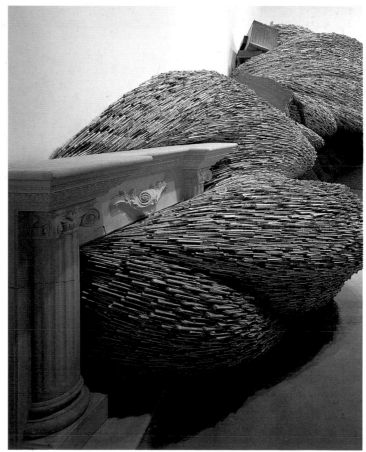

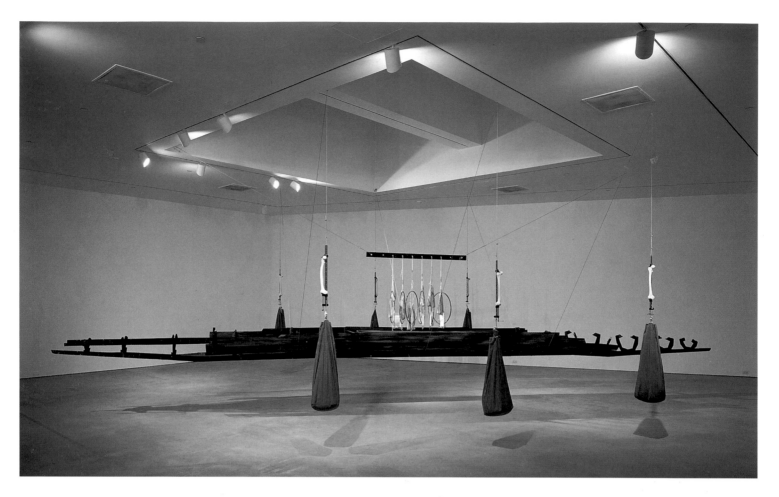

Carlos Aguirre, *None for Political Reasons II*, 1994

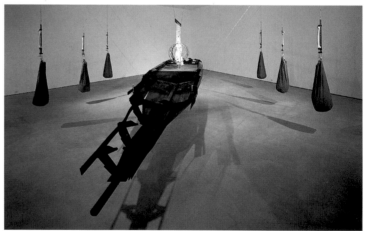

inSITE94: Carlos Aguirre, Anya Gallaccio, Silvia Gruner, Yukinori Yanagi

23 September–27 November 1994

The exhibition inSITE94 followed inSITE92 as the second in a series of presentations featuring site-specific and installation art throughout the San Diego and Tijuana communities. Thirty-eight institutions participated in the project, organized by Installation Gallery and co-sponsored by the Museum of Contemporary Art, San Diego, and the Centro Cultural Tijuana. MCA hosted inSITE94 artists Carlos Aguirre, Anya Gallaccio, Silvia Gruner, and Yukinori Yanagi at its downtown location. In addition, Nancy Rubins was commissioned to create a massive installation, *Airplane Parts and Building, A Large Growth for San Diego.* Mexican artist Aguirre's installation filled MCA Downtown's largest second-floor gallery. It comprised a handcrafted funerary boat suspended from the ceiling, delicately counterbalanced with canvas bags containing sand and cremated bones; written on the piece were the names of three hundred members of the Partido Revolucion Democratica murdered between 1988 and 1994 in the political violence that has gripped Mexico in recent years. In *Preserve: Maya,* British artist Anya Gallaccio installed a flat plane of fresh gerbera daisies, which were pressed against the windows near the MCA Downtown entrance. The deterioration of the daisies over the dura-

tion of the installation provided a visual and pungently odorous record of the process of transformation. Mexican artist Silvia Gruner created a sculpture entitled *The Middle of the Road,* installed at MCA Downtown. A commercial replica of the Aztec goddess Tlazolteotl was placed on top of a crossroads of woven steel. Video documentation of another component of the installation—111 ceramic Tlazolteotl figures installed on the United States–Mexico border fence—was also presented at MCA Downtown. In *America,* Japanese artist Yukinori Yanagi replicated the thirty-six flags of the nations of North and South America in a grid of Plexiglas boxes, each filled with pigmented sand forming the image of a particular flag. The boxes were connected by a system of clear tubing through which live ants slowly traveled from flag to flag in the grid, eventually disrupting the sand patterns—disassembling the flags and dissolving national identities. Curated by Lynda Forsha, director of inSITE94; projects at MCA coordinated by Kathryn Kanjo.

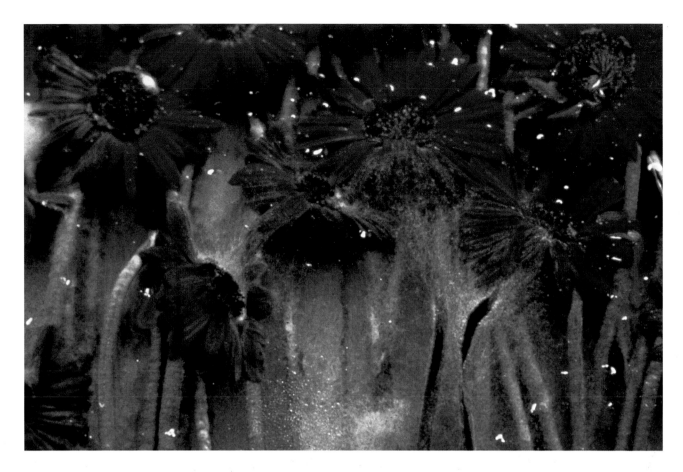

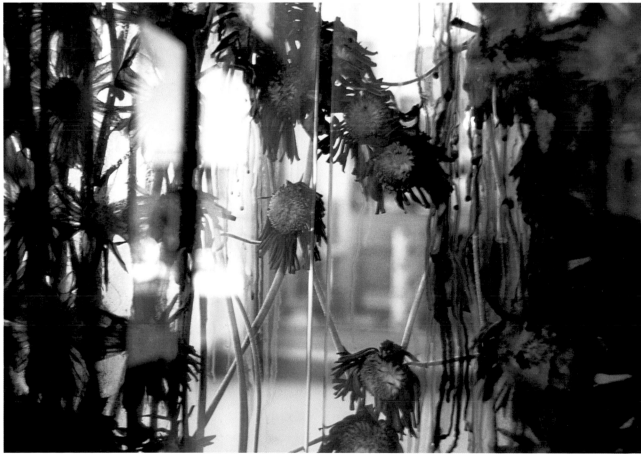

Anya Gallaccio, *Preserve: Maya,* 1994

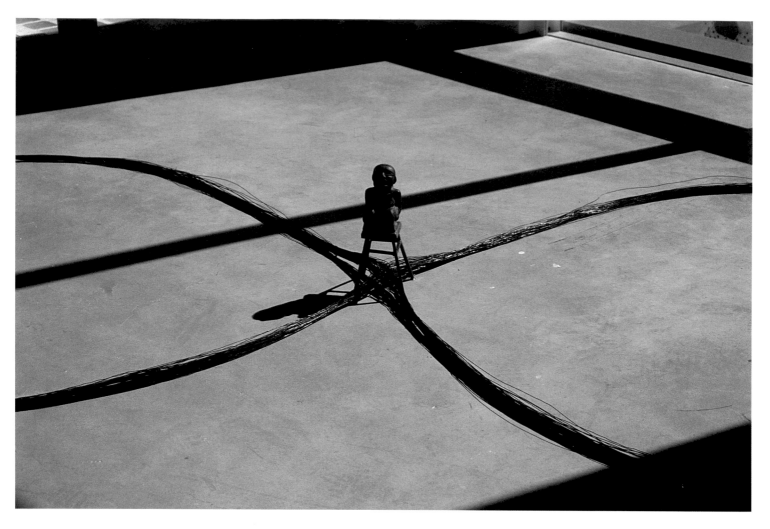

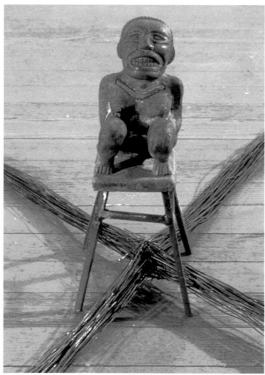

Silvia Gruner, *The Middle of the Road,*
1992

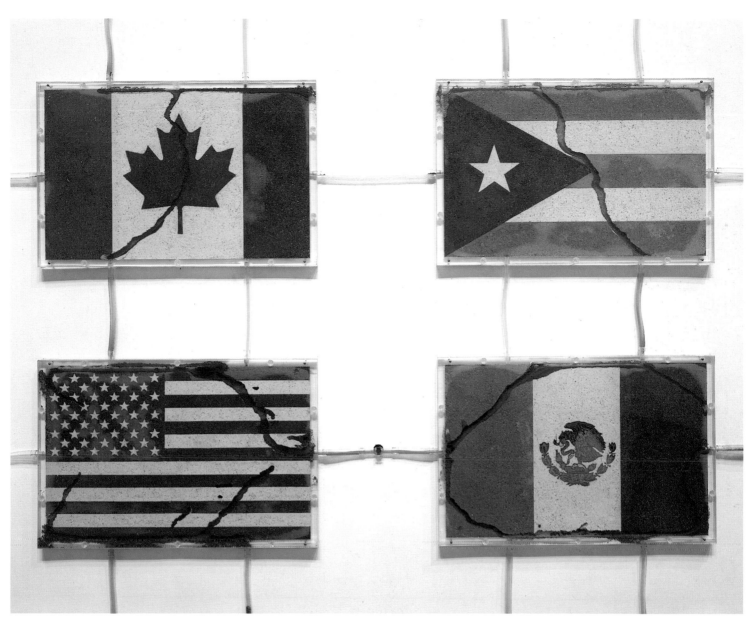

Yukinori Yanagi,
America, 1994

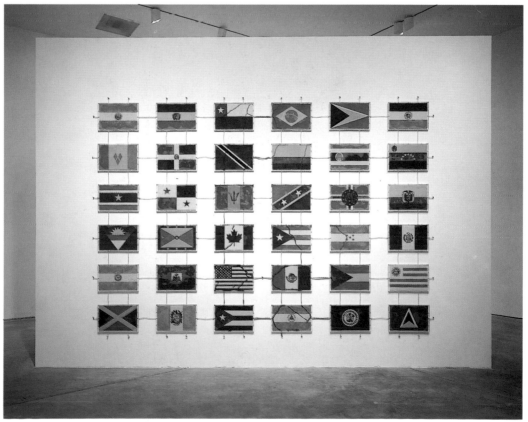

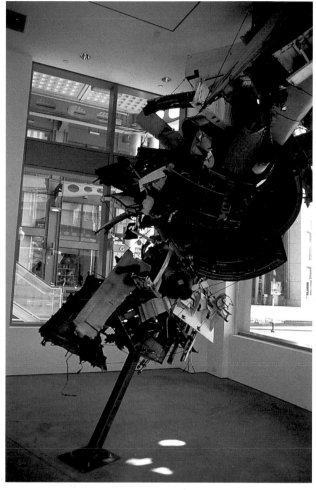

Nancy Rubins: Airplane Parts and Building, A Large Growth for San Diego
23 September 1994–1 May 1995

This installation was commissioned by MCA in conjunction with inSITE94. It featured Rubins's signature cluster of contorted debris and detritus on a massive scale. Made of discarded airplane parts gathered from the desert cemetery of retired or damaged airplanes located in eastern San Diego County, Rubins's work extended up and through the downtown Museum's clerestory windows and projected outside, into, and above the adjacent public plaza. Rubins linked the Museum's interior with the public exterior of the building—her choice of materials an apt one in San Diego, with its aeronautical industry and long history of aviation. The junkyard assemblage suggested environmental risk and implied industrial machines going out of control. Sixty-four page catalogue. Curated by Kathryn Kanjo.

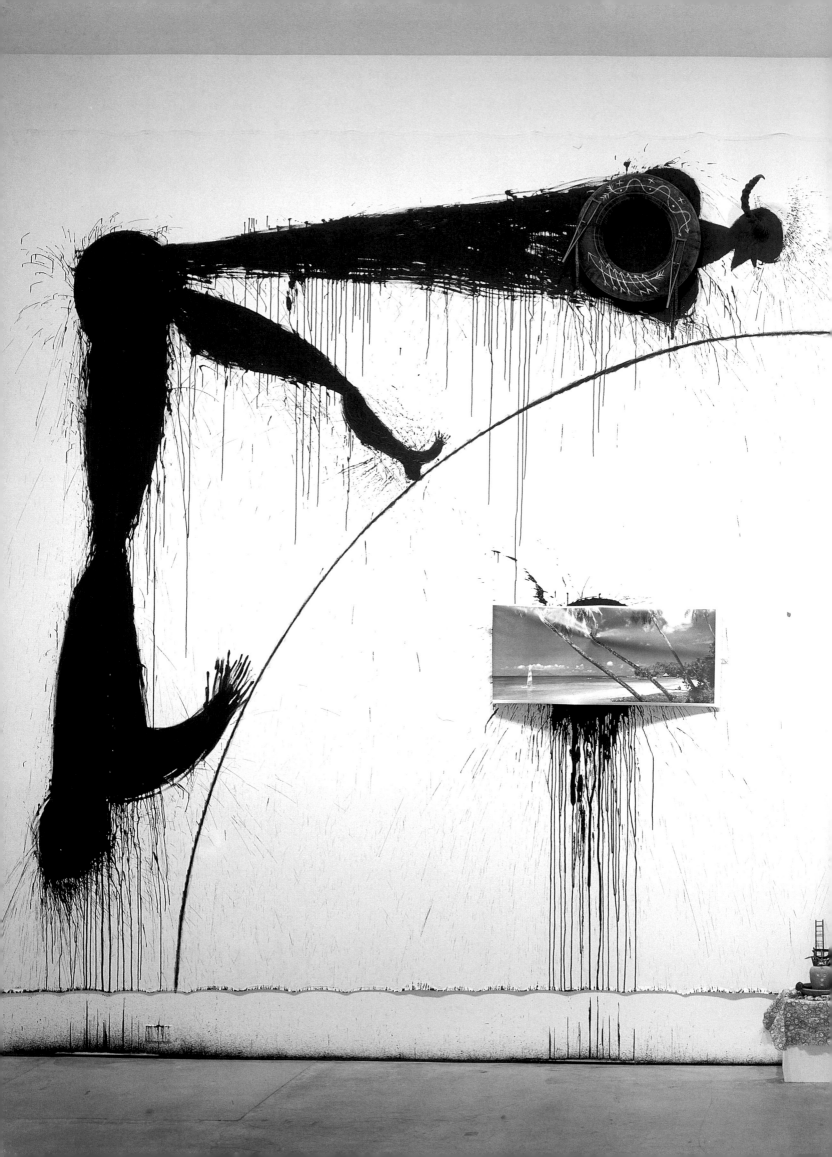

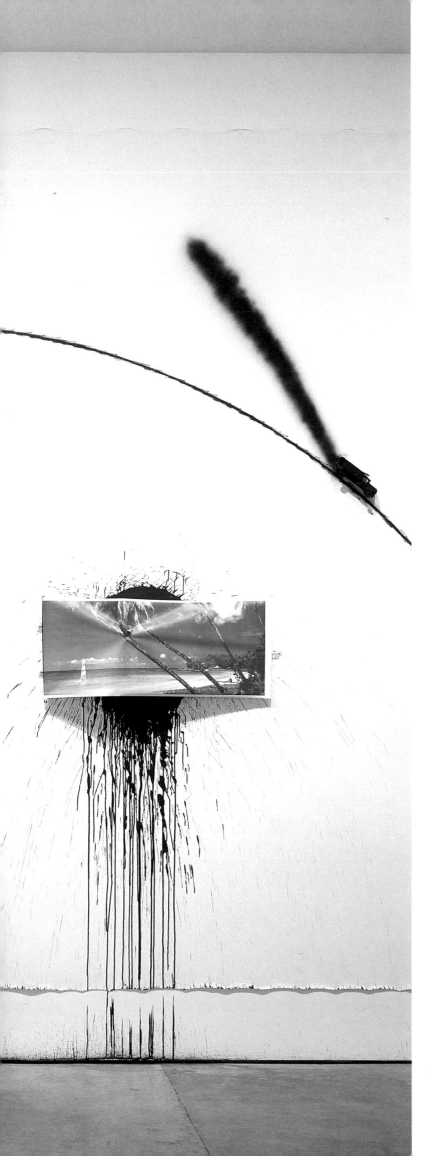

José Bedia: De donde vengo
18 February–14 May 1995

A traveling exhibition from the Institute of Contemporary Art, University of Pennsylvania, in Philadelphia, this was Bedia's first one-person museum show. The artist inventively addressed a Cuban—but also a universal—problem: *De donde vengo* ("Where I Come From") by blending Western painterly techniques and contemporary conceptual methods with materials and mythological elements gathered from various aboriginal sources. Bedia's choice of materials reflected the transcultural aspects of Cuba, assimilated from Spanish, African, Asian, and Amerindian roots. For the exhibition at MCA Downtown, Bedia created *Falsa Naturaleza (False Nature),* a mixed-media installation. Thirty-two page catalogue published by the Institute of Contemporary Art. Traveling exhibition curated by Melissa Feldman, Institute of Contemporary Art; coordinating curator, MCA, Louis Grachos.

Falsa Naturaleza (False Nature), 1995

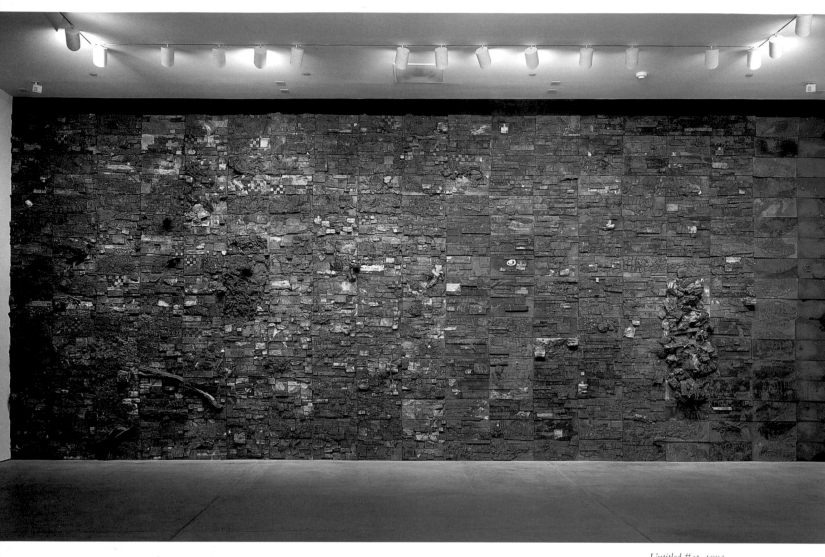

Untitled #45, 1995

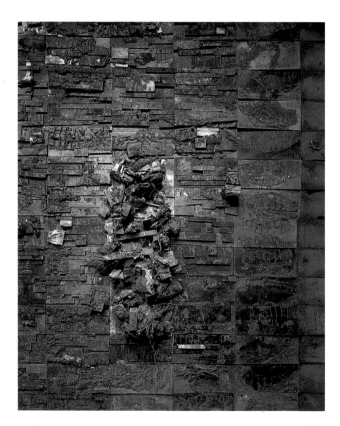

Leonardo Drew
13 August–29 October 1995

Drew fuses African and urban impulses into epic sculptural reliefs that examine the processes of natural decay and historical memory. Drew was artist-in-residence in San Diego for six weeks, during which time he made *Untitled #45*. The piece was composed of bits of cloth, plastic, wood, bone, and metal that the artist stained, burned, and rusted; the materials were affixed onto a loose grid of wood panels that filled an entire wall at MCA Downtown. Drew's work suggests the history of African Americans as well as the reality of contemporary urban squalor, but also relies on the post-Minimalist aesthetic of the 1980s and '90s. Also included in the exhibition was a new mixed-media work on paper. Brochure. *Parameters 34*. Curated by Kathryn Kanjo.

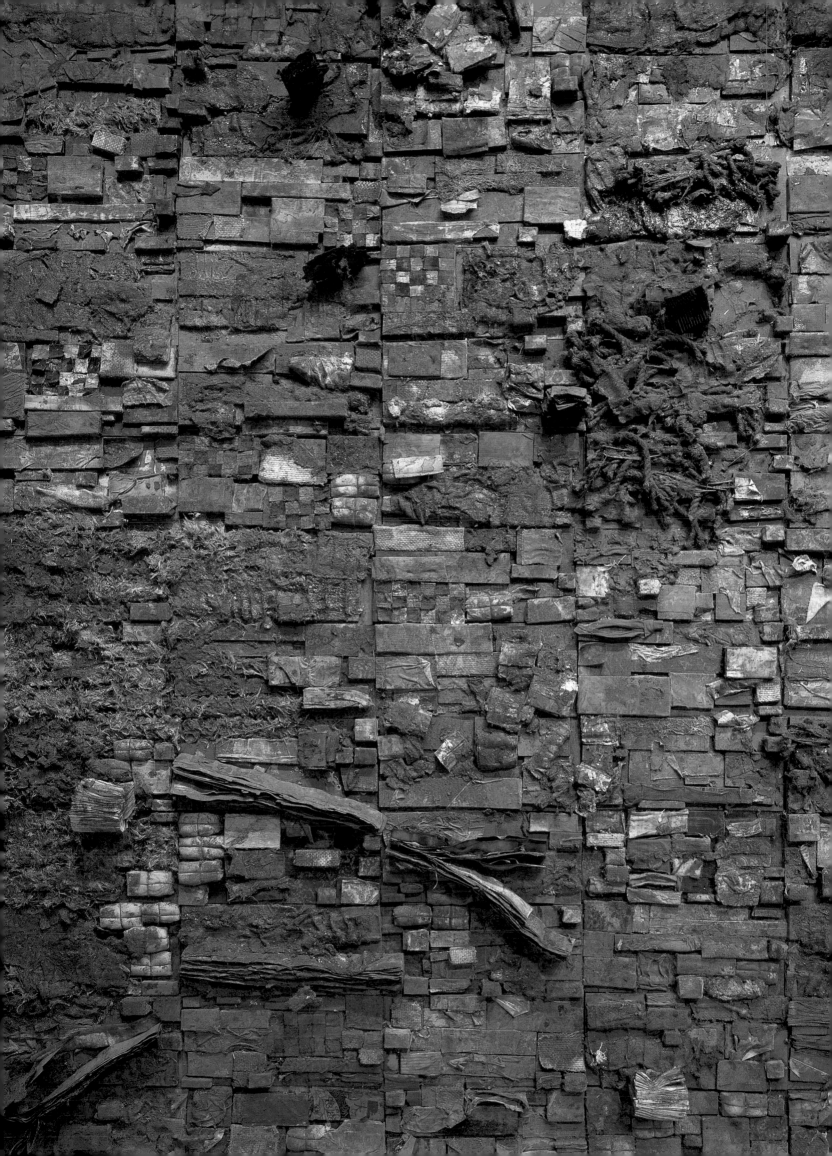

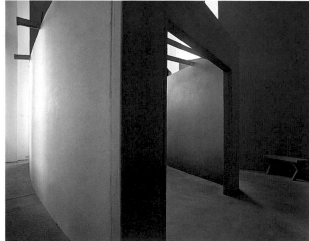

James Skalman: Samuel? . . .
4 November 1995–10 February 1996

In *Samuel? . . .*, a site-specific environment, Skalman created a vaguely domestic structure using modulated color, manipulated sound, and diminished light to fill the gallery at MCA Downtown. The artist intended the work to be viewed from the outside through the gallery windows as well as from inside. The structure's chambers suggested an abandoned scene of personal solitude that contrasted with the activity outside of the gallery windows, while the irregular floor plan and ceiling heights called attention to the downtown Museum's unusual architecture. Skalman's meditative enclosures—part architecture, part painting—allude to suburban architecture, domestic furnishings, and theatrical stages. *Parameters 35.* Curated by Kathryn Kanjo.

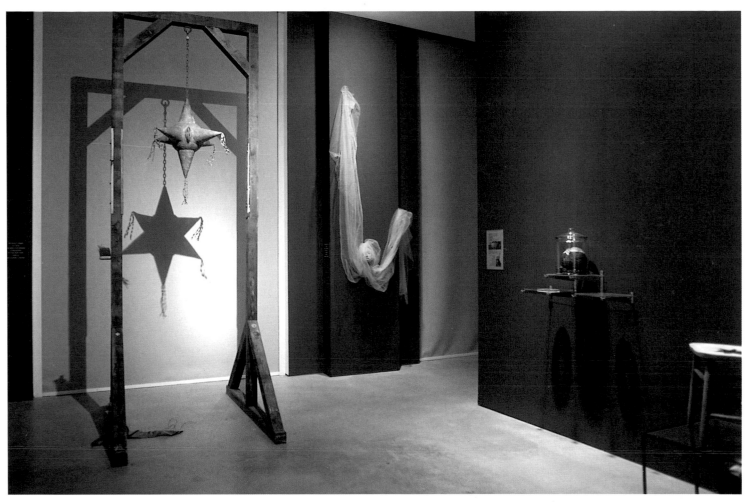

David Avalos, *Shards from a Glass House,* 1995

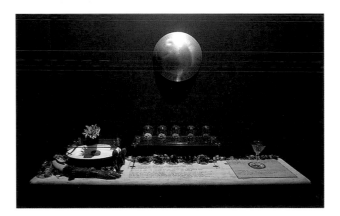

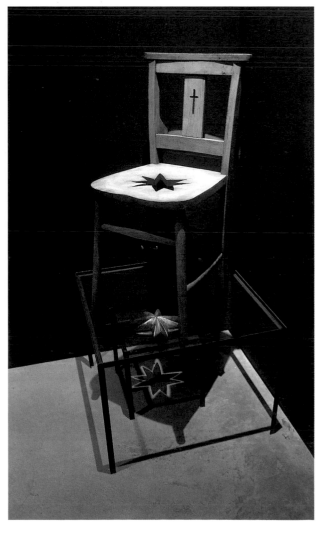

Common Ground: A Regional Exhibition
4 November 1995–10 February 1996

This exhibition surveyed the work of San Diego regional artists and included installations by Roman DeSalvo and Derek Stroup, and *Shards from a Glass House,* created by David Avalos for the second floor north gallery at MCA Downtown. A love poem formed the backdrop for the installation, which included objects referencing the artist's mythic sense of the mystery of love, creation, and transformation. The lighting, dramatic placement, and a range of media—lead, glass, wood, roses, and pomegranates—emphasized the layering of Avalos's personal life experience: his Chicano heritage and his family. Avalos challenged the mystical sense of romantic union by incorporating clichés about Chicano culture. The artist wrote on one gallery wall: "He wanted to be their Mr. Fiesta, but his piñata was in the shop being bulletproofed." Curated by Louis Grachos, Kathryn Kanjo, and Andrea Hales.

Nina Levy, *Infantile Tree Ornaments*, 1996

Inside/Out

10 March 1996—various dates

To inaugurate the renovated and expanded Museum in La Jolla, artists were commissioned to create new works in the recently renovated indoor and outdoor areas of the building. These artists included Edward Ruscha, Gabriel Orozco, Nina Levy, and Regina Silveira. For the new oceanfront Art Wall, Ruscha created the 25-by-41-foot work, *Brave Men Run in My Family.* Technicians transferred the image depicted in a small painting onto fabric that was then stretched onto a giant frame on the La Jolla building, overlooking the garden and ocean. The size of the highly cinematic scene—a misty silhouette of a clipper ship sailing across the ocean, a picturesque crimson sunset in the background—is reminiscent of a drive-in movie screen and is especially fitting for this site. The bold graphic title of the work fans across the top third of the wall against this backdrop. Ruscha, often inspired by Hollywood film culture, appropriated the title of the piece from a scene in the 1948 Bob Hope comedy/western, *The Pale Face.* The wisecrack, "Brave men run in my family," is disarming in its simplicity yet loaded with possible interpretations. Mexican artist Gabriel Orozco created *Long Yellow Hose,* an outdoor installation made of 1,200 feet of standard yellow plastic watering hose. The hose, which wove in and out of MCA's oceanfront garden, suggested the paradox

and intricacies of the underground watering system that enables such a lush landscape to survive and thrive in a community built on desert soil. The piece was like "a snake in the garden of Eden"; viewers who wandered through the garden of this pristine new building often puzzled why the gardener had left the hose out. In her outdoor installation, *Infantile Tree Ornaments,* Nina Levy suspended 170 small, multicolored glasslike infant heads from the gnarled branches of two Australian tea trees at the center of MCA's garden. The heads were linked together in chainlike configurations, their crystalline colors glowing from within as they captured natural light, especially at sunset, and were reminiscent of the festooned trees of the holiday season. Brazilian artist Regina Silveira was commissioned to create a work in the Axline Court, the central public space of the new MCA La Jolla. Her installation, *Gone Wild,* which was on view from 21 September 1996, responded to the spotted terrazzo floor in the court. Silveira extended and exaggerated the distinctive floor pattern designed by architects Robert Venturi and Denise Scott Brown onto the wall to create a continuation of the spots, which she described as a "perspectivated pattern that simulates galloping coyote footprints." Curated by Louis Grachos.

IY FAMILY

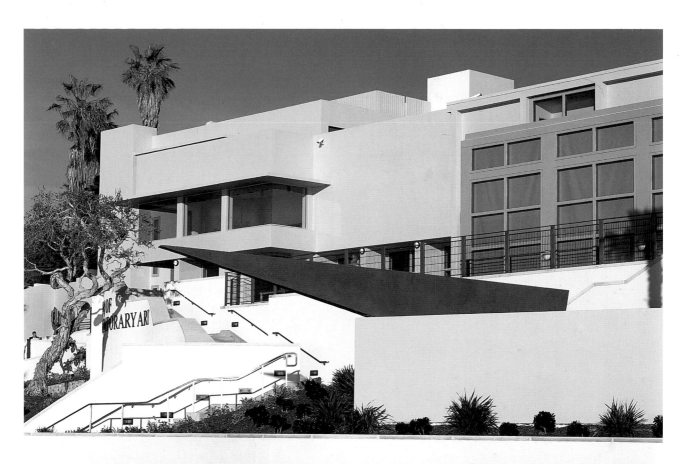

Mauro Staccioli, *Untitled*, 1996, at MCA La Jolla

Mauro Staccioli

10 March 1996–various dates

Italian sculptor Mauro Staccioli was commissioned by MCA to create two temporary site-specific works: *Tondo (San Diego),* for the South Plaza of MCA Downtown, and *Untitled* (1996) for MCA La Jolla. *Tondo (San Diego)* is an enormous reddish wheel-shaped disk poised precariously on its edge, its perfectly round form contrasting with the angles of the Helmut Jahn–designed Museum building and adjacent America Plaza office tower. The work focuses on the South Plaza as a place of intersecting movement and the modes of transportation that surround it: the San Diego trolley, the high volume of pedestrian traffic, the intersection of major automobile thoroughfares, and the historic Santa Fe Depot across the street. In La Jolla, Staccioli created a work reminiscent of his earlier sculpture, on view near that site from 1987 to 1994, when construction for the new building commenced. *Untitled* (1996), the same color as *Tondo (San Diego),* is poised on a ledge of the Wick Terrace. Staccioli's whimsical use of gravity and juxtaposition serve to activate what might otherwise seem an obdurate geometric form. Curated by Hugh M. Davies and Louis Grachos.

Blurring the Boundaries: Installation Art 1969–1996

21 September 1996–26 January 1997

This exhibition was the second part of a year-long presentation of works in the Museum's permanent collection, inaugurating MCA's renovated and expanded building in La Jolla. Some of the artists included were Vito Acconci, Stephen Antonakos, Chris Burden, Kate Ericson and Mel Ziegler, Dan Flavin, Ann Hamilton, Robert Irwin, Anish Kapoor, Paul Kos, Louise Lawler, Sol LeWitt, Tony Oursler, Markus Raetz, Alexis Smith, George Trakas, and James Turrell. In addition, the exhibition included a reconstruction of Bruce Nauman's *Green Light Corridor,* originally installed at MCA in 1971 and now in the Panza Collection of the Solomon R. Guggenheim Museum, New York. Two-hundred page catalogue, *Blurring the Boundaries: Installation Art 1969–1996* (1997). Curated by Hugh M. Davies and Lynda Forsha.

OPPOSITE: Mauro Staccioli, *Tondo (San Diego),* 1996, at MCA Downtown

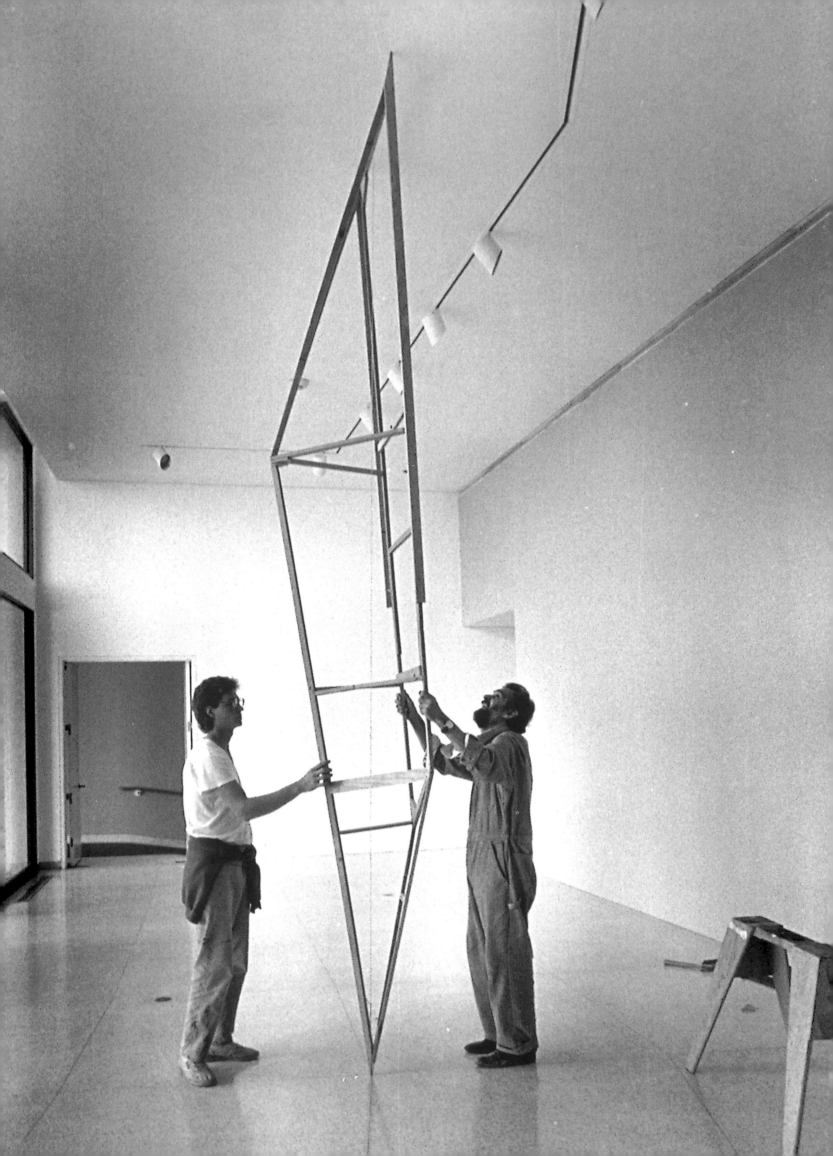

Related Works

There is no absolutely clear delineation between the installation works previously described and the related works discussed in the following section. In some cases, related works in the permanent collection may serve as collateral components for larger installations, as in Celia Alvarez Muñoz's *Lana Sube,* part of her larger work *Lana Sube/Lana Baja.* Other works are less dependent upon a specific site or architecture for viewing and understanding the piece than the installations discussed earlier. Although these related works can be installed and adapted in a more traditional way than installation works, they are distinguished from a standard art object by the manner in which the museum space is incorporated into the presentation of the work. A distinction can be made, however, if one compares a related work such as Tony Cragg's *Dying Slave* to Sol LeWitt's *Isometric Pyramid.* The LeWitt piece can be adapted to different sites and wall scales and varies in size with each installation, whereas the individual elements of the Cragg work are installed in a specific pattern detailed by the artist, so that in each presentation the piece never deviates from its original dimensions. The related works discussed here lie somewhere between installation and object art. In a sense, the works included in this section illuminate an intermediate step toward an installation.

Terry Allen
AMERICAN, B. 1943

The First Day (Back in the World), 1983
Sheet lead nailed to wooden structure, stuffed bird, photograph, acrylic paint, and mixed-media collage; overall dimensions: 60" × 96" × 11". Museum purchase, 84.2.1–7.

Three poems—"Morning," "Afternoon," and "Evening"—mark time in *The First Day (Back in the World),* part of Terry Allen's *Youth in Asia* series. The series explores the cultural impact of and personal stories about the Vietnam War. In these collage works, objects mingle with the written words to form a meditation on memory and loss.

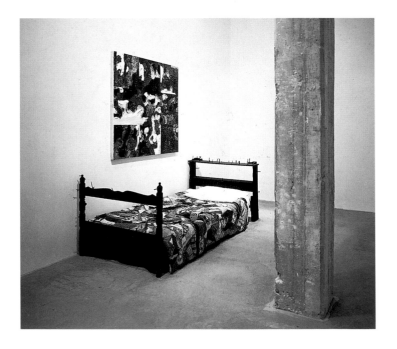

David Amico
AMERICAN, B. 1951

Bed, from the *Circus Boy* series, 1986
Oil on canvas, bed; painting: 47½" × 48"; bed: 33½" × 45½" × 85¾". Gift of Mandy and Cliff Einstein, 93.8.1–13.

Amico works in both representational and abstract styles, and here presents an unusual piece incorporating an actual bed and painting. One of the works from his *Circus Boy* series, the piece is like a scene from a play for which the viewer is to write the action. Jagged twigs pierce the headboard and footboard of the simply constructed child-size wooden bed, alluding to nails and evoking the sensation of pain. The bed is covered with a dark, hand-sewn crazy quilt, the random patterns of which are echoed in the painting displayed above the bed. The painting and bed interact, creating a nightmarish apparition in the viewer's imagination.

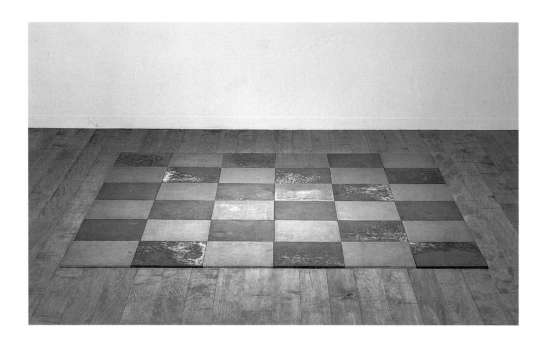

Carl Andre

AMERICAN, B. 1935

Magnesium-Zinc Plain, 1969
Magnesium and zinc; ⅜" × 72" × 72". Museum purchase with matching
funds from the National Endowment for the Arts, 74.4.1–36.

In *Magnesium-Zinc Plain,* a tiled rug of metal foundry
plates of equal size are placed on the floor in a checker-
board pattern. This flat sculpture that is viewed looking
down radically breaks from the traditional orientation
of painting on a wall as well as the typical experience
of sculpture in the round. With Minimalist detachment,
Andre's composition is non-hierarchical—using only an
anonymous grid and objective geometry. The materi-
als are literal—magnesium and zinc. Easily overlooked,
Magnesium-Zinc Plain marks a space that the viewer enters,
consciously or unconsciously, by walking on and across
the piece. This physical intervention emphasizes the expe-
riential effects of the work—the difference between the
two materials can be sensed, and the tipsy step of walking
on and off stage is suggested.

Alice Aycock

AMERICAN, B. 1946

The Glass Bead Game: Circling 'Round the Ka'ba, 1986
Wood, latex paint, and steel; diameter: 240". Gift of RSM Company,
Cincinnati, Ohio, 89.7.

This room-size sculpture was created for MCA's 1986
exhibition *Sitings.* The piece incorporates Aycock's trade-
mark synthesis of architecture and furniture, and recalls
children's marble games and the Kaaba, Islam's holiest
shrine in Mecca. Pilgrims circle the Kaaba, a small build-
ing that houses a sacred black stone, in the same way that
viewers circle Aycock's structure, their movements imitat-
ing both a pilgrim and a ball set in motion along grooves
in a game board. The structure overwhelms the room and
is similar to Aycock's large-scale outdoor works. In this
self-contained work Aycock prompts viewers to use their
imaginations to relate the archetypal realms of magic,
religion, and mythology.

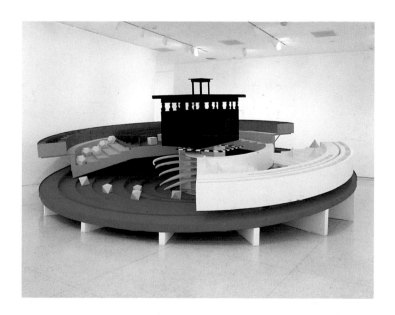

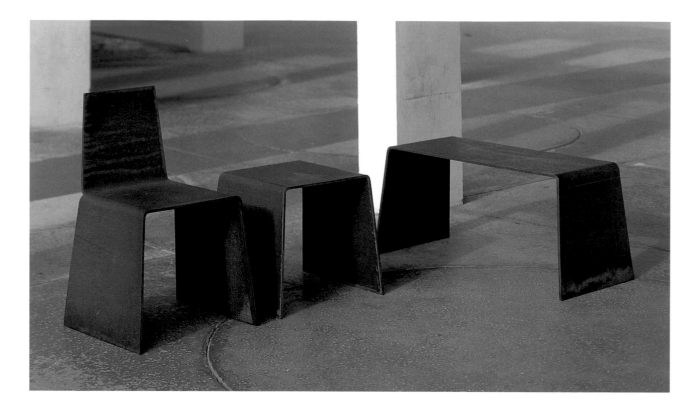

Scott Burton
AMERICAN, 1939–1989

Steel Furniture, 1979–80
Hot-rolled steel, rusted and lacquered; stool: edition II, two of four, 18" × 19¾" × 18¼"; chair: edition II, three of six, 32" × 20" × 19"; bench: edition II, one of four, 18" × 39" × 18½". Gift of RSM Company, Cincinnati, Ohio, 84.14.1–3.

In his performance pieces of the early 1970s, Scott Burton's slow-moving actors shared the stage with non-human presences: furniture. Burton subsequently eliminated the actors and instead invited public participation in the work. His functional sculptures elegantly blur the boundaries between art and furniture. Here, the hot-rolled steel forms—stools, chairs, and benches—recall Minimalist objects as readily as domestic design.

Christo and Jeanne-Claude
AMERICAN, B. 1935 (BULGARIA)
AMERICAN, B. 1935 (FRANCE)

Store Front, 1965–66
Galvanized metal, wood, Masonite, fabric, Plexiglas, and electric light; 97½" × 118" × 17". Museum purchase, 79.45.

The artists' series of storefronts made between 1964 and 1968 are rhythmic re-creations of commercial facades, with measured space for human passage and product display. Yet in these reticent works, the shop is sealed, the windows obscured. *Store Front,* with its loose cotton veil, prevents and provokes rather than permits and presents. This air of mystery is further enhanced by the glowing light hidden within. The in-progress format recalls the artists' metal-trimmed vitrines from 1963, in which brown paper similarly masks a dimly lit interior. Christo and Jeanne-Claude's interactions with the surrounding world have moved from the personal to the global. Their recurring dialectic of highlighting by obscuring—calling attention to by canceling out—is elegantly contained in this seminal early work.

Tony Cragg

BRITISH, B. 1949

Dying Slave, 1984
Plastic wall construction; overall dimensions: 118" × 41".
Museum purchase, Contemporary Collectors Fund, 88.26.1–157.

This is one of Cragg's "mosaic sculptures," in which discarded pieces of plastic are systematically arranged into various shapes on a floor or a wall. Various shards of plastic detritus, all in shades of creamy white, form the silhouette of Michelangelo's sculpture *Dying Slave.* Just as Cragg mimics the size of Michelangelo's sculpture, the ivory hues of the various plastics parody the subtle variations of marble. The plastic objects give the piece a sculptural quality, and yet the flat plane of the wall contradicts our spatial understanding of three-dimensional sculpture. Cragg invites viewers to actively decipher the individual, nonbiodegradable products, their entrapment in the human silhouette, and the title *Dying Slave.*

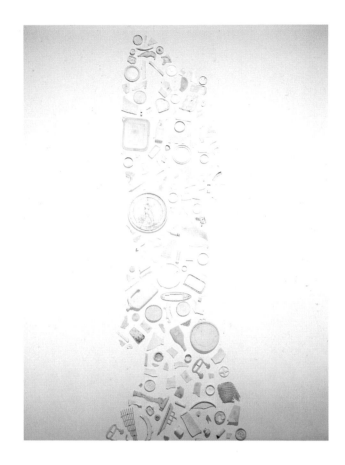

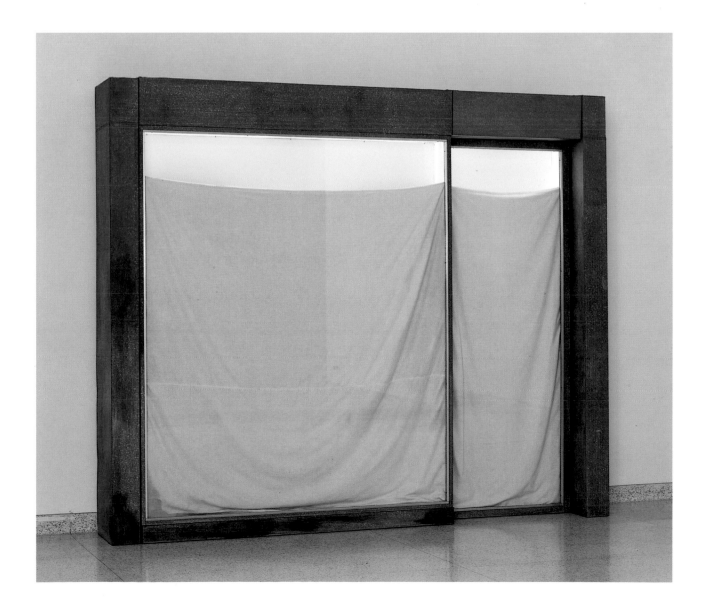

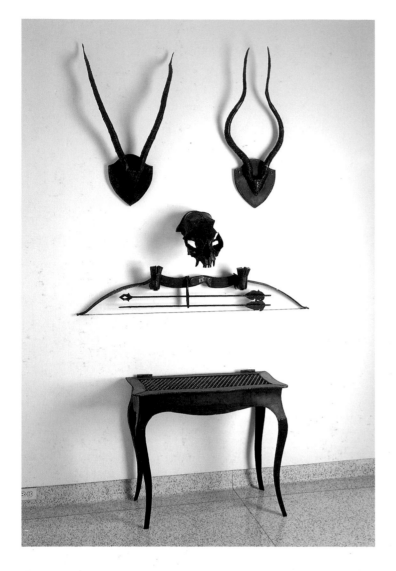

James Drake
AMERICAN, B. 1946

Knife Table, 1984
Steel; overall dimensions: 84" × 48" × 18". Museum purchase with funds from the Lannan Foundation, 88.3.1–7.

In *Knife Table,* various trophies and tools of the hunt have been replicated in unpainted, industrial steel. These scenes and symbols of domination and oppression are arranged on the wall to form a human face. In the enclosed table below, also roughly handcrafted of the same steel, several ominous knives ranging from small daggers to foot-long hunters' weapons are displayed. In this looming tableau, claims of protection, hearth, and home represented by these objects are cancelled out and silenced by other arguments of power, control, and violence that these objects also convey.

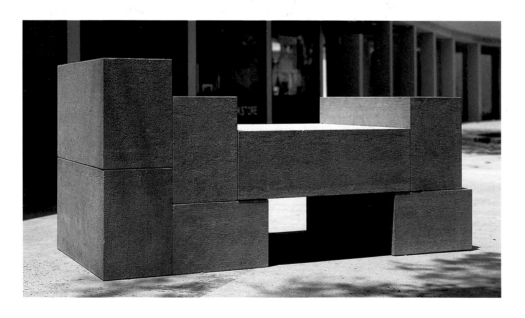

Richard Fleischner
AMERICAN, B. 1944

Froebel's Blocks, 1983
Limestone; 44⅜" × 91⅜" × 44⅛". Museum purchase, Contemporary Collectors Fund in honor of Ronald J. Onorato, 87.11.1–8.

Spatial relationships and perceptual experiences are significant components of Fleischner's work. The artist often collaborates with architects, builders, and designers to enhance public spaces. *Froebel's Blocks* comprises eight identical limestone blocks that form what looks like a throne or a bed. The title of the piece refers to the Swiss educator who developed children's building blocks based on intuitively derived proportions.

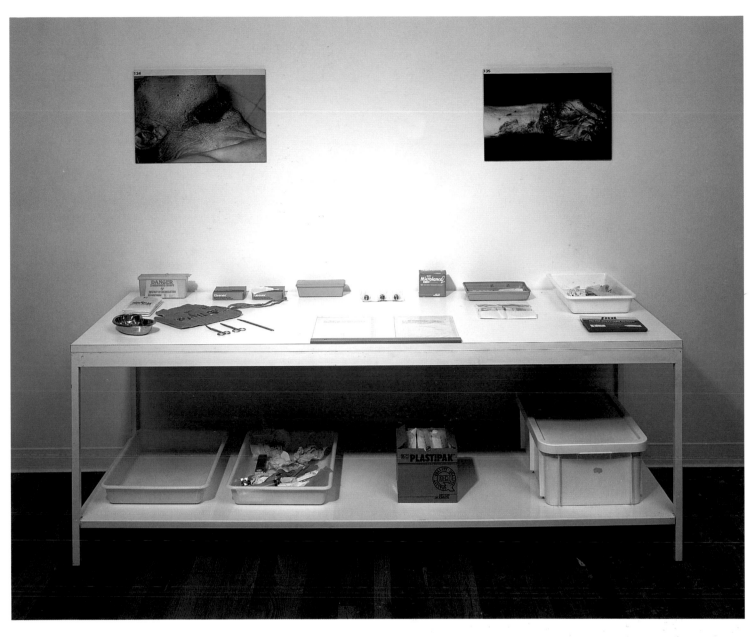

Damien Hirst
BRITISH, B. 1965

When Logics Die, 1991
Painted metal and Formica table, various medical supplies, surgical tools, and two color photographs mounted on aluminum; photographs, each: 16" × 20"; table: 30" × 84" × 30"; overall dimensions: 70½" × 84" × 30". Museum purchase, Contemporary Collectors Fund, 94.2.

When Logics Die presents the viewer with two versions of death—one accidental, the other suicidal—in the two large-scale color photographs displayed over a clinical array of surgical tools arranged on a metal table. This sterile objectification reminds us that whether the cause of death is deliberate or random, decided by choice or fate, the result is identical. Hirst's blood-chilling scenario examines the questionable logic of placing value upon knowing the cause of death.

Louise Lawler
AMERICAN, B. 1947

Well Being, 1986

Framed Cibachrome print, paint, and label; 72" × 96"; overall dimensions vary with each installation. Museum purchase, Contemporary Collectors Fund, 86.31.1–2.

A museum label, an aid to interpreting an artwork, is usually placed next to works displayed in a gallery or museum. In Lawler's piece, however, the label is placed in the center of the installation and functions as its focal point. The label's placement suggests that it refers to the color photograph of two Léger paintings, but the text actually describes the two areas of color on which the photograph hangs. The small pink area represents money invested in health research, while the larger blue expanse represents money invested in military research. The artist anchors her political outlook with important established works of art. The Légers are held captive in their affluent setting and lose their power as celebrations of the physical labor they depict. In the same way, Lawler states that in a museum her own work may be muted by its context. Lawler also continues to explore her interest in documenting the display of art. She proposes that, whether institutional or private, art is bound to its context and cannot be seen independently of its exhibition surroundings.

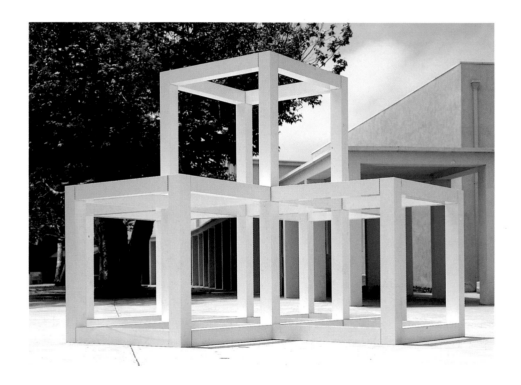

Sol LeWitt
AMERICAN, B. 1928

Six-Part Modular Cube, 1976

Polyurethane on aluminum; 120" × 180" × 180". Museum purchase, Museum Art Council Fund, 82.6.

In *Six-Part Modular Cube,* the geometric forms typical of LeWitt's work have been opened and enlarged to monumental scale. LeWitt incorporates conditions of the outdoor site in the same way that he does in his interior wall drawings, which integrate the wall's surface. The geometric simplicity of *Six-Part Modular Cube* contrasts with the nearby vegetation, rocks, and ocean. The modular cubes are exemplars of what we know—each section of the whole is identical in size, surface, and color—and what we see—each section of the piece looks different, depending on the light, shadow, and where we stand in relation to the object. The viewer can imagine entering the mathematical maze to experience the dichotomy between these fundamental units of order and the free-form elements of nature that surround it. Everything changes and everything remains the same; as LeWitt has said: "The functions of conception and perception are contradictory."

Richard Long
BRITISH, B. 1945

Baja California Circle, 1989
Baja La Cresta granite; diameter: 168". Museum purchase with funds from the Elizabeth W. Russell Foundation, 89.4.

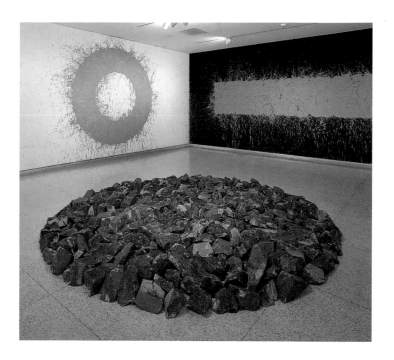

Long, who travels widely, records his walks through nature by temporarily marking the land in some way. The artist often uses geometric forms to make his human mark upon the landscape visible: he has made circles of stone or has trodden down grasses so that his path along a straight line may be seen. Because these marks are temporary, Long documents the results through photographs. In other works, such as *Baja California Circle,* the artist has removed elements from a particular environment he has encountered in his travels and created a memory of that place in the gallery setting. While visiting the San Diego countryside during his 1989 residency at MCA, Long selected granite stones originating from Baja California and placed them on the gallery floor in a circle 14 feet in diameter. Long's physical engagement with his work is critical to his art making; in essence, he is re-creating his experiences with the land on his own human, physical scale, which is minute in comparison to the scale of the landscape. He has said that his art "is really just an ordering or a ritualizing of my life, . . . the possibility to do something pure and focused and simple in a chaotic world."

David Mach
SCOTTISH, B. 1956

Untitled (Gargoyle), 1991
Chandelier, television, fiberglass, and paint; 98" × 55" × 48". Museum purchase, Contemporary Collectors Fund, 92.2.1–3.

In this unsettling work, a double-headed, hermaphroditic, snarling, snouted beast crouches naked on top of a television emitting static from its screen. The guardian gargoyle-cum-compulsive-consumer hoists an illuminated chandelier overhead in a dramatic pose of triumph or anger. It is unclear whether this erstwhile sunbather (note the tan lines) is condemning consumerism or fighting for a bargain.

Roy McMakin

AMERICAN, B. 1956

A Furniture and Painting Set for a Small Study, 1984
Acrylic on Masonite and maple veneered plywood with enamel paint;
large painting: 84" × 84"; small painting: 20" × 18"; table: 27" × 23" ×
23"; two chairs, each: 36" × 16" × 18¾"; bookcase: 39¾" × 32" × 12";
overall dimensions vary with each installation. Gift of Robert and Anne
Nugent, 87.24.1–6.

McMakin's installations investigate architectural issues on a
domestic scale. Meant to be placed in a corner, *A Furniture
and Painting Set for a Small Study* consists of a richly pig-
mented brown table and two chairs, a bookcase, and two
paintings, one large and one small, each to be hung in a
specific place in relation to the furniture. Characterized by
simple, almost severe forms, McMakin's furniture is rem-
iniscent of an earlier American era. Yet the artist avoids
nostalgia by incorporating surprising details, such as the
asymmetrical shape of the bookcase and the runners
added to the chairs. Drawing upon earlier sources in art,
furniture, and architecture, McMakin has been particularly
influenced by the work of Irving Gill, the early twentieth-
century architect who designed the original Ellen Brown-
ing Scripps house, now the site of MCA La Jolla.

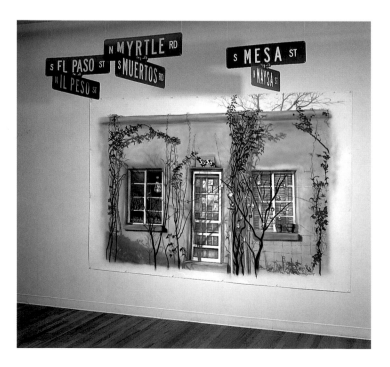

Celia Alvarez Muñoz

AMERICAN, B. 1937

Lana Sube, 1988
Airbrushed acrylic on canvas, and six metal street signs; painting: 71" ×
108"; overall dimensions vary with each installation. Museum purchase
with funds from the Elizabeth W. Russell Foundation and gift of the
artist, 91.8.1–10.

Muñoz's distinctly Chicana perspective and personal
memories of her childhood growing up in the border
town of El Paso find expression in *Lana Sube,* one com-
ponent of her larger installation, *Lana Sube/Lana Baja.* A
desert dwelling forms the focal point of an installation that
features three pairs of street signs suspended from the ceil-
ing. The street names are puns, in which the English and
Spanish words sound the same but have vastly different
meanings: El Paso/Il Peso, Myrtle/Muertos, Mesa/Maysa.
Muñoz invites the viewer to participate in her intimate
bicultural landscape, and to consider the notion of assimi-
lation and the difficulties of translating meaning from one
culture to another.

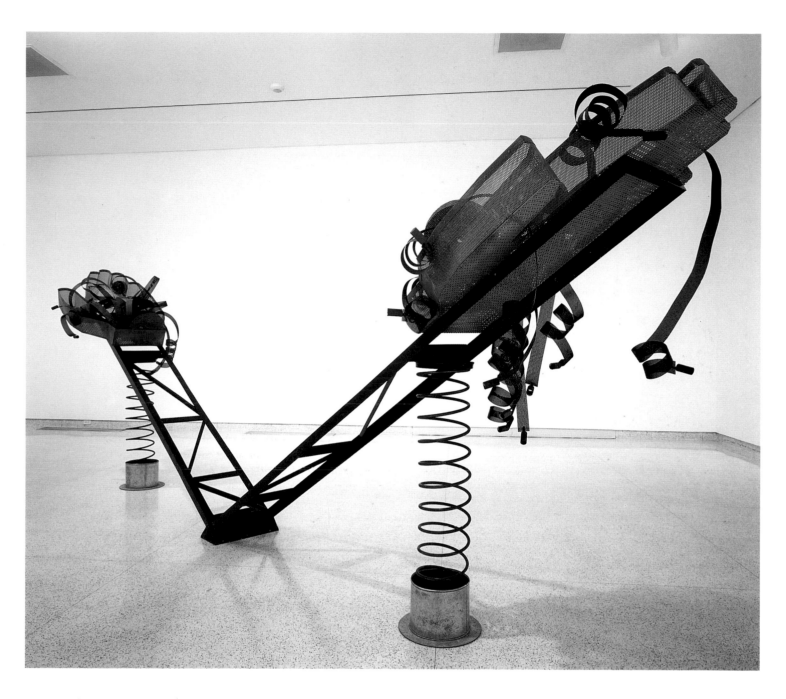

Dennis Oppenheim
AMERICAN, B. 1938

Power Fingers, from the *Fireworks* series, 1983
Assorted metals and paint; 91" × 216" × 31". Gift of Solgar Company,
Inc., Lynbrook, New York, 86.43.

Power Fingers reflects Oppenheim's continuing interest
in the parallels between machinery and the human body.
Despite their animated appearance, the "fingers" are not
actually powered, rather the viewer must complete the
implied movement through his or her imagination.
Oppenheim's sculptures and drawings are metaphors
for the artist's principal concern: the materialization
of thought.

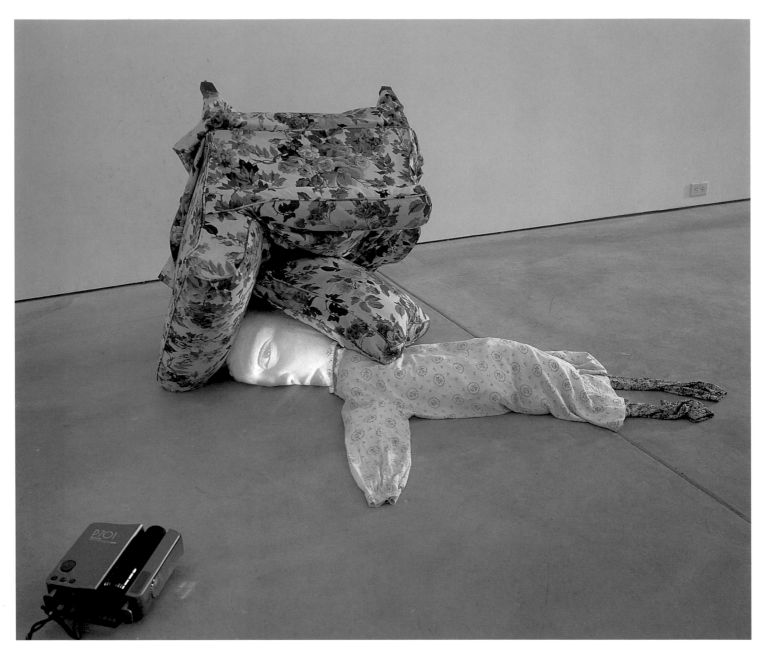

Tony Oursler

AMERICAN, B. 1957

Don't Look at Me, 1994
Video projector, VCR, videotape, armchair with cushion, cloth figure,
and wood prop; 32½" × 91½" × 55½"; overall dimensions vary with
each installation. Museum purchase, Contemporary Collectors Fund,
95.1.1–10.

Oursler often deals with themes of isolation, loneliness,
and angst. In this work, he combines the realism of
video projection and found objects in a haunting scene
of helplessness. The toppled chair appears to trap the
figure beneath it, a woman whose face is animated by a
video projection. Her scowling face cries out to be left
alone, yet the viewer remains transfixed. The figure's
relentless and often aggressive incantations seem to be
directed toward the viewer: the eyes alternately look
away from and directly at the viewer. Oursler's hypnotic
assemblage emphasizes not only the trapped victim's psy-
chological state, but also the viewer's. While the figure
visibly suffers and emotes, viewers quietly experience
their own emotional responses—from surprised humor,
to dread, to voyeuristic unease.

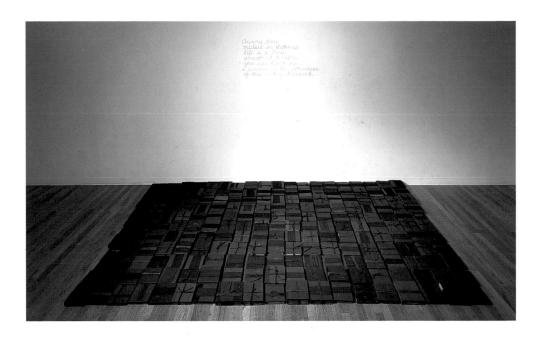

Maurizio Pellegrin
ITALIAN, B. 1956

Your eyes desert me, 1993
Tempera, books, fabric, rope, and graphite; variable dimensions. Gift of
the artist and John Gibson Gallery, New York, 94.3.

The title of this work, *Your eyes desert me,* is a line from
a poem written by Pellegrin. This piece is one component
of a larger installation of the same name. The theme of the
installation is knowledge, and this particular piece consists
of several hundred black books, each individually num-
bered and bound, which carpet the floor of the gallery;
Pellegrin's poem is inscribed on the wall behind the books.
The artist has chosen to combine various books because
of the information, or knowledge, each of them contains.
Pellegrin explains that the numbers stamped on each book
express the amount of energy contained within each book,
and that the individual bookbindings maintain the vital-
ity and the reminiscences present in each of the books.
Pellegrin's work is tinged with a sense of mystery that of-
ten triggers memories for the viewer, memories that, in
turn, are shared with others, expanding the installation be-
yond the gallery experience.

Jeffrey Schiff
AMERICAN, B. 1952

Scribe, 1987
Felt and steel; 84" × 130" × 15". Museum purchase, 87.18.

Scribe was originally installed as part of a 1987 exhibition
of Schiff's work at MCA's downtown space. The minimal
look of the work belies Schiff's inspiration for creating
the piece: the celebration of tools and the human move-
ments they engender. A flat, industrially textured felt pad
is bolted directly to the wall. A steel bar with a machine-
made knurled handle is bolted on top of the felt near one
side. The two elements are a hybrid of age-old artisanal
traditions and the simple machines of the early industrial
revolution. The artist activated *Scribe* by grasping the
handle and turning the steel bar in a compass circle, leav-
ing arcs—different kinds of trace records—on architecture
(the wall) or art (the felt) for the viewer to contemplate,
alluding to texts and images in graphic or pictorial arts.

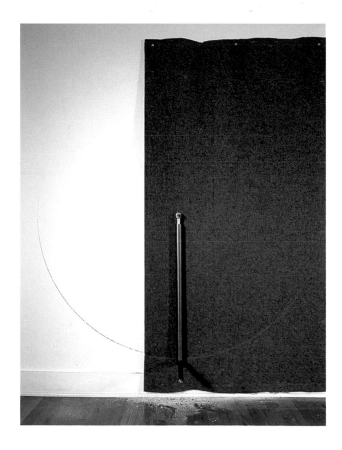

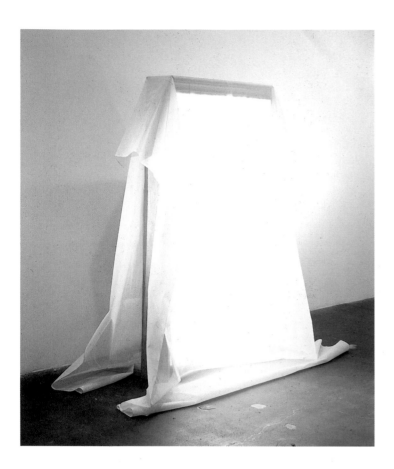

Sarah Seager
AMERICAN, B. 1958

Panacea (with fluorescents), 1989
Cotton scrim, wood, and fluorescent lights; 75" × 80" × 34". Gift of
Burnett Miller Gallery, Santa Monica, 94.14.1–2.

Sarah Seager's work is both mysterious and mundane. A
loose scrim veils a free-standing wooden frame that is as
large as a portal. Lights placed behind the scrim illuminate
the draped structure from within and extend the object's
reach from the architectural to the atmospheric. Seager is
known for spare paintings, drawings, and sculptures that
avoid a clutter of images or glut of constructions.

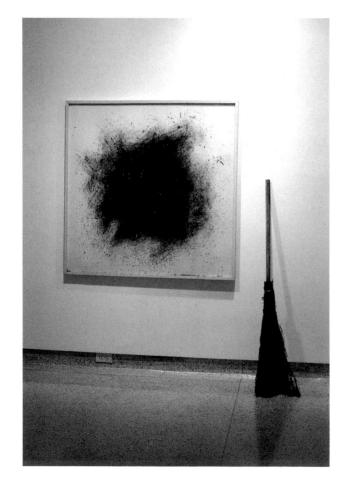

Eric Snell
BRITISH, B. 1953

Broom Drawing, 1988
Burnt wood on paper with broom; drawing: 45½" × 45½"; broom:
55¼" × 12" × 5". Museum purchase with funds from the Lannan
Foundation, 88.24.1–2.

Snell addresses issues of material, time, and energy. In
Broom Drawing, the artist used the charred end of a burnt
broom to create the gestural marks of the drawing, and he
also incorporated the broom as an element of the piece.
The ordinary cleaning tool loses its functional purpose
and gains new meaning as both an art-making tool and
a work of art. Snell describes the result: "By burning the
object you lose it. But you don't, really; you just get a
transference of energy." He makes this energy visible in
the free form of the very gestural drawing, and by leaving
the singed broom next to the drawing, Snell explicitly
calls attention to this reciprocal relationship.

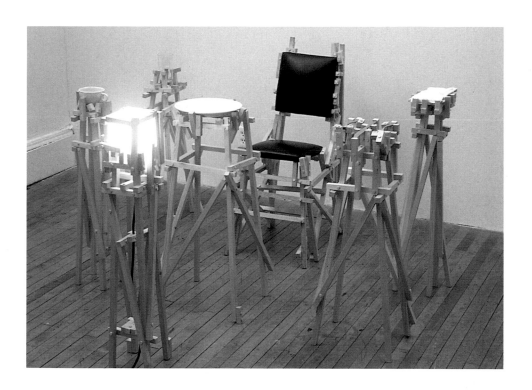

Allan Wexler

AMERICAN, B. 1949

Scaffold Furniture, 1988
Pine, leather, flatware, electric light, glass, ceramic plate and cup, and cloth napkin; 34¼" × 72" × 52"; overall dimensions vary with each installation. Museum purchase with funds from the Elizabeth W. Russell Foundation, 91.9.1–14.

Wexler's work is informed by his professional training as an architect and urban designer. He is concerned with function yet, ironically, his works are usually nonfunctional. Everyday logic and assumptions regarding furniture are reversed, prompting the viewer to reconsider his or her surroundings. In *Scaffold Furniture,* Wexler isolates and investigates the individual props typically used in the Western convention of dining. Each scaffold carries an individual object for a particular use: one stand holds the diner's plate, another the flatware, and so forth. By isolating the objects, the artist opens them, and, simultaneously, the social behavior and eating habits associated with them, to closer scrutiny.

Bill Woodrow

BRITISH, 1948

Still Waters, 1985
Three car hoods, three spring mattresses, and enamel and acrylic paints; 54" × 122" × 245". Museum purchase, 85.13.1–8.

Disparate images of commerce, media, home, and nature collide in Woodrow's floor-hugging *Still Waters.* An elk head fashioned from a cut-and-bent car hood seems to swim up an implied stream of mattresses. Various symbols of power and control—a gold bar, a key, and a microphone—lie tangled in its antlers. The elk also pulls—or is restrained by—large objects that refer to domestic life, including a chair, a stepladder, and a sinking boat—a commentary on the clash of nature with our culture of consumption.

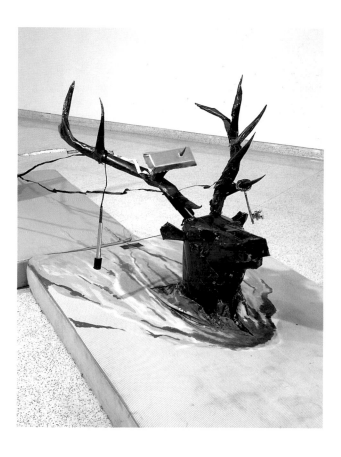

Curatorial Chronology, 1969–1996

1969
Thomas S. Tibbs, Director
Larry Urrutia, Assistant Director
Fran Preisman, Curator of Education

1970
Thomas S. Tibbs, Director
Larry Urrutia, Assistant Director
Fran Preisman, Curator of Education

1971
Thomas S. Tibbs, Director
Larry Urrutia, Assistant Director
James Victor Bower, Assistant Curator

1972
Thomas S. Tibbs, Director
Larry Urrutia, Assistant Director
James Victor Bower, Assistant Curator

1973
Sebastian Adler, Director
Larry Urrutia, Assistant Director
Jay Belloli, Curator
James Victor Bower, Assistant Curator/
 Registrar

1974
Sebastian Adler, Director
Jay Belloli, Curator

1975
Sebastian Adler, Director
Steven Brezzo, Chief Curator
Richard Armstrong, Curator

1976
Sebastian Adler, Director
Richard Armstrong, Curator
Christopher Knight, Curator

1977
Sebastian Adler, Director
Richard Armstrong, Curator
Christopher Knight, Curator

1978
Sebastian Adler, Director
Richard Armstrong, Curator
Christopher Knight, Curator

1979
Sebastian Adler, Director
Robert McDonald, Chief Curator
Richard Armstrong, Curator
Christopher Knight, Curator
Adina Wingate, Curator
Lynda Forsha, Assistant Curator/
 Registrar
Martha Winans, Assistant Curator

1980
Sebastian Adler, Director
Robert McDonald, Chief Curator
Adina Wingate, Curator
Lynda Forsha, Assistant Curator/
 Registrar
Martha Winans, Curator of Education

1981
Sebastian Adler, Director
Robert McDonald, Chief Curator
Lynda Forsha, Assistant Curator/
 Registrar
Martha Winans, Curator of Education

1982
Sebastian Adler, Director
Robert McDonald, Chief Curator
Lynda Forsha, Curator

1983
Hugh M. Davies, Director
Lynda Forsha, Curator
Burnett Miller, Curator

1984
Hugh M. Davies, Director
Lynda Forsha, Curator
Burnett Miller, Curator

1985
Hugh M. Davies, Director
Ronald J. Onorato, Senior Curator
Lynda Forsha, Curator

1986
Hugh M. Davies, Director
Ronald J. Onorato, Senior Curator
Lynda Forsha, Curator

1987
Hugh M. Davies, Director
Ronald J. Onorato, Senior Curator
Lynda Forsha, Curator
Madeleine Grynsztejn, Assistant Curator

1988
Hugh M. Davies, Director
Ronald J. Onorato, Senior Curator
Lynda Forsha, Curator
Madeleine Grynsztejn, Assistant Curator

1989
Hugh M. Davies, Director
Lynda Forsha, Curator
Madeleine Grynsztejn, Associate Curator

1990
Hugh M. Davies, Director
Lynda Forsha, Curator
Madeleine Grynsztejn, Associate Curator
Sarah E. Bremser, Assistant Curator

1991
Hugh M. Davies, Director
Lynda Forsha, Curator
Madeleine Grynsztejn, Associate Curator
Sarah E. Bremser, Assistant Curator

1992
Hugh M. Davies, Director
Lynda Forsha, Curator
Kathryn Kanjo, Assistant Curator
Seonaid McArthur, Education Curator

1993
Hugh M. Davies, Director
Lynda Forsha, Curator
Kathryn Kanjo, Assistant Curator
Seonaid McArthur, Education Curator

1994
Hugh M. Davies, Director
Louis Grachos, Curator
Kathryn Kanjo, Assistant Curator
Andrea Hales, Curatorial Coordinator
Seonaid McArthur, Education Curator

1995
Hugh M. Davies, Director
Louis Grachos, Curator
Kathryn Kanjo, Associate Curator
Andrea Hales, Curatorial Coordinator
Seonaid McArthur, Education Curator

1996
Hugh M. Davies, Director
Elizabeth Armstrong, Senior Curator
 (from October 1996)
Louis Grachos, Curator (to June 1996)
Andrea Hales, Curatorial Coordinator
Seonaid McArthur, Education Curator

Index

Titles of works are set in *italic* type. Titles of exhibitions are also set in italic type and are followed by the notation "(exh.)" (one exception is inSITE, which is set in roman type). Page numbers set in **bold** type indicate the location of illustrations.